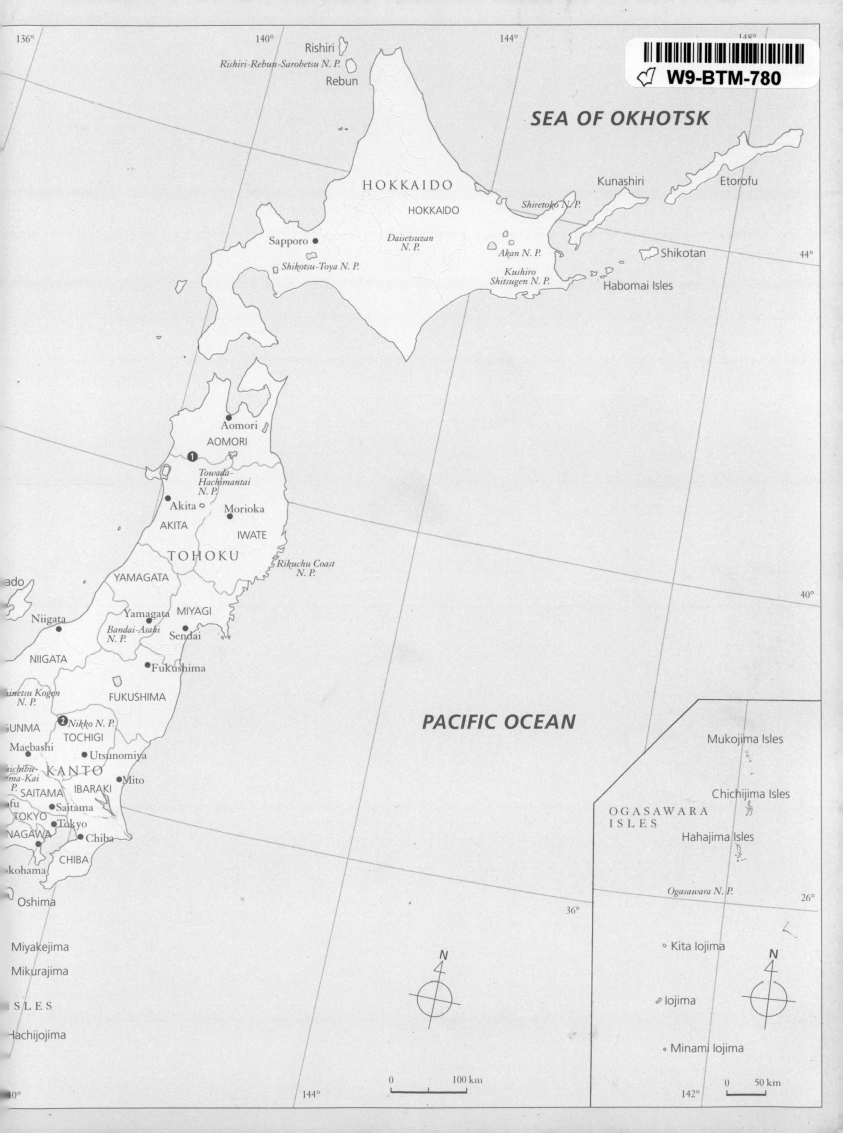

136° 140° 144° 148°

SEA OF OKHOTSK

Rishiri
Rishiri-Rebun-Sarobetsu N. P.
Rebun

HOKKAIDO

HOKKAIDO

Kunashiri Etorofu

Shiretoko N. P.

Daisetsuzan N. P.

Sapporo

Shikotsu-Toya N. P.

Akan N. P. Shikotan 44°

Kushiro Shitsugen N. P.

Habomai Isles

Aomori
AOMORI

1 *Towada-Hachimantai N. P.*

Akita Morioka

AKITA IWATE

TOHOKU

Rikuchu Coast N. P.

YAMAGATA

40°

Niigata Yamagata MIYAGI

Bandai-Asahi N. P. Sendai

NIIGATA Fukushima

inetsu Kogen N. P. FUKUSHIMA

GUNMA **2** *Nikko N. P.*
TOCHIGI

Maebashi Utsunomiya

ichibu-
ma-Kai
P. KANTO Mito

SAITAMA IBARAKI

fu Saitama

TOKYO Tokyo

NAGAWA Chiba

ohama CHIBA

Oshima

PACIFIC OCEAN

Mukojima Isles

Chichijima Isles

OGASAWARA
ISLES

Hahajima Isles

Ogasawara N. P. 26°

36°

Miyakejima

Mikurajima

Kita Iojima

ISLES

Iojima

Hachijojima

Minami Iojima

N

144°

0 100 km

142°

0 50 km

N

40°

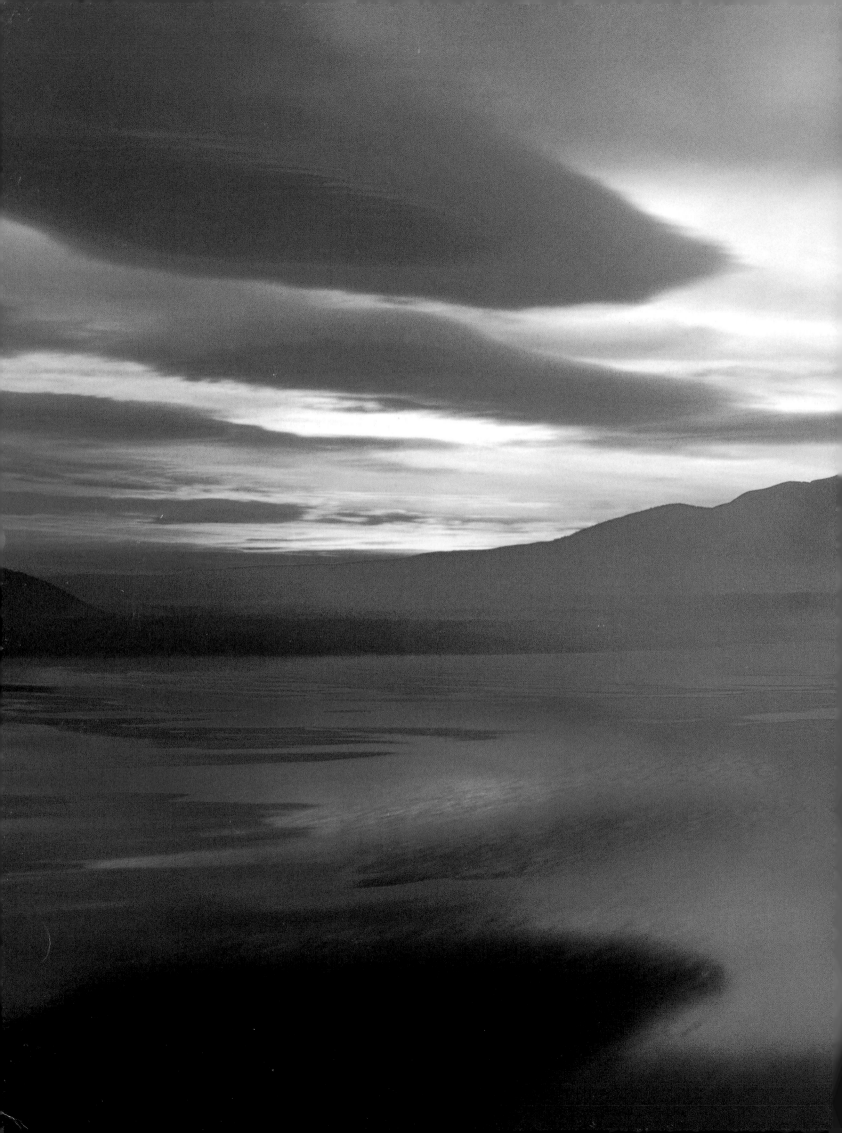

SEEING JAPAN

TEXT BY **Charles Whipple**

FOREWORD BY **Morihiro Hosokawa**

KODANSHA INTERNATIONAL
Tokyo • New York • London

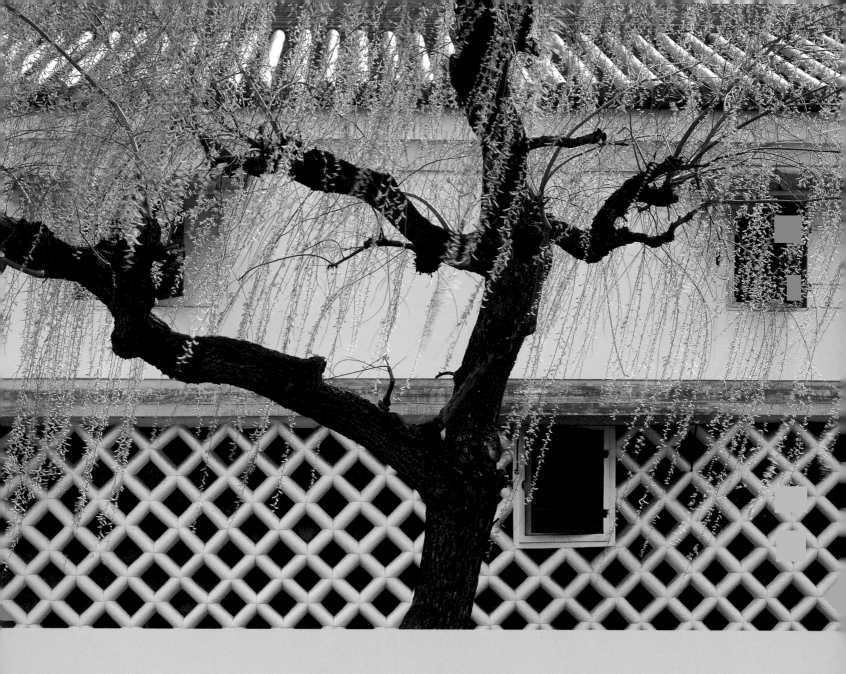

Distributed in the United States by Kodansha America, Inc., and in the United Kingdom and continental Europe by Kodansha Europe Ltd.

Published by Kodansha International Ltd., 17–14 Otowa 1-chome, Bunkyo-ku, Tokyo 112–8652, and Kodansha America, Inc.

Book concept and design copyright © 2005 by Kodansha International Ltd. Text copyright © 2005 by Charles T. Whipple. Foreword copyright © 2005 by Morihiro Hosokawa.
All rights reserved. Printed in Japan.
ISBN-13: 978–4–7700–2337–7
ISBN-10: 4–7700–2337–5

First edition, 2005
12 11 10 09 08 07 06 05 10 9 8 7 6 5 4 3 2 1

Library of Congress Cataloging-in-Publication Data available

www.kodansha-intl.com

ABOVE: Weeping willow and traditional storehouse. **TOP RIGHT:** *Koinobori* carp banners on Boys' Day. **MIDDLE RIGHT:** *Kadomatsu* New Year's decoration. **BOTTOM RIGHT:** Silver pampas grass in the moonlight.

PAGE 1: Cherry blossoms herald the start of spring in Japan.
PAGES 2–3: Mt. Fuji at sunrise.
PAGES 6–7: Riotous autumn leaves at Daisetsuzan, Hokkaido.
PAGES 8–9: Terraced rice paddies at Doya, Nagasaki.
PAGE 10: Skyline at night in Odaiba, Tokyo.

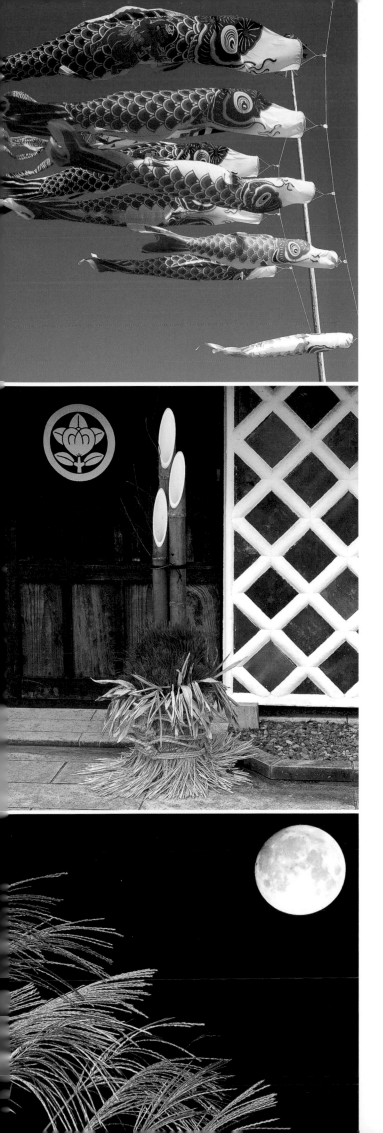

CONTENTS

FOREWORD

Morihiro Hosokawa

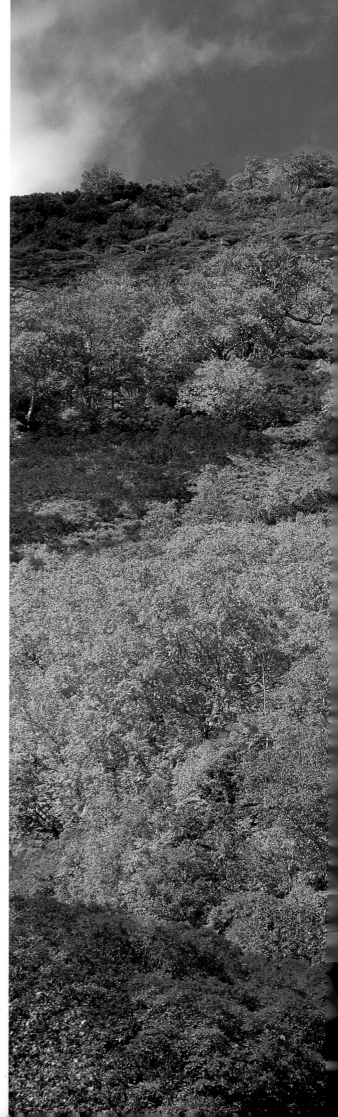

The ideal of living in a quiet environment devoted to the studious life, as expressed by the well-known phrase *seiko udoku* (literally, "farming on fine days, reading on rainy days"), captured my imagination early on. Retirement from politics finally gave me the opportunity to put this ideal into practice in 1998. In the hot spring resort town of Yugawara—about sixty miles from Tokyo—I took up just such a quiet life, cultivating a small garden of some twenty varieties of vegetables, making pottery and firing it in kilns built on the property, traveling afar or going fishing in the hills when the spirit moves me, and devoting my evenings to reading and writing.

There is something compelling about this way of life. It must be universal, for sages as far apart as Seneca, philosopher of ancient Rome, and Yoshida Kenko, medieval Japanese priest and author of *Tsuzuregusa* ("Essays in Idleness," c. 1330), wrote of the yearning for peace of mind and a sense of fulfillment, and the attraction of abandoning the bonds of worldly ambition and obligation to live to the fullest for the perhaps not-so-many years remaining in one's life. The works of the fifth-century Chinese poet Tao Qian, too, are full of the yearning of the Asian intellectual for the rural, sequestered life. While serving in a succession of official posts and being in close contact with people of power and influence, Tao wrote over and over of "returning to one's native place," "going back to live in the country," and recognizing one's ultimate home in the countryside. I was likewise impressed by William Wordsworth's works championing the "simple life, noble spirit" and by other writings praising the country life, like *The Private Papers of Henry Rycroft* by George Gissing, and some works by World War I British foreign minister Edward Gray. Ultimately, however, I was drawn even more strongly by the examples of the Asian recluses, the practitioners of the *seiko udoku* life free from worldly cares.

Images of this sort of life may be varied—the sequestered life, the idle life, the hermit's life, the life of quiet retirement—but all derive from the mingling of Confucianist and Buddhist ideas and the teachings of Lao-tsu (Taoism) that have been passed down by people in East Asian cultures for many centuries. When you look at a Chinese, Korean, or Japanese landscape painting you will often find the diminutive figure of a sage sheltered by a simple hut perched on the edge of a waterfall in the mountains. What you see there is not the image of a person *escaping* reality but firmly and deliberately *returning* to the original mode of human life in nature, a life unburdened by material possessions and worldly ambitions. These people, whether the hermit sage, the scholar recluse, or the retired philosopher, were all followers of the "simple life." Some of them stayed in one place, living in simple huts; others were itinerant, moving from one temporary abode to another—but all were adherents of a way of life affirming withdrawal from society.

Kamo no Chomei (1155?–1216), whose *Hojoki* ("Account of a Ten-foot-square Hut") comments on the tumultuous times at the transition from the stability of the ancient regime to the chaos of the medieval period, was himself committed to the simple life. Particularly in Japan, the sentiments of the committed recluse, together with the Buddhist concept of *mujo*—the transience of life—and appreciation of nature, along with ideas from the world of Tea, such as the deliberately simple urban life, form a distinct cultural tradition.

In my own "quiet" life, pottery occupies an important place. I make pottery in the Japanese traditions of Raku, Shigaraki, and Karatsu, as well as the Korean traditions of Ido and Kohiki, and fire the pieces in four different types of kilns. Pottery is created by a person with an earnest and open mind working with those very basic and ancient elements: clay and fire. Of course, pottery is by no means limited to Japanese culture—it is a universal craft—but what has fascinated me personally is that it allows me to experience what I think is the essential spirit of what it means to be Japanese. That spirit can be found specifically in the making of utensils for the tea ceremony, and I myself have found it in making teabowls.

What is the fascination of making a teabowl? It is hard to describe, but perhaps it is because a teabowl can be the projection of one's very spirit. The ceramics of the West,

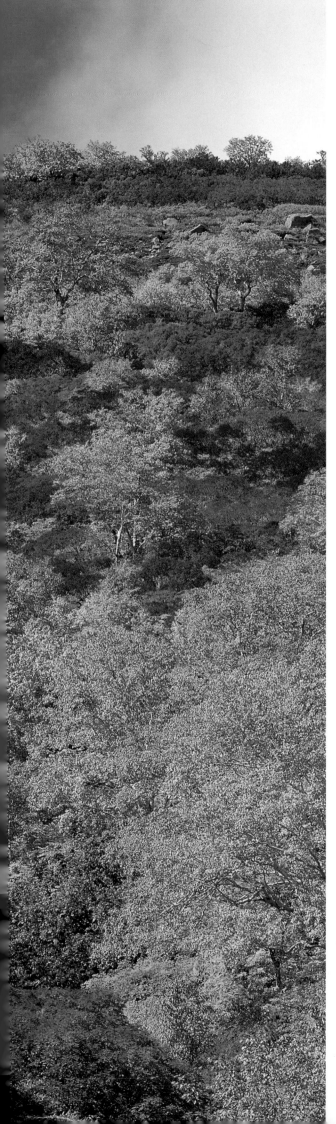

with their geometrical and symmetrical patterns, seem to have an affinity for the universal. For the Japanese teabowl, however, the subjective and distinctive qualities are what are important and prized. Unlike painting or music, its beauty may be determined by factors beyond the control of human artifice—by designs resulting from the effects of fire, that intangible hand of the divine (one might call it the power of the god of the kiln). No matter how the artist may create and contrive, at some stage in the process unpredictable forces are inevitably at work—it is this aspect of pottery making that I find irresistible.

The experience of making teabowls reawakened my longtime interest in the Azuchi-Momoyama period (1568–1600), a time when art and aesthetics were so important that even a teabowl could play a role in the political and cultural events of history. This short period of less than fifty years was one of constant and turbulent change, of invention and innovation, of iconoclasm and experimentation. The unconventional and avant-garde black-glazed Raku teabowls of Chojiro (1515–92) were as different as night and day from the deformed and irregularly shaped teabowls of Furuta Oribe (1544–1615), but both were products of the Momoyama spirit. The innovation and aesthetic of Momoyama was not, however, disconnected from traditions going back to antiquity.

Sen no Rikyu (1522–91), the tea master who put Chojiro to work making teabowls, was a consummate art director. Via the tea garden he ushered the visitor into a realm apart from the world of mundane affairs where the tea room, a small space of perhaps only ten square feet, formed a universe all its own. The Momoyama period was above all an era of extraordinary personalities who distinguished themselves in various fields. Of these, I am particularly attracted by the potter Koetsu, and the free and graceful lines of his teabowls.

Some of the most admirable figures in Japan's cultural history—such as the Heian-period poet Saigyo, the fourteenth-century poet and essayist Yoshida Kenko, the eighteenth-century painter Ike no Taiga and the painter and haiku poet Yosa Buson—though from different periods, share the qualities of the person cultivated in the arts and classics who has little interest in money, position, glory, or material goods. The Zen poet Ryokan (1758–1831) wrote "If you desire nothing, life is satisfactory; if you are greedy, you will always feel poor." Both Koetsu and Ryokan were people who could have led lives of material wealth if they had wanted to but decided instead to live simply. Having chosen this life of their own free will, their minds were free to roam in the world of refinement and good taste. Today, for Japanese who feel overwhelmed by the material abundance around them, such affirmation of simplicity and self-sufficiency has tremendous appeal.

If we look at the way these people lived, it is clear that they had grasped a clear principle regarding material possessions: the more money or goods a person possesses, the more worries and the less freedom one has. To put it a different way, by keeping one's material possessions to an absolute minimum, one can attain great freedom and spiritual richness. In our current times of excessive material abundance and declining richness of the spirit, this principle—which I believe is at the very core of the Japanese identity, and an essential aspect of the philosophy of the simple life—and these historical figures clearly shine like beacons in the dark.

These days, Japan calls itself an economic superpower and others seem to agree, but it is still within very recent memory that life on these islands, where farmland and resources are limited and natural disasters are frequent, was far from abundant. The climate, though, is moderate, making for a more comfortable environment than in regions of intense tropical heat or extreme cold and, blessed with plentiful rainfall and clear weather, has given us a landscape of great scenic beauty. Japanese have therefore not been locked in combat with nature nor inclined to think of it as an adversary; rather we are more likely to take comfort in nature, sharing our enjoyment of its blessings. A poem by the thirteenth-century Zen priest Dogen reads: *Haru wa hana, natsu hototogisu, aki wa tsuki, fuyu yuki-saete suzushi karikeri* (Ah! The flowers of spring, the warblers of summer, the autumn moon, even the glistening winter snows feel cool.) This is testimony to the way Japan's abundant landscape and its ever-changing seasonal beauty fostered refined traditions of aesthetic taste, close sensibility to human feeling, and deep appreciation for beauty. Fine works of Japanese art shun the artificial and contrived, instead finding perfection in expressions that transcend mere human invention, and treasuring the uniqueness that emerges naturally thereby. It seems to me that this is the result of a spirit that has been nurtured in Japan's particular climate and landscape.

INTRODUCTION

I first came to Japan in the 1960s as a university student in search of its language and culture. I spent thirteen months in the city of Takasaki in Gunma prefecture, where ever-patient Mrs. Suzuki, barely five feet tall, stern as a headmaster, and not inclined to laugh at the antics of foreigners, tutored me in Japanese and tried to teach me manners. When not studying under Mrs. Suzuki's watchful eye, I wandered Takasaki on a second-hand bicycle, poking around shops—I especially liked the one selling apricot pastries from large glass jars—and speeding along the riverbank in the wind, dodging gaggles of students in navy-blue uniforms. I became quite famous, the tall gaijin who refused to use English but was unable to speak coherent Japanese.

I felt especially comfortable in one small corner of Takasaki. Keiko, clad in hand-knitted skirt and sweater with matching knee-length socks, her feet shoved into wooden slippers, was a tough, no-nonsense Gunma woman who matched the dry blustery wind of that hard land. She waited the three tables at Kinoshita Shokudo, a tiny place near the Karasu river that served a plate of noodles fried with cabbage and a whiff of pork for twenty-five yen, or cuttlefish tempura that came with rice, miso soup, and pickled takuwan radish for thirty-five. At Kinoshita's, with its floor of tamped earth, the tables and chairs tottered on spindly iron legs. But the food was good and Keiko's rosy cheeks were always dimpled with a smile.

After graduation from university in Hawaii, the language I had learned from Mrs. Suzuki, along with what I studied in school, helped me land a job with a major American food company that transferred me to Japan in 1968. Once settled in Tokyo's Nishi Azabu area, I bought a fastback coupe to see the country. The next-door neighbor's parents owned an inn in Kesennuma, a town famous for its pristine beaches, so I decided to spend a night there on the way north to Matsushima, which I had been told was one of the three most beautiful places in the entire country.

Fronting a golden sand beach, the inn in Kesennuma was a long house with six eight-mat rooms in a row separated only by paper *fusuma* sliding doors. The open space from the lintels to the bare ceiling far above allowed sound to bounce so clearly that even whispers could be understood. That night, the chorus of snores and sighs left me with the impression that sleep had been a figment of my imagination.

In the morning, the inn's owner gave me a hand-drawn map of a quick back-road route to Matsushima, but I was soon lost on a matrix of dirt roads wending through endless paddies where water glinted among waist-high stalks of rice. A farmer stood by the way leaning on his shovel, so I stopped to ask directions in my best standard Japanese.

"Matsushima?" he queried, and I nodded. He pointed and reeled off a string of words in a dialect that I did not understand. I nodded my head, rolled up the window, and drove away more lost than ever. I finally found a paved road and a sign with an arrow pointing toward Tokyo, so I was saved from forever wandering in search of Matsushima and its vaunted scenery. But in driving over all those back roads, I felt I had gotten a rather good look at rural Japan.

As the twentieth century came to a close, I took my eldest daughter, Emma, to Kanazawa on the Sea of Japan coast to get a taste of traditional Japan. She had grown up in Tokyo but went to the United States for high school and college. Now, in a few days, she would go to work for a Los Angeles design firm and she wanted to see what she had so often heard me talk about. We went to Daijoji, a Jodo-sect Buddhist temple on the outskirts of Kanazawa that eschews the two moneymakers many other temples cater to, neither conducting funerals nor accepting bus tours. Under overcast skies, Daijoji was nearly monotone, its walls silvery gray and its roof tiles a gunmetal hue that matched the granite that paved the approach. The bare ground reflected the roof tiles, wet and black. The foliage was still damp from passing rain and glimmered dark green over the gray-brown trunks of cypress, sakaki, zelkova, and beech.

Passing through the gate and into the *genkan* foyer, we met an abbot dressed in simple indigo cotton. Savoring the perfect silence and inhaling the fragrance of sandal-

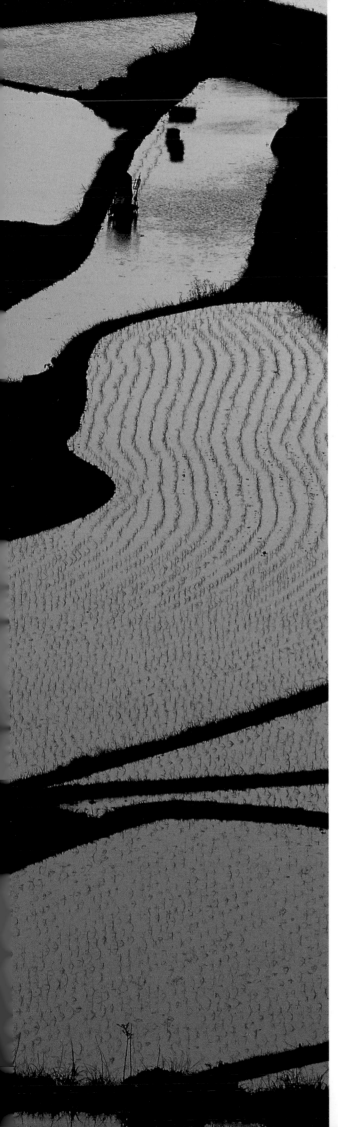

wood incense, we passed with him into the main hall where tatami mats, worn slick from kneeling, surrounded a central altar. Further around the walkway, we came to the *butsuden* room, the repository for the temple's precious statue of Buddha. "Look at the floor," the abbot said as we stood staring at the centuries-old statue, a national treasure. "It is earthen. The monks wipe it down each morning with damp cloths and over the centuries it has hardened like polished stone." Standing on that age-old earthen floor, we understood how patience helps bring change.

In her Kanazawa atelier, Mizuno delicately dyed kimonos in the *Kaga-yuzen* fashion handed down to her from her father. She sat at a low table with the dyes around her in white ceramic dishes. A can of brushes at her elbow, she showed us how the silk stretches tight over bamboo frames and how an electric heater set into the center of the table quickly dries brushed-on dye into artful designs to turn silken kimonos into family heirlooms.

Emma and I were early and the only guests at Yoshimura's restaurant in Kanazawa's Daikumachi district. "What'll you have?" Yoshimura asked. "The same as always," I said, and Yoshimura grinned. He raised a finger to his number two chef, who took a net to the fish tank and scooped out a palm-sized flounder while Yoshimura reached into the cold cabinet for a packet of sea bream slices wrapped in *konbu* seaweed. The flounder got filleted, dredged in seasoned cornstarch, deep fried, and arrayed in perfection on a celadon pottery plate, while the sea bream sashimi was served on a glass platter designed to look like ice. Specially brewed soy sauce with aromatic perilla spikes complemented the feast for the eyes and for the palate.

For the last twenty years or so, my friend Shonosuke Okura, heir to a six-hundred-year-old Noh dynasty, has given a midnight concert every night of the full moon. One night we drove to the Miura peninsula south of Tokyo, where Okura's biker friends had begun to arrive and cars full of people were pulling into the bluff-top parking lot above Chojagasaki. On the beach below, flames rose from the two *kagaribi* fire baskets and cast flickers of firelight across the wavelets. At midnight, Okura took a position between the fire baskets and the waves, wearing black jeans, a denim shirt, and a black leather vest—a far cry from the formal attire of a Noh performance. He held his *otsuzumi* drum to his thigh with his left hand, bending his leg slightly to bring the drum's head into proper alignment. The concert began with the full moon directly overhead, and Okura's *kakigoe* shouts and sharp beats from his drum pierced the night, as Mt. Fuji loomed from across Sagami Bay.

Japan is here to see and to enjoy, the modern and the historical alike. The photographs and text in this book offer glimpses into the pulsing heart of this traditional yet ever-changing culture. I began looking at Japan nearly half a century ago, and now, after living here for more than three decades, I still find something new each day—a pair of chopsticks resting on an autumn leaf, a man who plucks a brush from his suit coat pocket to sign his name, a state-of-the-art cell phone with a lacquered case—and realize I have just begun to learn the art of seeing Japan.

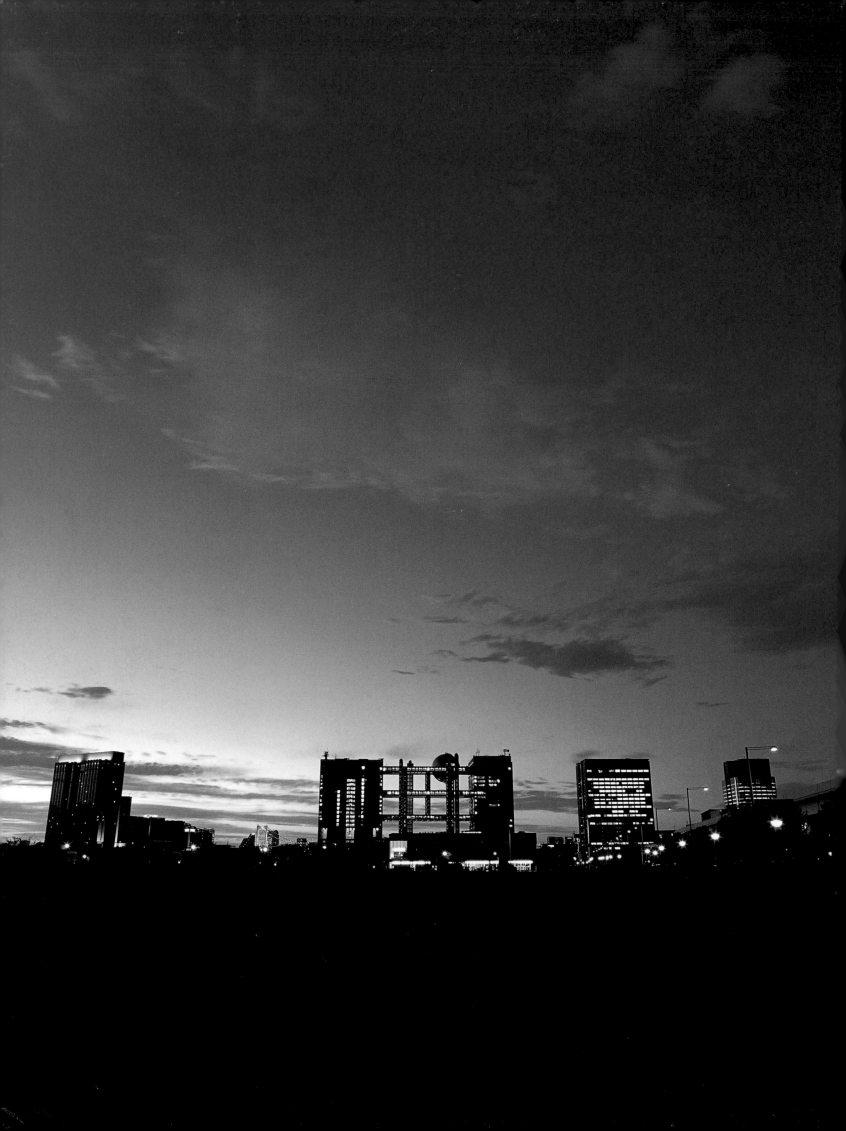

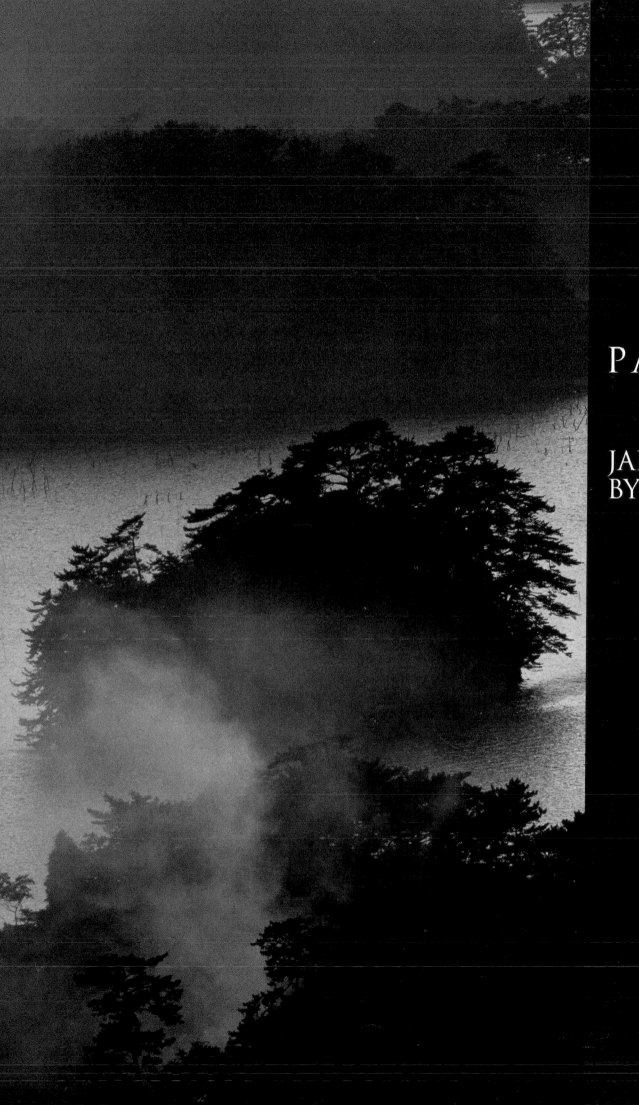

PART I

JAPAN
BY REGION

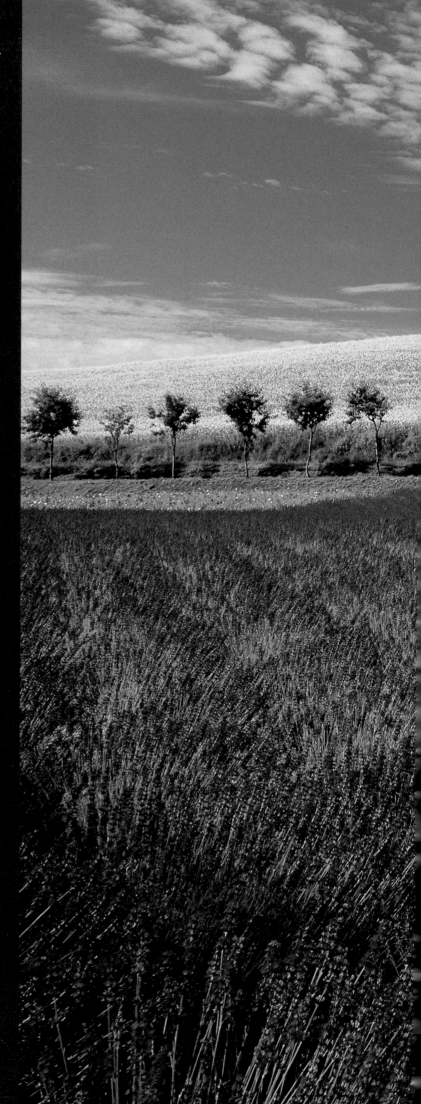

Fields of lavender in Furano, Hokkaido.

TOHOKU AND HOKKAIDO

The Tohoku region is the northeastern end of Honshu, and Hokkaido is the northernmost of Japan's islands. Together, Tohoku and Hokkaido account for forty-three percent of Japan's land area but less than fifteen percent of the country's population.

Six prefectures comprise Tohoku, a land of wondrous mountain wildernesses and delightful deciduous forests. The Shirakami mountain range is a World Heritage Site for its primeval beech forest, the largest in East Asia, and home to the endangered Japanese golden eagle. Osorezan, a craggy volcano on the Shimokita Peninsula, is the site of Entsuji, a temple dedicated to the souls of children who died in infancy, and is also famous for *itako*, oracles that commune with the dead. Further south, volcanic eruptions at Mt. Bandai in 1888 formed a chain of lakes in the Aizu-Bandai area. And Matsushima, a group of islands an hour from the city of Sendai, is designated one of Japan's three most beautiful natural sights.

An intriguing look at the Jomon hunting, fishing, and gathering civilization is available at Sannai Maruyama, a reconstructed village on a site dating to about 2000 B.C. located near the present-day city of Aomori. Today, though, Tohoku farmers produce twenty percent of Japan's rice harvest and its most delicious rice varieties, as well as some of the nation's most delectable fruit.

PREVIOUS PAGE: Matsushima is one of Japan's top three scenic vistas.

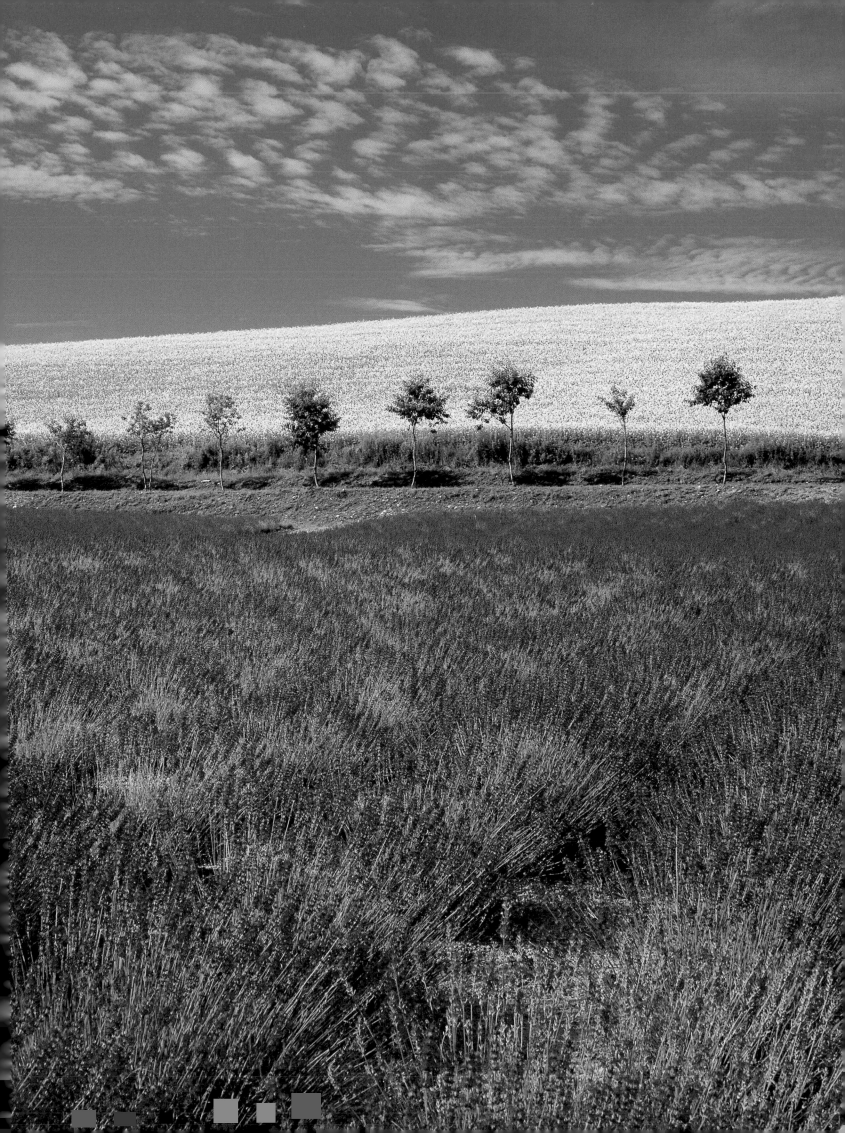

Citizens of Tohoku prize the region's sharply delineated seasons. Spring brings cherry blossoms and lively flower-viewing parties, and summer is a time of festivals, many of which are famous nationwide. Fall frosts turn the leaves of Tohoku's forests into brilliant yellows and reds, and winter at Mt. Zao in Yamagata offers some of Japan's finest skiing.

Hokkaido is snowbound for a third of the year. It hosted the 1972 Winter Olympics, and is home to the annual Sapporo Snow Festival in February, which attracts more than two million visitors from all over Japan and the world.

Hokkaido is Japan's frontier island, annexed in the late nineteenth century. It is the homeland of the indigenous Ainu people, and many place names on the island are Ainu in origin, including the capital city of Sapporo. The Ainu especially revere Hokkaido brown bears, which still roam the island's wilderness areas. Other well-known wildlife includes red foxes, Ezo deer, and red-crested cranes.

While Hokkaido is a breadbasket for Japan, visitors flock to its scenic wonders: Daisetsuzan National Park; the secluded Shiretoko Peninsula; the Kushiro wetlands where red-crested cranes perform their mating dance; the Shikotsu-Toya National Park with its volcanoes and lakes; and the rugged Shakotan coast. Hokkaido also offers the best of hot spring spas at Noboribetsu, Jozankei, and Sounkyo.

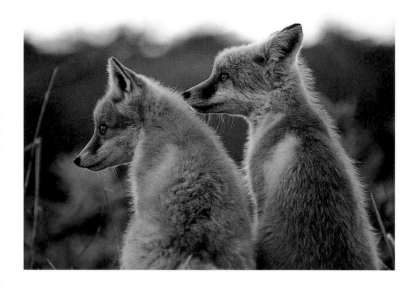

ABOVE: Red foxes are native to Hokkaido. **BELOW:** Red-crested cranes beneath the moon at Kushiro, Hokkaido. **RIGHT:** The Snow Festival in Sapporo, Hokkaido.

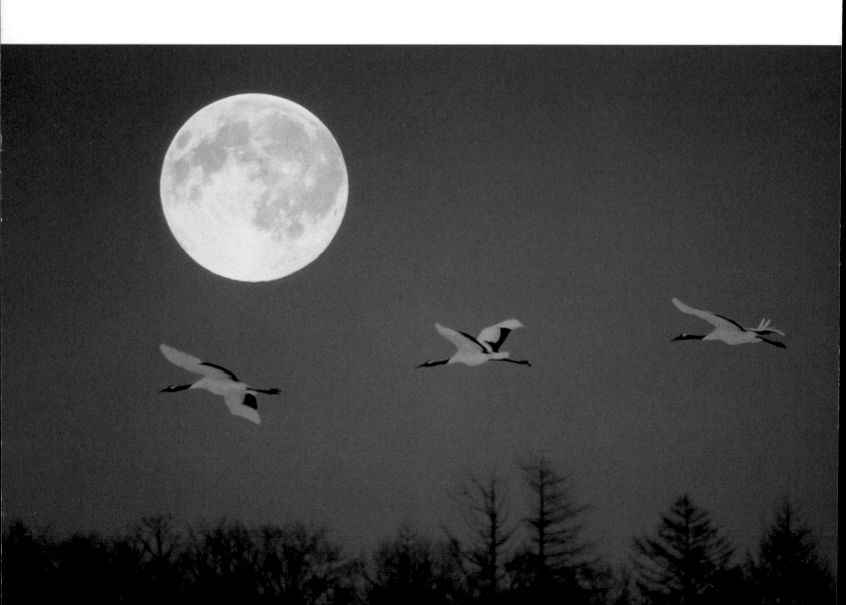

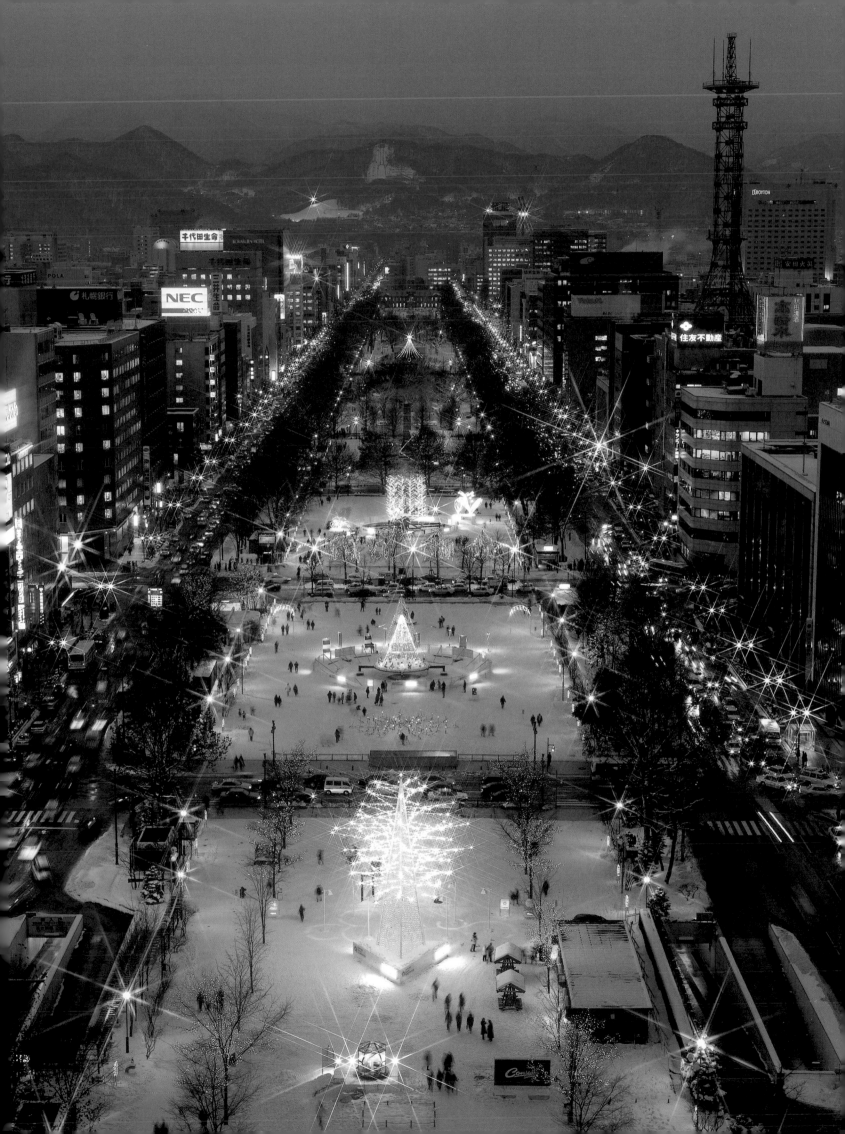

Both Tohoku and Hokkaido boast active fishing industries. The collision of warm and cold ocean currents creates a tremendously productive fishing ground off the Pacific Coast, and fishermen from Hokkaido and Tohoku vie for the giant blackfin tuna that cruise the Tsugaru Straits. Gourmets seek out Tohoku scallops, oysters, and abalone, and prize crabs and mussels from the cold waters off Hokkaido.

BELOW: Lighted figures in the Nebuta festival, Aomori prefecture. **TOP RIGHT:** Forest in the Shirakami mountain range, a World Heritage Site. **BOTTOM RIGHT:** Sanriku coastline, Iwate prefecture.

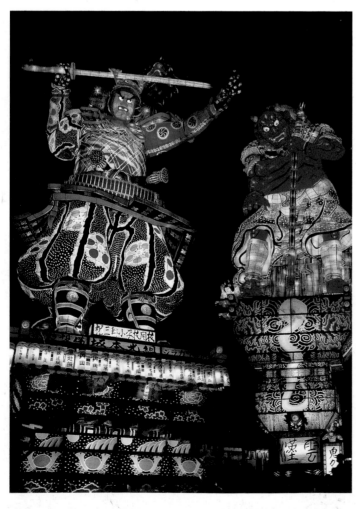

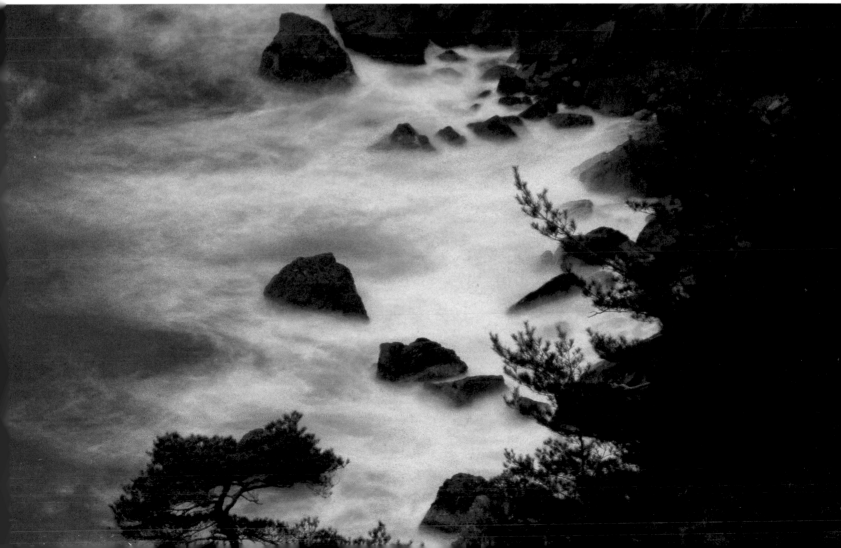

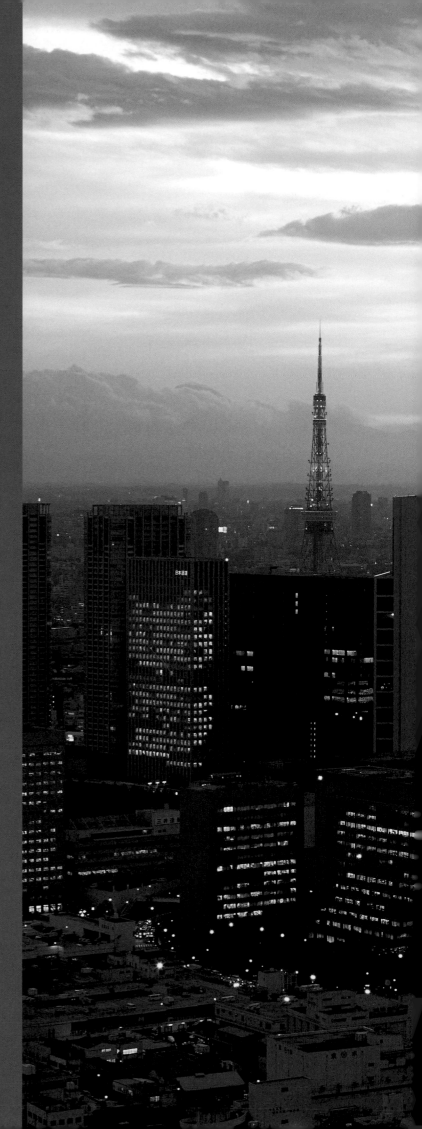

Tokyo, heart of Japan's urban culture.

KANTO

The Kanto region in eastern Honshu encompasses six prefectures and the metropolis of Tokyo. The Kanto plain accounts for much of the region's land area, and is home to 39.7 million people. In Tokyo's twenty-three wards, population density reaches thirteen thousand inhabitants per square kilometer, more than double the density of Thailand's crowded capital, Bangkok, yet Kanto still offers stunning vistas and quiet rural neighborhoods a mere hour by train or car from central Tokyo. The region also boasts an efficient network of expressways and highways, and an extensive rail system delivers people and goods even to out-of-the-way places quickly and on schedule.

Tokyo is the hub of Japanese politics, economic activity, industry, culture, and information. The metropolis covers 837 square miles (2,168 square kilometers), including the mountains of Okutama to the west and the Izu and Ogasawara island chains to the south. In all, some twelve million people call Tokyo home, but Yokohama, the nation's second-largest city, lies a mere sixteen miles (twenty-six kilometers) south.

In Tokyo, retail and wholesale trades tend to cluster in separate areas by industry. Harajuku, for example, caters to the teenage crowd with leading-edge fashion outlets and shops full of funky goods. Aoyama is a more upscale fashion district, and Ginza is famous for both shopping and entertainment. Those in the market for electronics gravitate to Akihabara, while people seeking a night on the town may well go to Roppongi or Shinjuku, famous for its neon lights and skyscrapers. Shibuya entertains the younger crowd, while lately the more romantic sights of Odaiba and Rainbow Bridge have attracted couples.

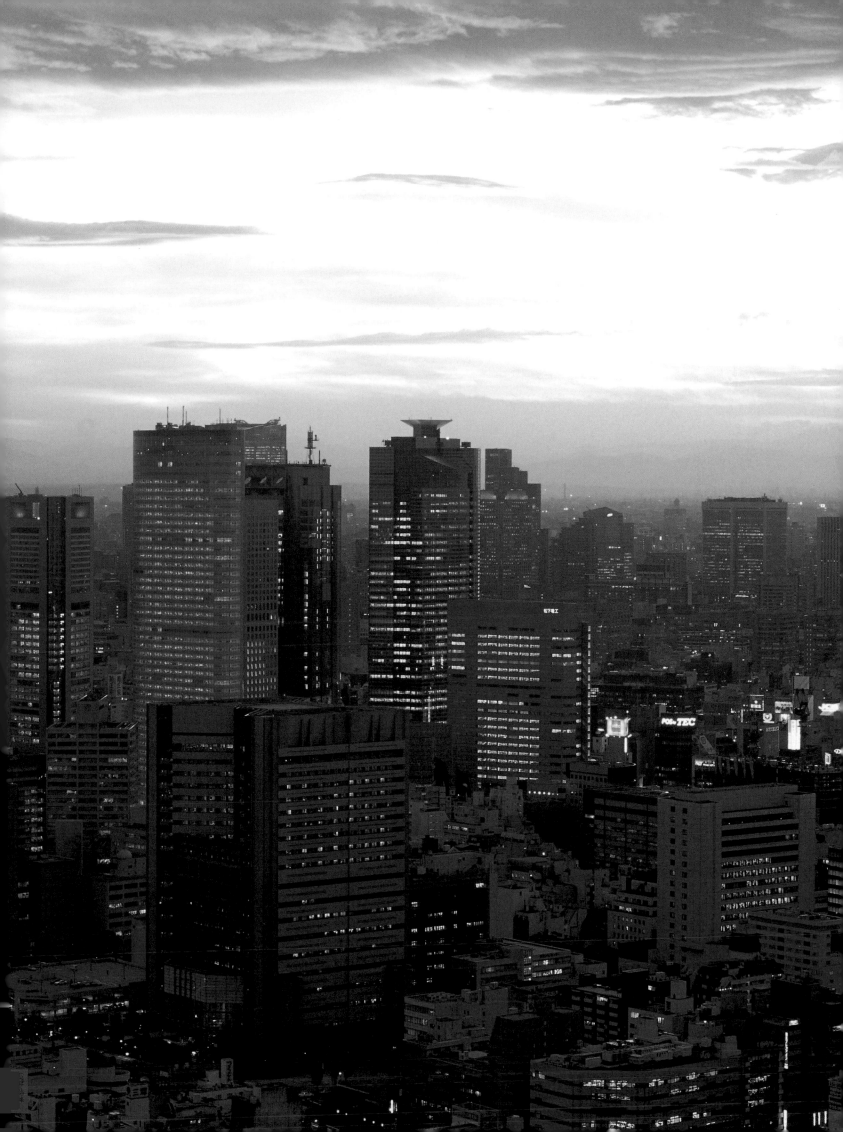

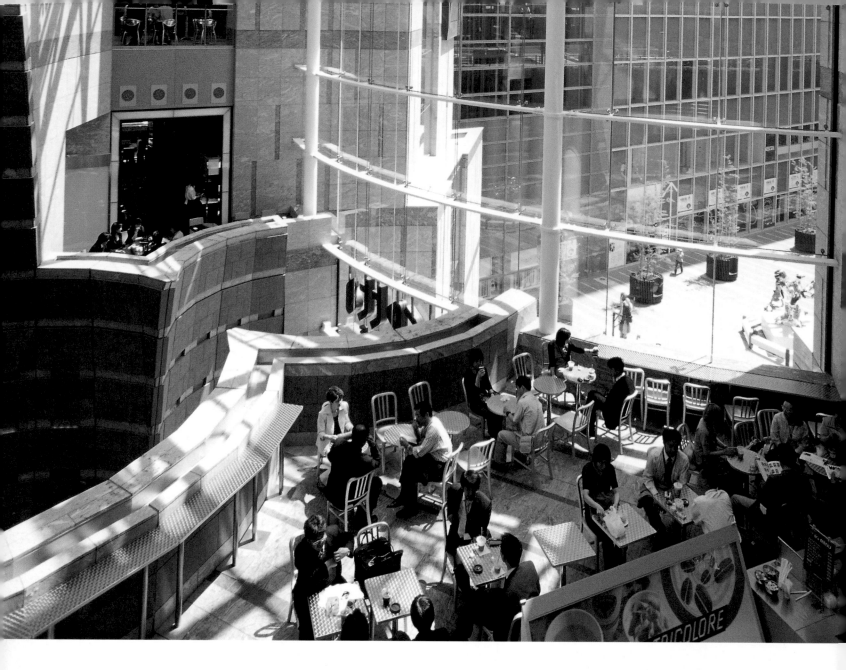

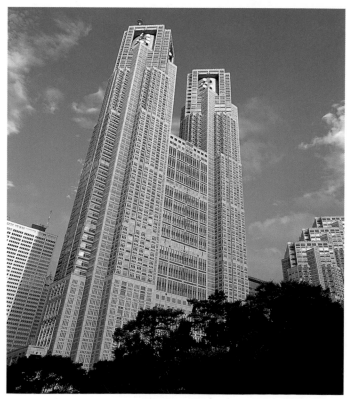

ABOVE: A relaxing tearoom in a highrise in Shiodome, Tokyo. **RIGHT:** The Tokyo Metropolitan Government Office Building, Shinjuku, Tokyo. **FAR RIGHT:** A forest of skyscrapers in Shinjuku.

OVERLEAF: The Tokyo Bay Fireworks Festival.

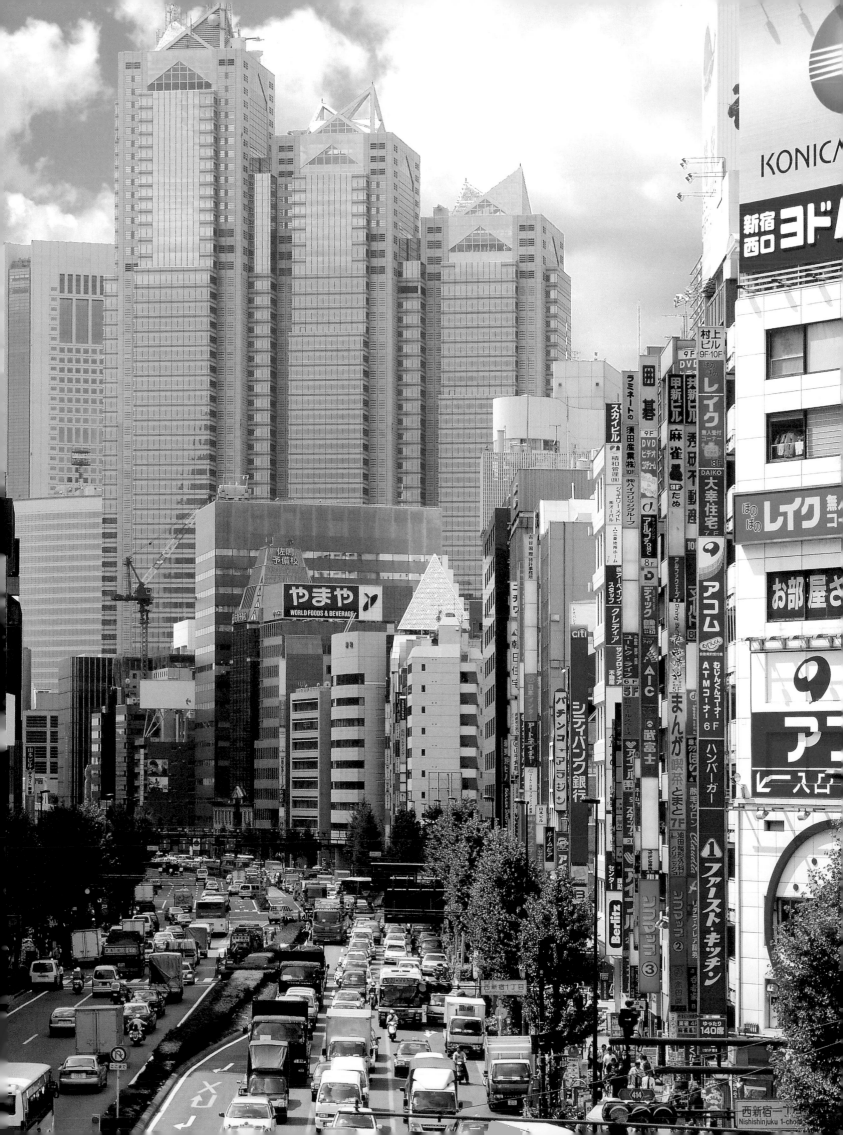

In the heart of Tokyo's old town, Asakusa is home to Sensoji, the oldest Buddhist temple in the city, dating back to 645. The approach to the temple is lined with shops, and presents a festive atmosphere every day of the year. Many artisans in Asakusa preserve traditional arts such as *yuzen* dyed kimonos, hand-painted *tenugui* towels, charcoal-roasted rice crackers, and much more.

Other famous temples and shrines include Meiji Shrine, dedicated to the first emperor of Japan's modern era; Sengakuji, where the graves of the celebrated forty-seven loyal retainers are located; and Yasukuni Shrine, which venerates Japan's war dead. The grounds around the Imperial Palace provide a restful haven from the bustle of the city, while Ueno Park is home to several major museums.

Tokyo is not the only city in Kanto that served as the nation's capital. In 1192, Minamoto Yoritomo located his military government in Kamakura, a coastal city on Sagami Bay southwest of Tokyo, where it continued for more than a century. Today Kamakura is a lazy seaside city that attracts hordes of visitors to its broad sandy beaches, and to its historic sites, shrines, and temples.

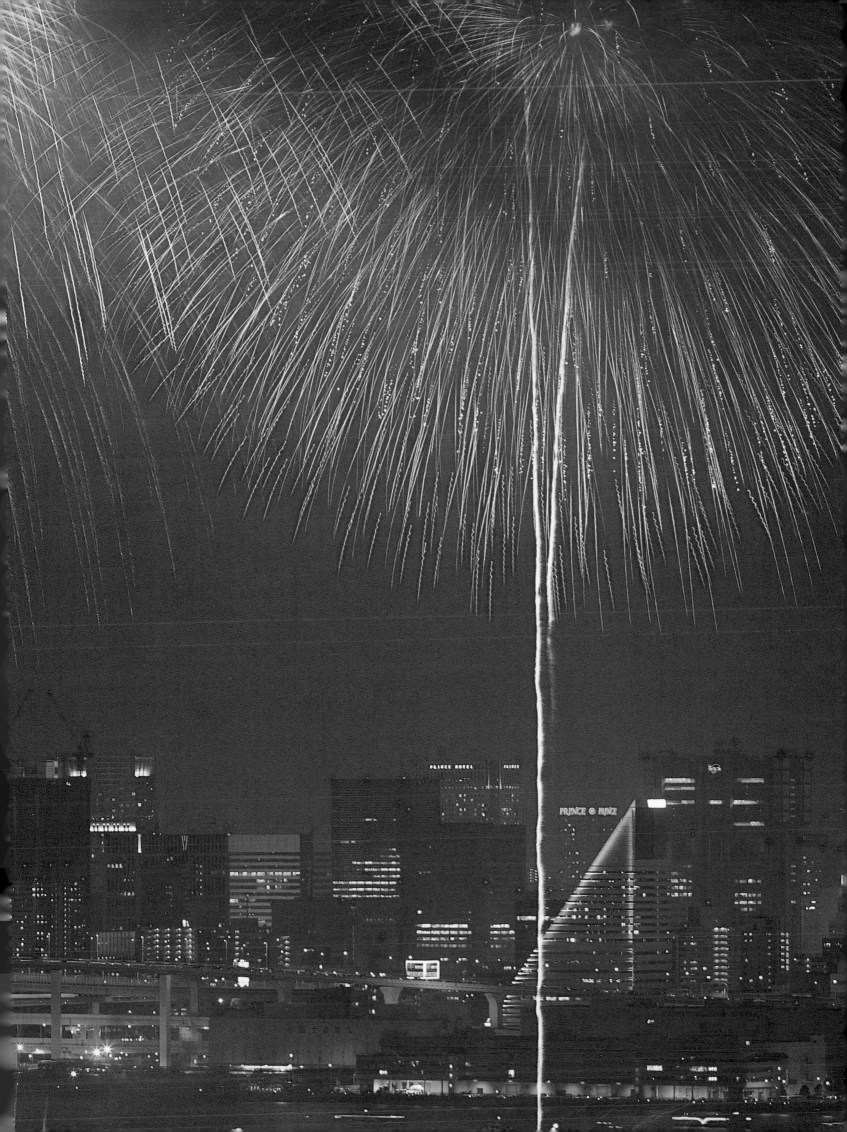

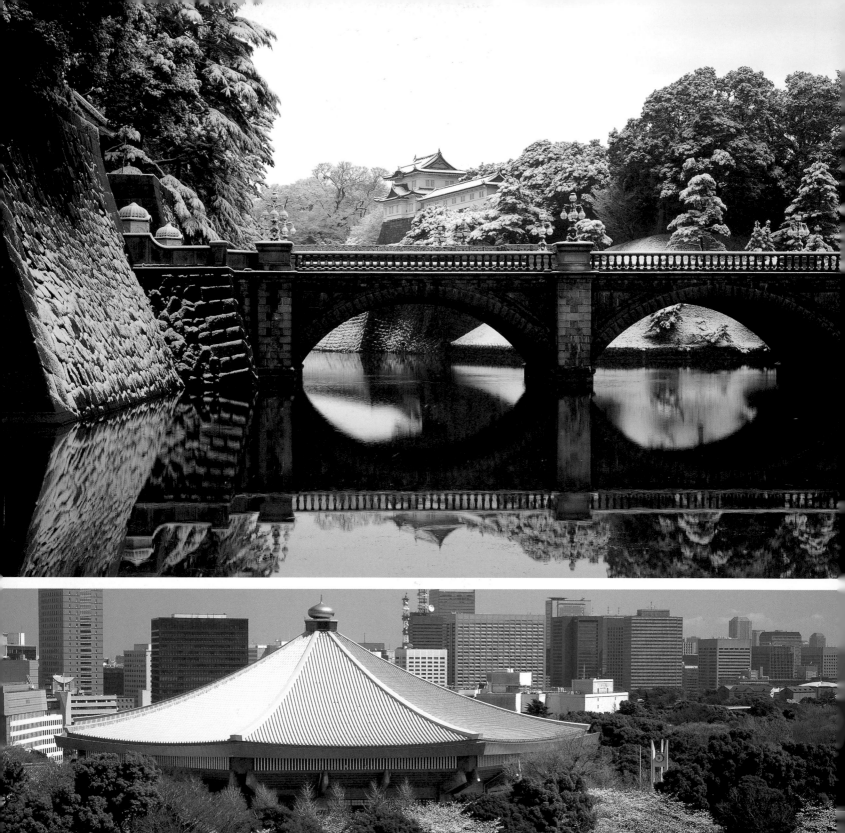
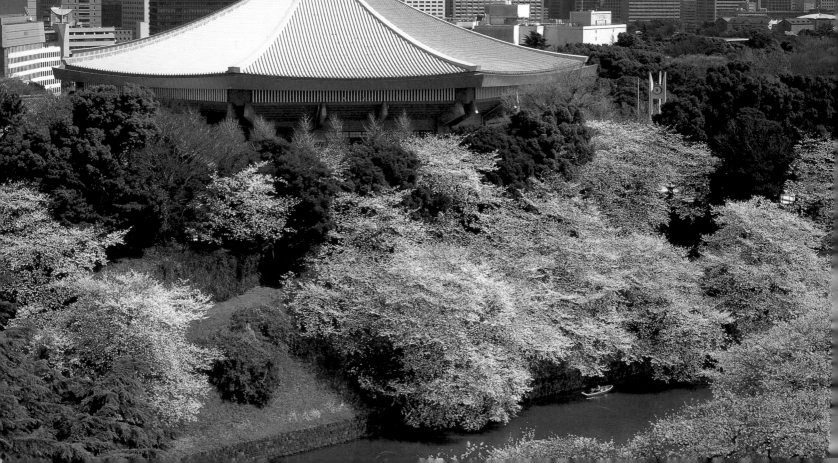

TOP LEFT: Nijubashi Bridge leads to the Imperial Palace, Tokyo. **BOTTOM LEFT:** Cherry blossoms around the Budokan Hall, Tokyo. **RIGHT:** Firemen demonstrate traditional skills on New Year's Day in Asakusa, Tokyo. **BELOW:** Tokyo's Kabuki-za theater in Ginza.

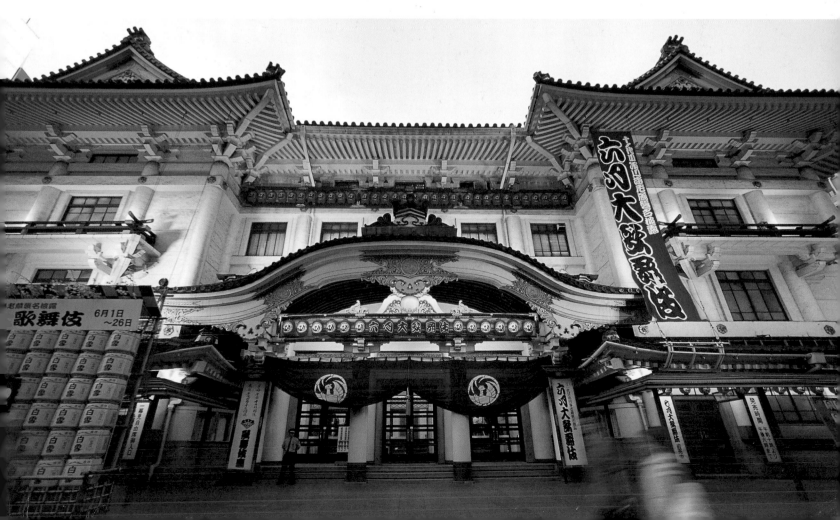

The military class subscribed to Zen Buddhism, and there are today five active Zen temples in Kamakura: Kenchoji, Engakuji, Jochiji, Jufukuji, and Jomyoji. Another must-see is Tsurugaoka Hachimangu, a Shinto shrine dating to 1083 and dedicated to Hachiman, the patron god of the Minamoto family in particular and the samurai class in general. The shrine deifies ancient emperors and empresses, and hosts spectacular horseback archery exhibitions.

The Great Buddha of Kamakura at Kotokuin temple ranks prominently among the sights of the city. Cast in 1252, it once sat within a temple, but at the end of the fifteenth century a tsunami swept the building away and left the statue in the open air, where it has remained ever since. Of all the statues of Buddha in Japan, at a height of 36 feet (11 meters) the Great Buddha of Kamakura is second in size only to the one located at Todaiji in Nara.

Kamakura is surrounded by steep hills on three sides, with hiking trails that lead to out-of-the-way sites like Zeniarai Benten, a natural grotto shrine where coins washed in the spring are said to attract more money.

To the north of Tokyo lies Nikko, which served as a mountain retreat for both Buddhist and Shinto adherents for hundreds of years. Tokugawa Ieyasu, founder of the Tokugawa dynasty that ruled Japan for two and a half centuries until 1868, chose Nikko as the place to build Toshogu, the mausoleum for his earthly remains and shrine to himself as deity. The grounds are dotted with both Shinto and Buddhist buildings, and are surrounded by primal forest. Toshogu departs from traditional Japanese simplicity of design, being lavishly decorated with elaborate and colorfully painted wood carvings.

Northwest of the town, Lake Chuzenji graces Nikko National Park, formed thousands of years ago in the aftermath of eruptions from now extinct volcanoes. Renowned for its beautifully forested shores, the lake is dominated by the sacred volcano Mt. Nantai. Nearby Chuzenji hot spring spas tout the beautiful 318-foot (97 meters) Kegon Falls as a main attraction. Nikko is especially impressive in autumn when its deciduous forests are ablaze with color.

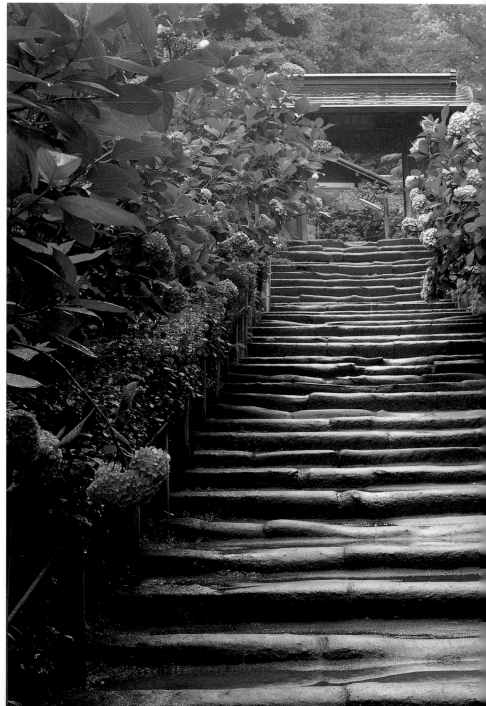

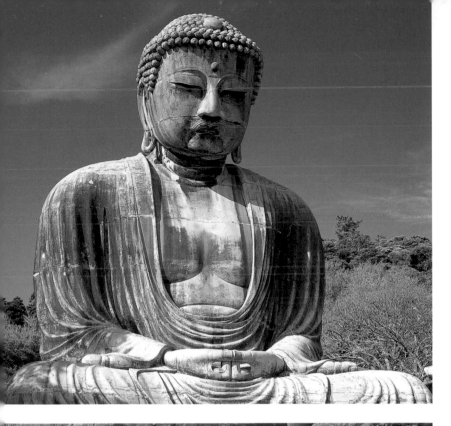

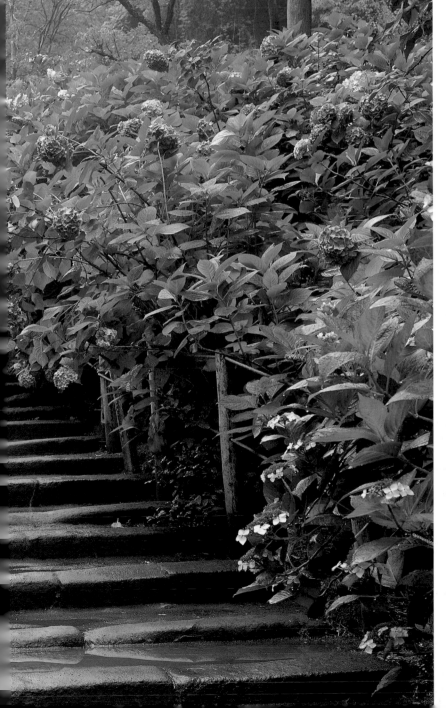

TOP LEFT: Kamakura's Tsurugaoka Hachimangu, a shrine dedicated to the Minamoto family. TOP RIGHT: The Kamakura Daibutsu, the second largest statue of Buddha in Japan. BOTTOM: Meigetsuin temple in Kamakura is famous for hydrangeas and irises. BELOW: Kamakura-bori lacquerware.

OVERLEAF, LEFT: The Kegon Falls at Nikko. TOP RIGHT: Toshogu, Tokugawa Ieyasu's mausoleum and shrine at Nikko. BOTTOM RIGHT: "Hear no evil, speak no evil, see no evil" carving at Toshogu.

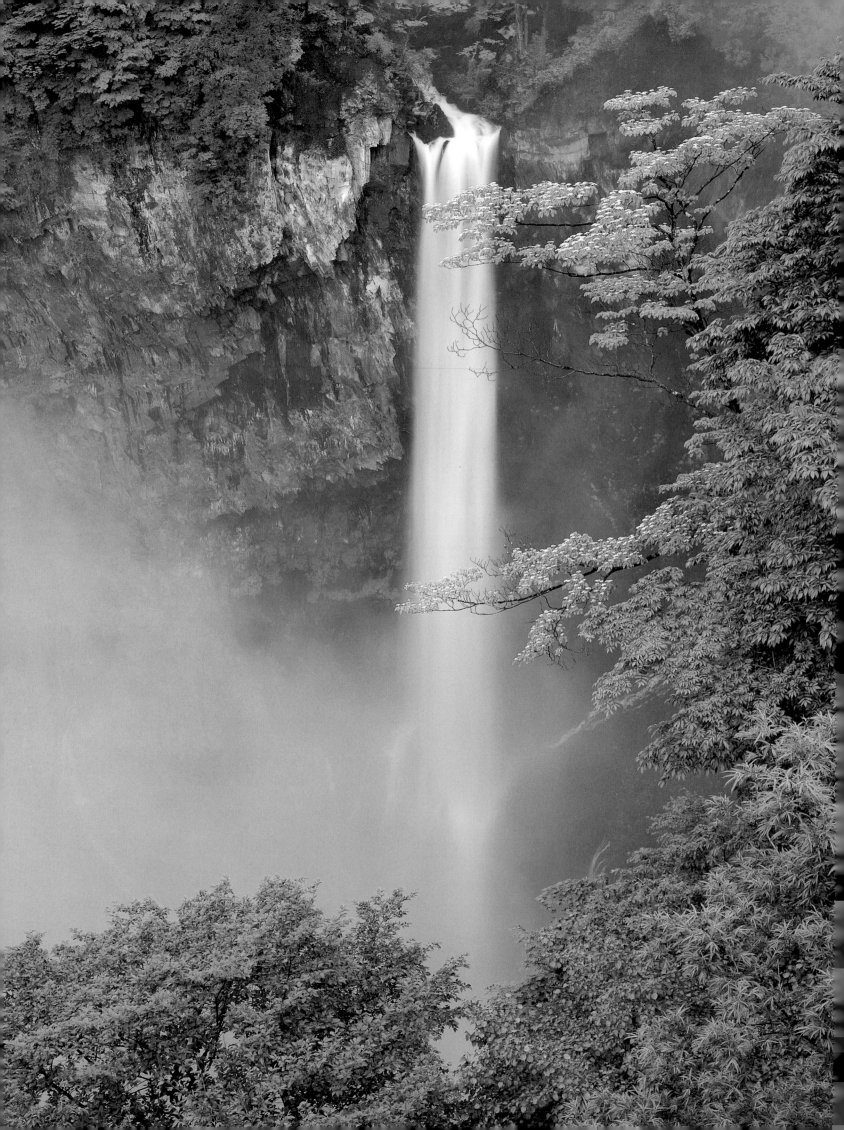

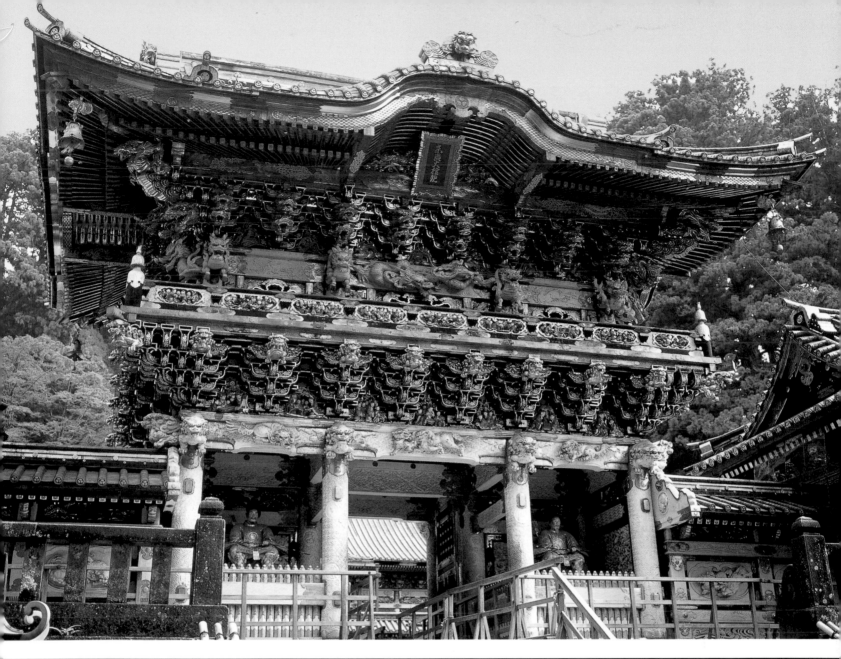

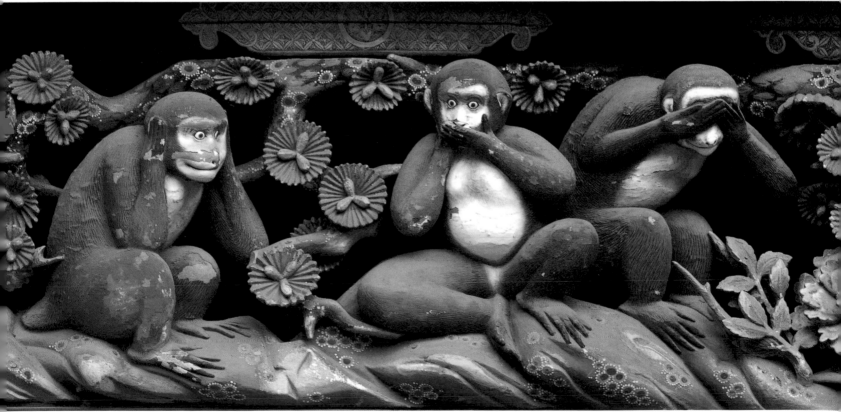

SHINETSU, HOKURIKU, AND TOKAI

The Shinetsu, Hokuriku, and Tokai regions form a broad belt across the midriff of Honshu, and offer gorgeous beaches and seascapes on both Pacific and Sea of Japan coasts. This area contains Japan's highest mountains, including Mt. Fuji, its tallest at 12,388 feet (3,776 meters), and the Japan Alps. The mountain backbone of the Hokuriku region and the eastern mountains of Shinetsu tempt skiers and snowboarders, and challenge mountaineers. The active volcano Mt. Asama, near Nagano, last erupted in 2004.

Tokai covers four prefectures and contains much that is representative of Japan, from Mt. Fuji in Shizuoka prefecture to the Ise shrines in Mie and manufacturing powerhouses such as Toyota located in Aichi. Constructed on a manmade island in Ise Bay, Central Japan International Airport serves both international and domestic flights round-the-clock.

The city of Nagoya lies on the Nobi plain, and is the focal point of the nation's third-largest concentration of population, after the Kanto and Kinki regions. Nagoya began as the castle town of Owari in the early seventh century, and the rebuilt castle still dominates the cityscape.

West of Nagoya in Mie prefecture, the Ise Grand Shrine is dedicated to the goddess Amaterasu Omikami, the mythical ancestor of the imperial family. The Inner Shrine dates to the third century and is rebuilt every twenty years in the same traditional architectural

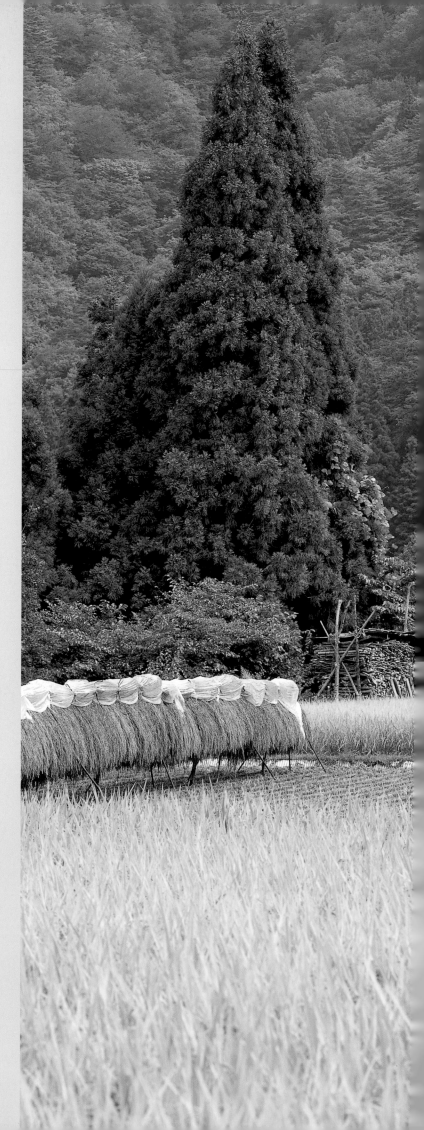

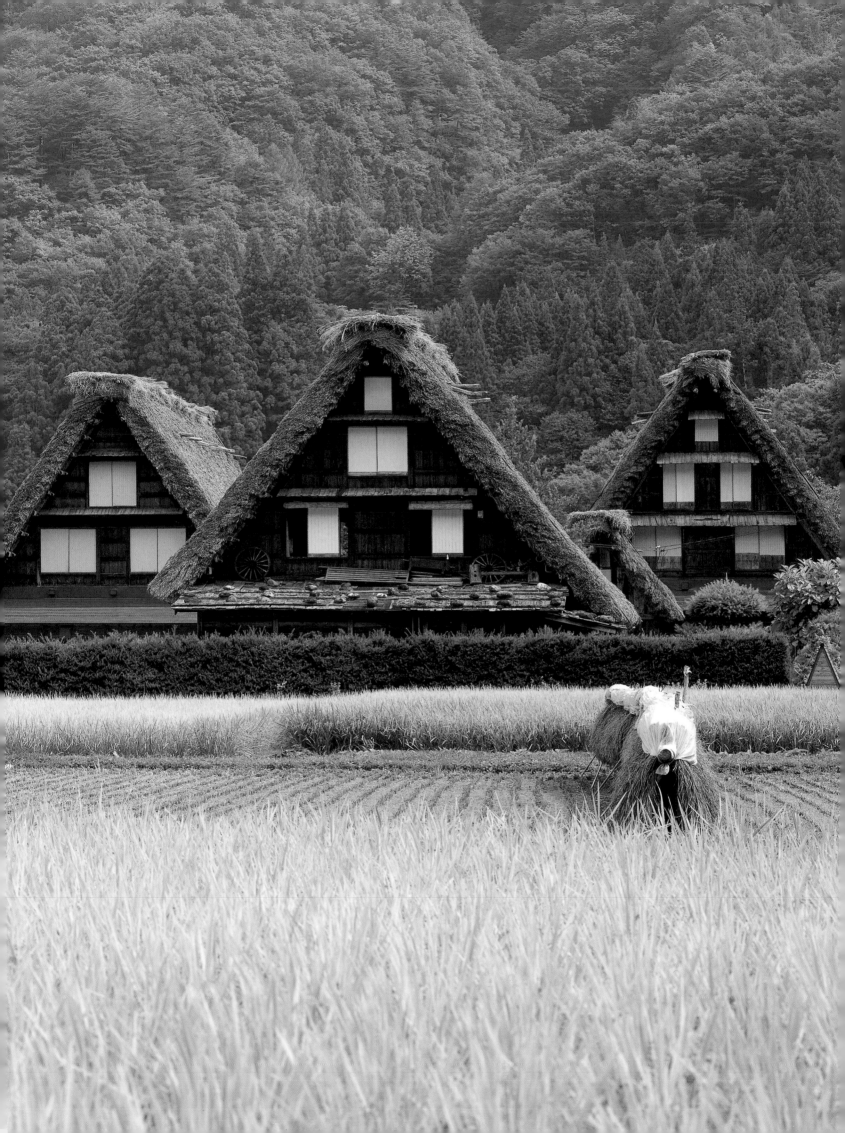

style. Toba Bay, near Ise, is home to Japan's cultured pearl industry.

Gifu prefecture's Shirakawa village is a World Heritage Site famed for its distinctive thatched farmhouses and traditional lifestyle. Nearby Takayama is the site of the only remaining Jinya shogunate outpost, built when the area was the source of high-grade timber and skilled carpenters.

The Hokuriku region encompasses three prefectures lying along the Sea of Japan coast. The southernmost, Fukui, borders Kyoto and for centuries acted as a conduit for Kyoto culture's northward migration to Kanazawa in Ishikawa prefecture. Fukui's harbors also linked the ancient capital of Japan to the Korean Peninsula and the Asian mainland.

Inland, Hokuriku's mountains soar to heights well over two thousand meters. The Hakusan range is one of the most scenic. Mt. Haku is held sacred, and its foothills have some of Japan's most popular hot spring spas such as Yamanaka and Yamashiro.

Ishikawa prefecture boasts some of Japan's most beautiful coastline along the Noto Peninsula, a number of nationally protected natural monuments, and important cultural assets such as swords by masters Nagamitsu and Yorizane, Wajima lacquerware, and the Kaga *yuzen* school of kimono dyeing. Its capital city of Kanazawa, like Kyoto, escaped bombing during World War II, and thus offers more in the way of historical sites than anywhere outside the ancient capital. While the Ishikawa gate is all that remains of the Kanazawa Castle, other vestiges of this major castle town include samurai villas, an extensive temple district, and a charming street of *chaya* teahouses. The Kenrokuen garden is famed for containing all six attributes of the perfect garden—spaciousness and seclusion, artifice and antiquity, abundant water, and broad vistas, and the Ishikawa Prefectural Art Museum is located within its grounds.

In Shinetsu, the castle town of Matsumoto in Nagano prefecture boasts the oldest surviving donjon in Japan, built in 1595. Matsumoto is also the gateway to the northern Japan Alps, where the mountain resort of Kamikochi is accessible only by bus during the summer months, but is snowbound in the winter months.

The northernmost prefecture of the region, Niigata, produces Japan's most delicious strain of rice, resulting in numerous, top-quality local brands of saké. Niigata fishermen bring home bountiful catches from the cold waters of the Sea of Japan, and Niigata's rivers teem with salmon.

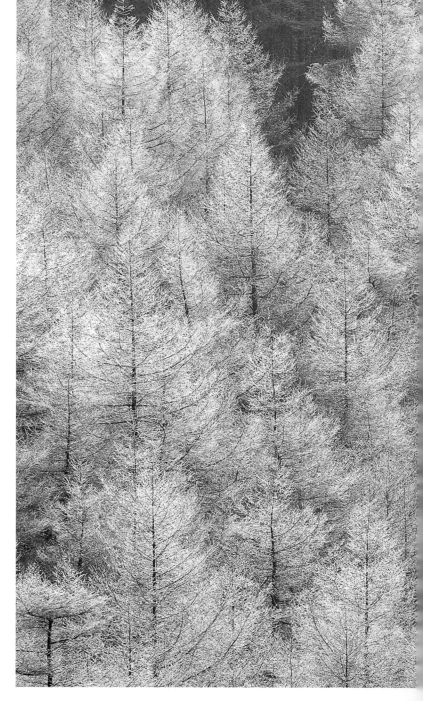

TOP: Frost on bare pines in the northern Japan Alps. BOTTOM LEFT: Kasagatake peak and alpine ridge in the northern Japan Alps. BOTTOM RIGHT: Rock ptarmigan live in the Alps.

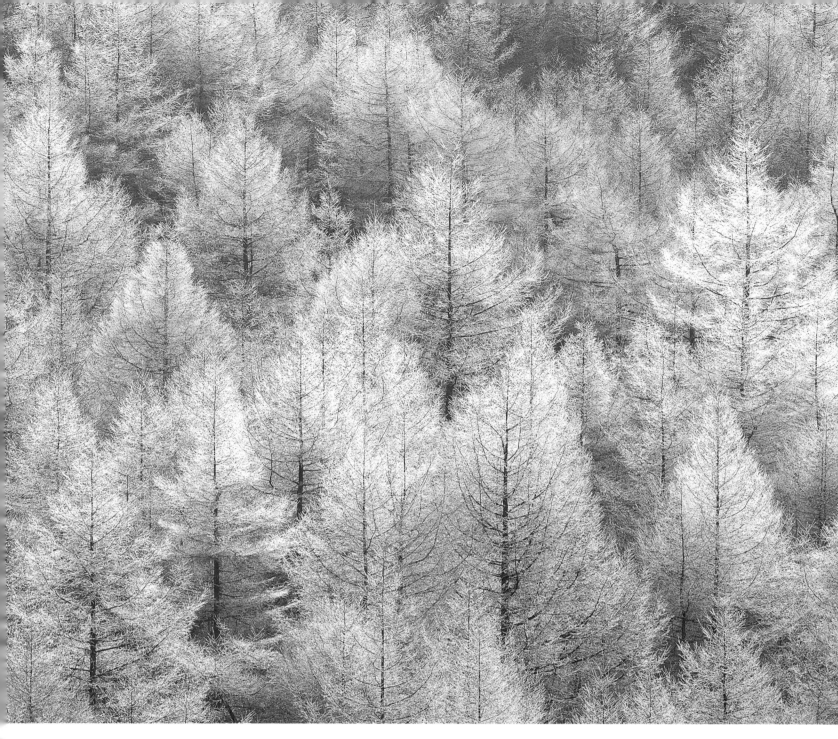

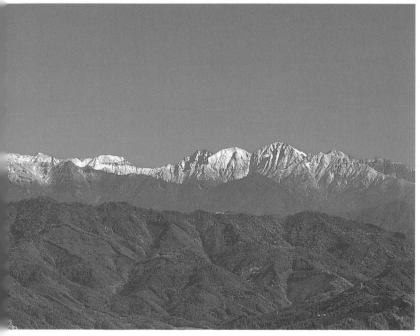

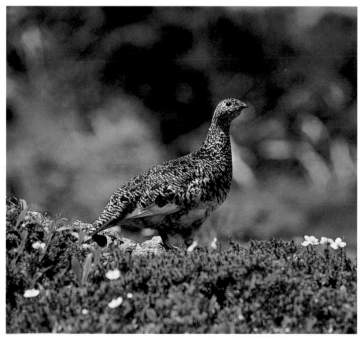

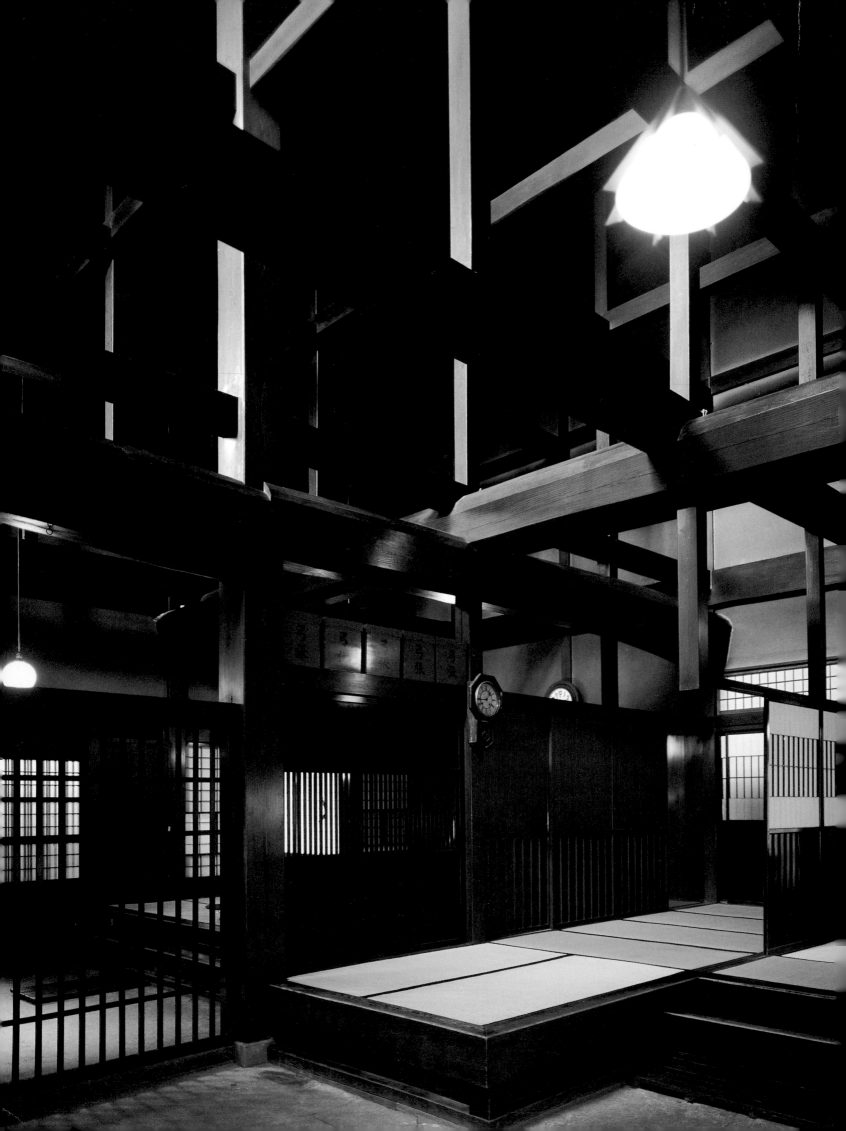

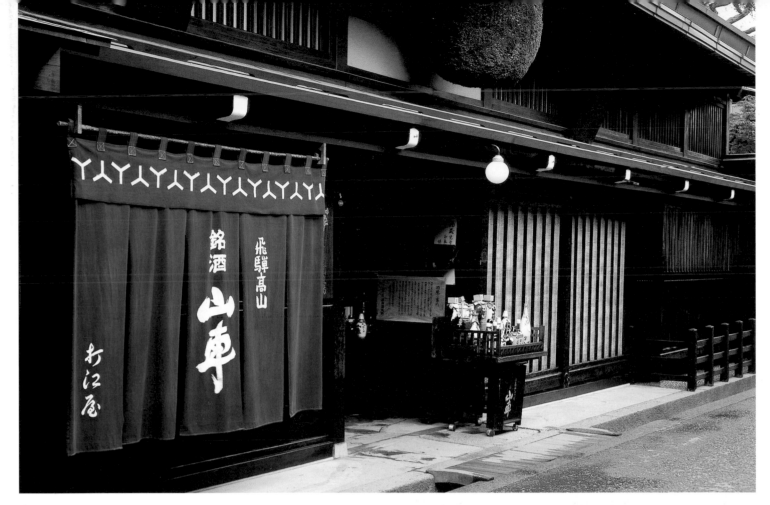

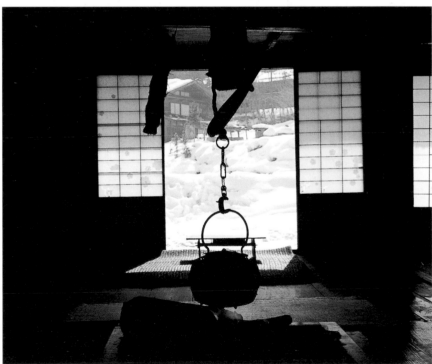

FAR LEFT: Merchant Yoshijima's home in Takayama, Gifu prefecture. **TOP:** Takayama strives to maintain its traditional atmosphere. **LEFT:** A Gifu paper lantern. **ABOVE:** Snowscene from the *hiroma* living space of a traditional Takayama farmhouse.

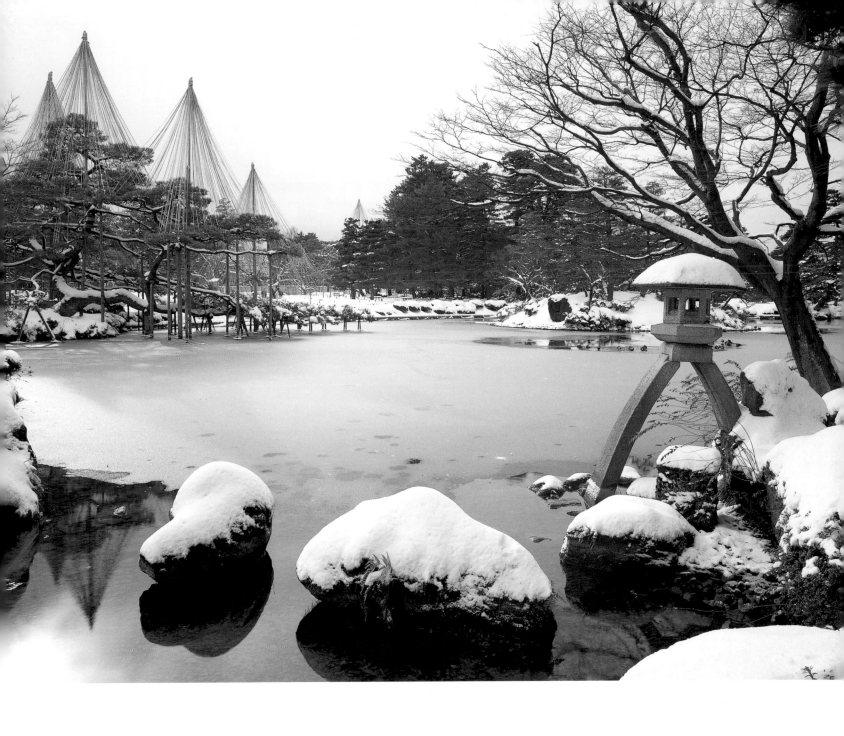

LEFT: Kanazawa roof tiles are slick-glazed so snow will slide off. **ABOVE:** *Yukitsuri* support tree branches in the snowy Kenrokuen garden. **RIGHT:** Kanazawa is famous for gold leaf.

The temple of the Golden Pavilion in Kyoto.

KINKI

The Kinki region, also known as Kansai, is the cradle of Japanese civilization and culture, and today is the nation's second largest industrial region.

Kyoto served as Japan's capital city from 794 to 1868, well over a millennium, and has always been a major cultural center. In 792, Emperor Kanmu chose the location because its mountains and rivers formed a natural fortress, and named his new city Heian-kyo, or Capital of Peace. Heian-kyo was modeled after the Tang Chinese capital, on a regular grid pattern. Originally, two temples guarded Rashomon, the capital's main gate—Toji to the east and Saiji to the west. The palace and government buildings lay at the other end of the north-south avenue, but none now survive.

At first impression, today's Kyoto resembles any other modern city, but pockets of beauty still capture its history and make exploring it an adventure. Central Kyoto offers the Imperial Palace, where the emperors lived until 1868; Nijo Castle, where the Tokugawa shogun resided when in Kyoto; and Honganji, the head temple of the Jodo Shinshu sect. In all, the city has some 1,600 temples, 250 shrines, 60 Japanese gardens, 24 museums, and 2 imperial villas, as well as many traditional crafts to see.

Eastern Kyoto boasts the Sanjusangendo, its long hall lined with 1,001 gilded statues of Kannon; Kiyomizudera, famous for its huge raised wooden terrace; Ginkakuji—the temple of the Silver Pavilion; and the Gion entertainment district, famous for its geisha and teahouses.

In the north of the city lies Kinkakuji—the temple of the Golden Pavilion, the celebrated dry landscape garden of Ryoanji, and the Daitokuji temple complex, which contains many important works of art. On Mt. Hiei, Enryakuji, the head temple of the Tendai sect, was burned to the ground by the warlord Oda Nobunaga in 1571, but rebuilt in its present form in 1584.

OVERLEAF, LEFT: Brilliant maples at Komyoji, Kyoto. RIGHT: Sagano, Kyoto, is famous for its beautiful bamboo forest.

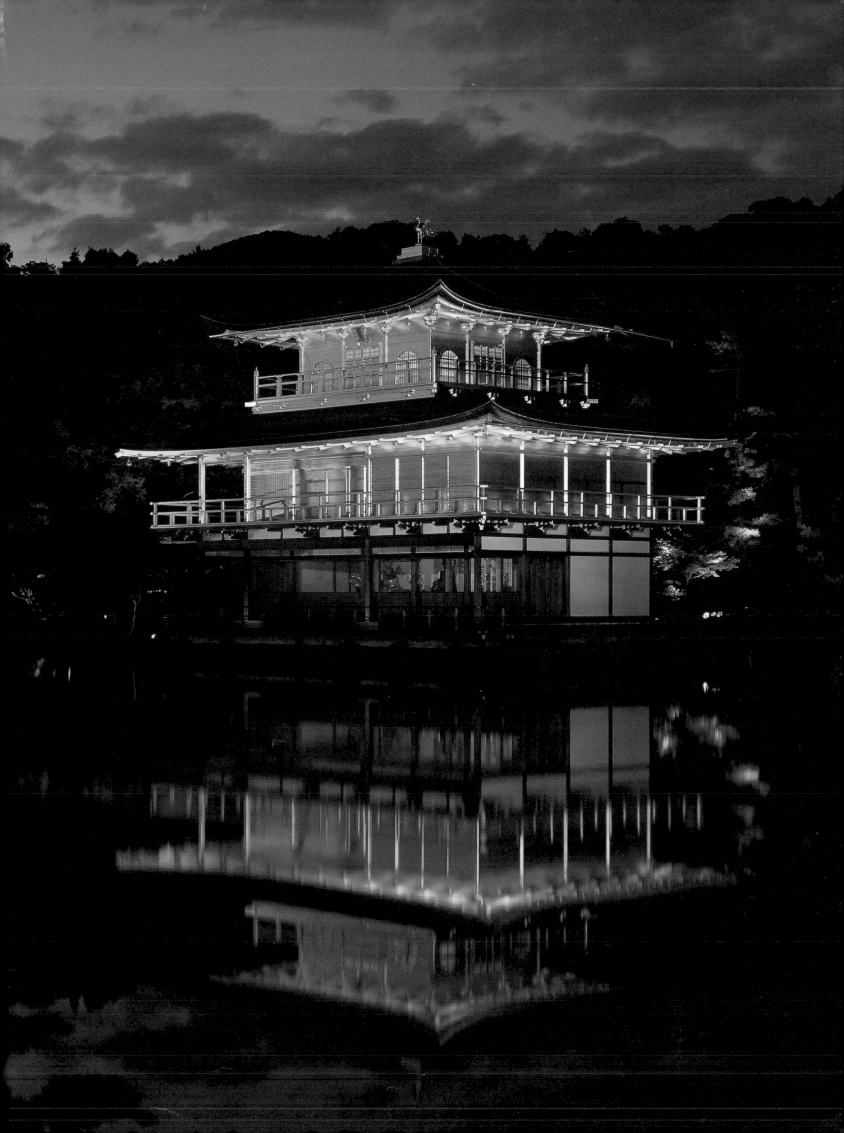

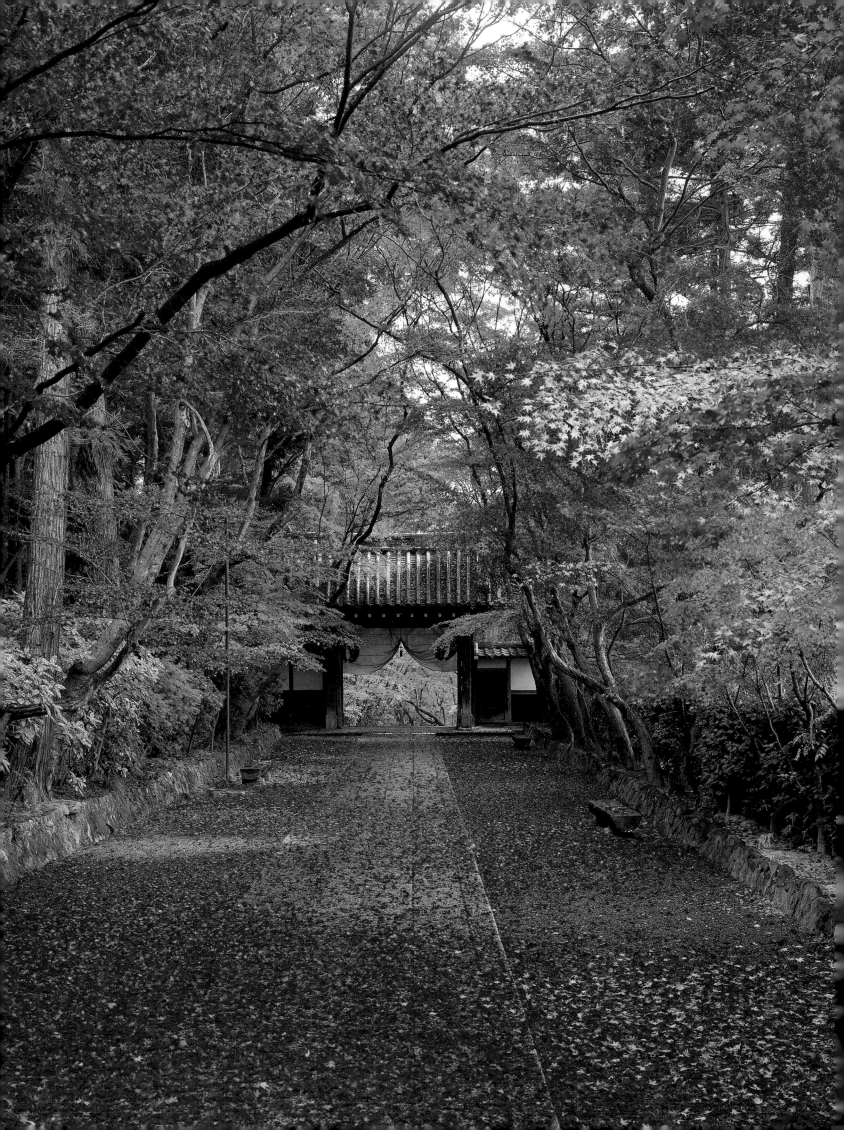

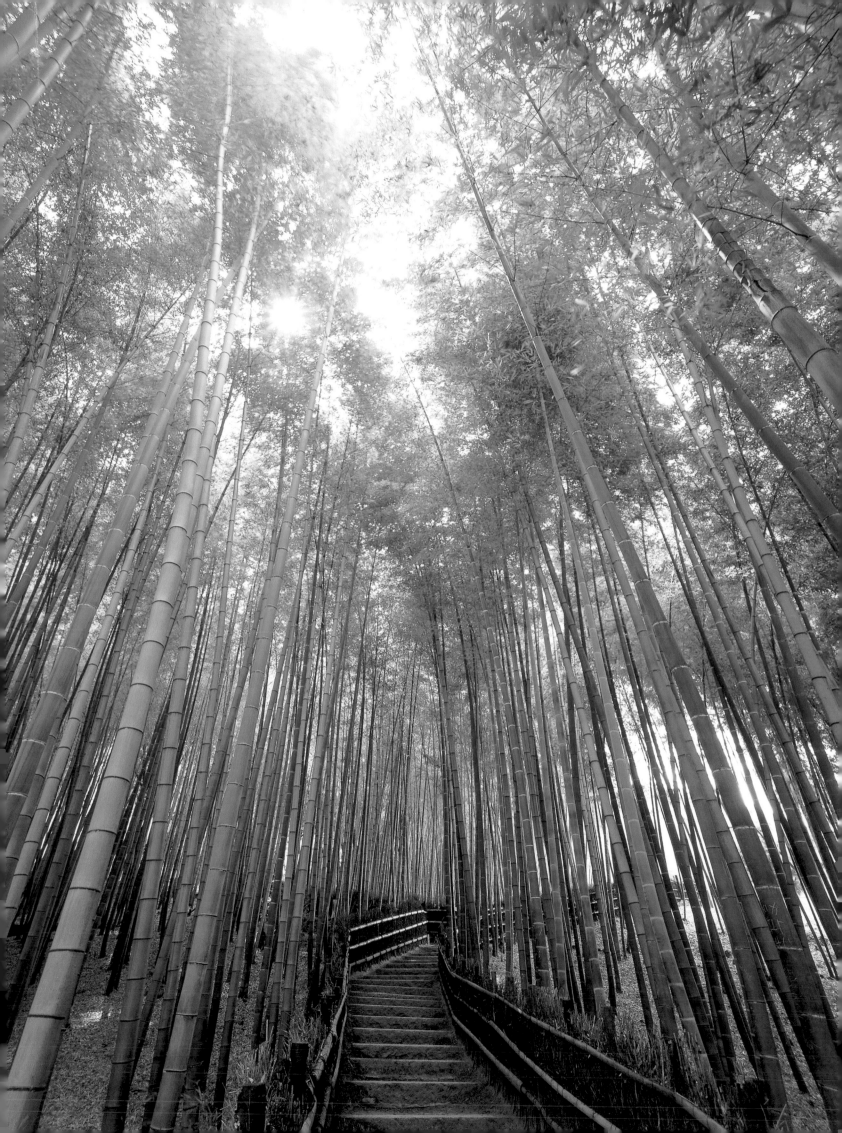

To the west is the Katsura Detached Palace, an imperial villa originally completed in 1645 and recently renovated, and one of the finest examples of indigenous Japanese architecture and landscape garden design. In addition, many colorful textiles are displayed in Nishijin, the historical weaving district.

Scattered among the temples of Kyoto are many Shinto shrines whose deities protect the city. Mt. Atago's deity protects against fire, and the Shimo-gamo and Kami-gamo shrines are dedicated to the Kamo River deity. Kitano shrine is for the spirit of Sugawara no Michizane, Minister of the Right until his untimely death in 903, and fetes the gods of thunder, literature, and learning.

FAR LEFT: Saihoji is also known as *Kokedera*, the moss temple. **ABOVE LEFT:** Elaborate Kyoto embroidery. **ABOVE RIGHT:** Traditional sweets. **BELOW:** *Ogi* fans used in traditional dance.

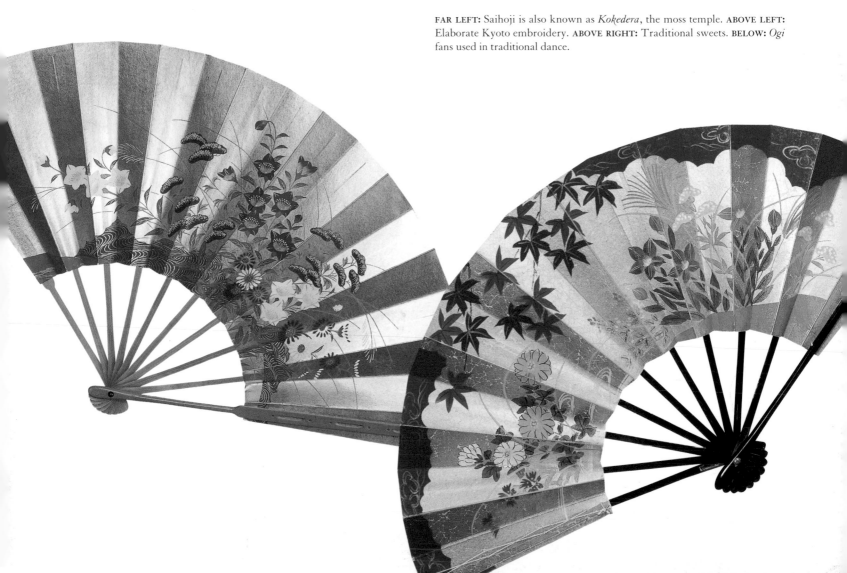

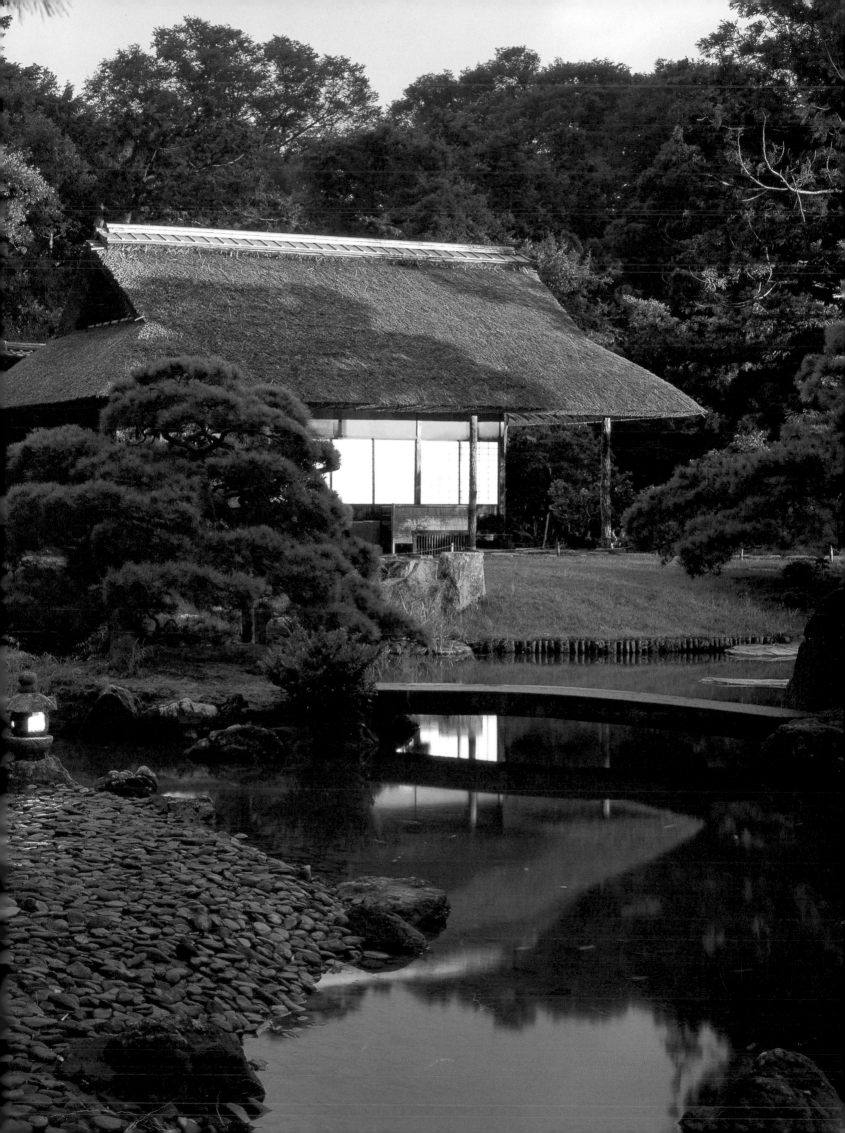

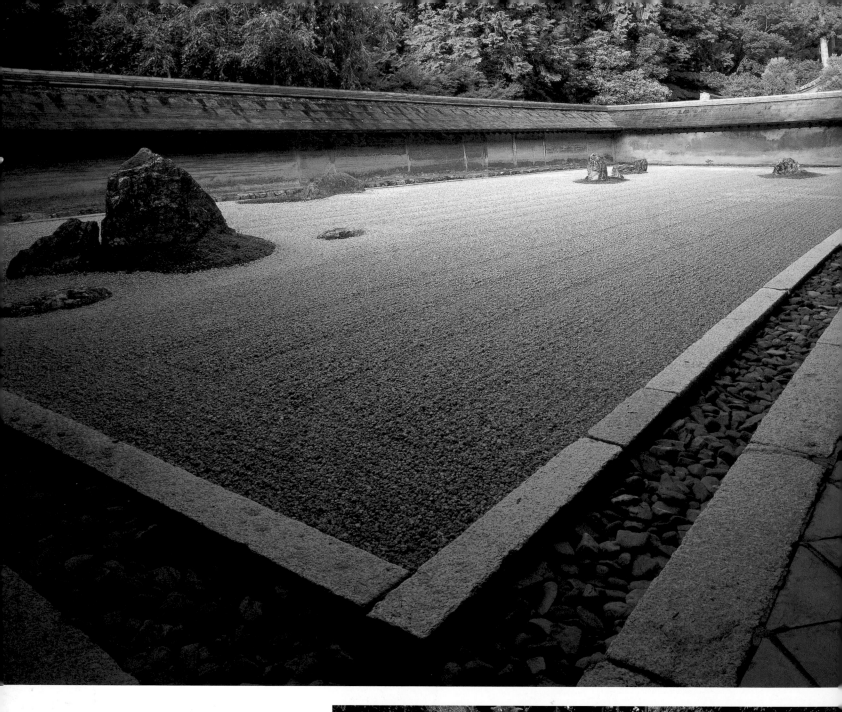

PREVIOUS PAGE: Kyoto's Katsura Detached Palace at night.

ABOVE: The famous Zen dry landscape garden at Ryoanji temple, Kyoto. RIGHT: A monk tends Ryoanji's dry garden.
FAR RIGHT: Wall painting of a pine tree in Nijo castle, Kyoto.

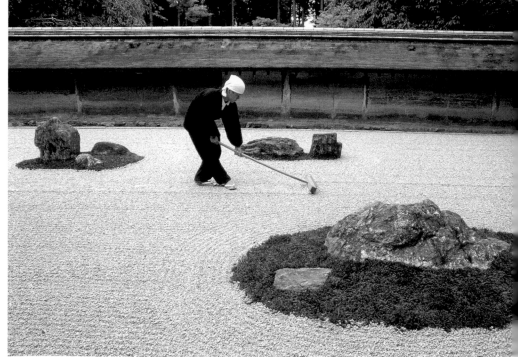

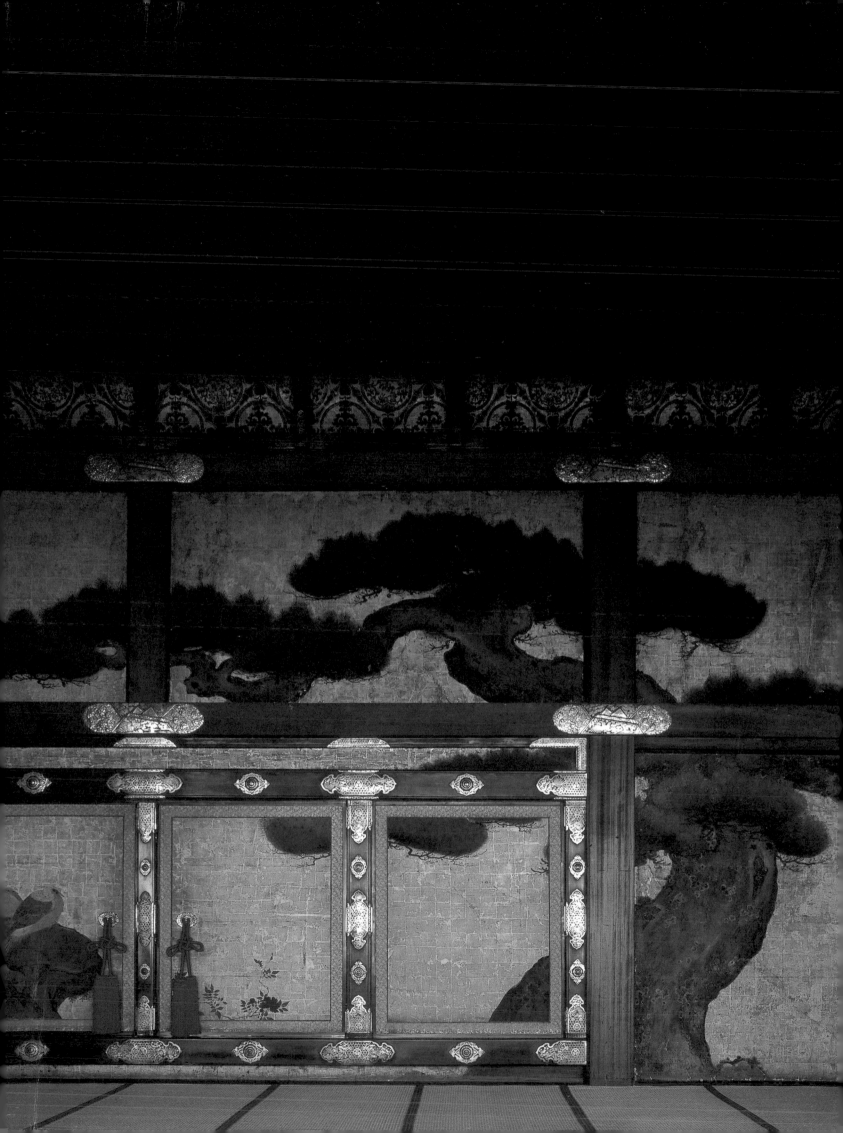

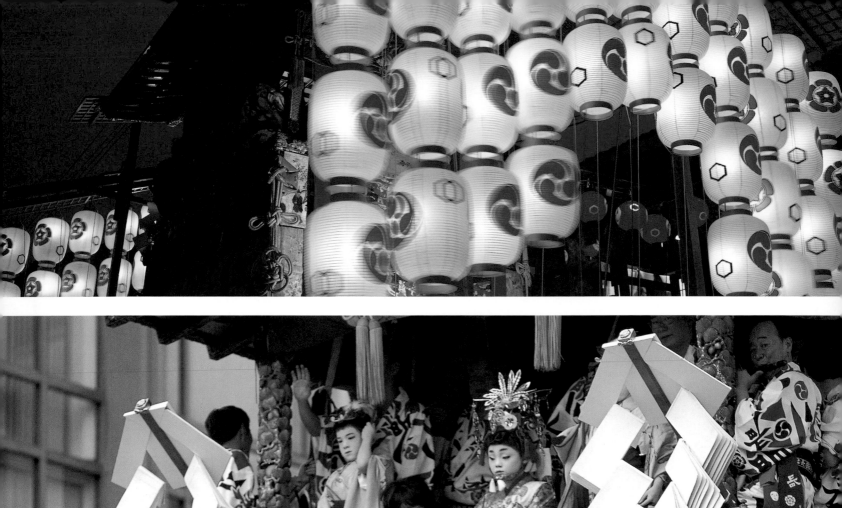
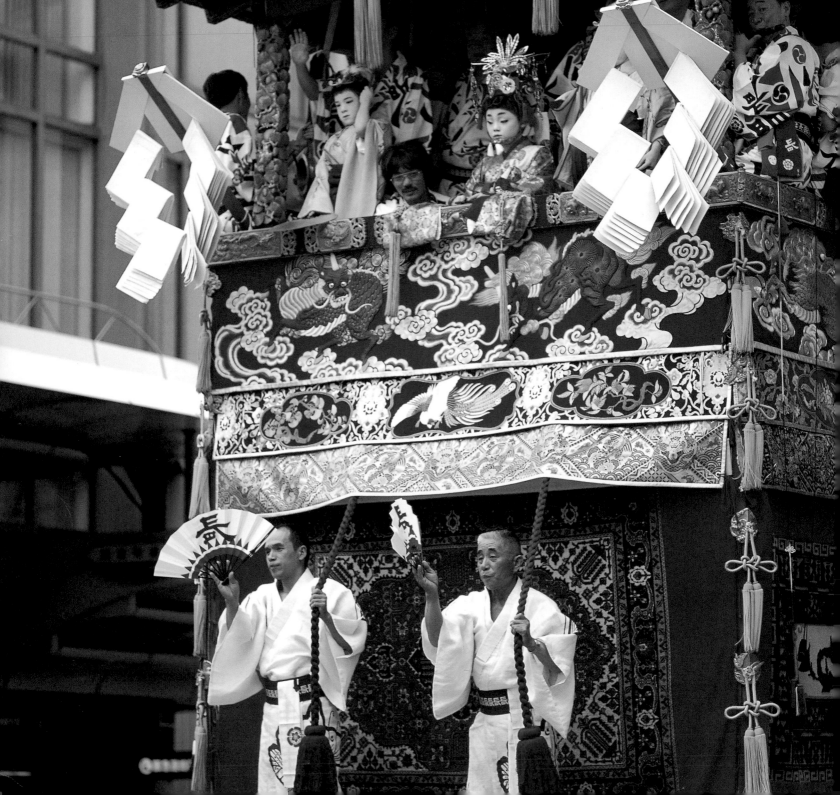

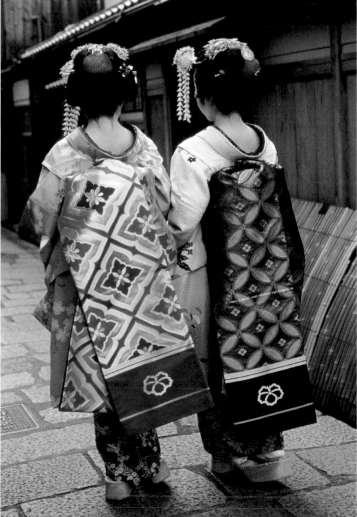

Each year, Kyoto celebrates four clear-cut seasons with an array of festivals. The city's summers are unbearably hot with high humidity, and its winters can be bitterly cold. Spring is marked with early plum blossoms and cherry blossoms later in the season, bringing forth the same rowdy exuberance as in most other areas of Japan. Fall brings a rush of crimson and yellow leaves that are especially brilliant at Arashiyama in the western part of the city. Kyoto's biggest festivals are at New Year, with the ringing of the bell at Chionji temple, and the Bon Festival of August when the souls of the dead are allowed to return temporarily to the realm of the living.

Southwest of Kyoto, the Osaka-Kobe district is western Japan's center of commerce and industry. Kobe is one of Japan's oldest and largest ports, and is known for its international flavor. The city was severely damaged by a major earthquake in January 1995, but it has almost completely recovered, and little evidence remains of the tragedy other than a memorial with photographic and video displays.

TOP LEFT: Lanterns at Kyoto's Gion festival. FAR LEFT: Huge floats take part in the Gion festival parade. ABOVE: Tatsumibashi Bridge in Shirakawa, Gion. LEFT: *Maiko* apprentice geisha in Kyoto.

49

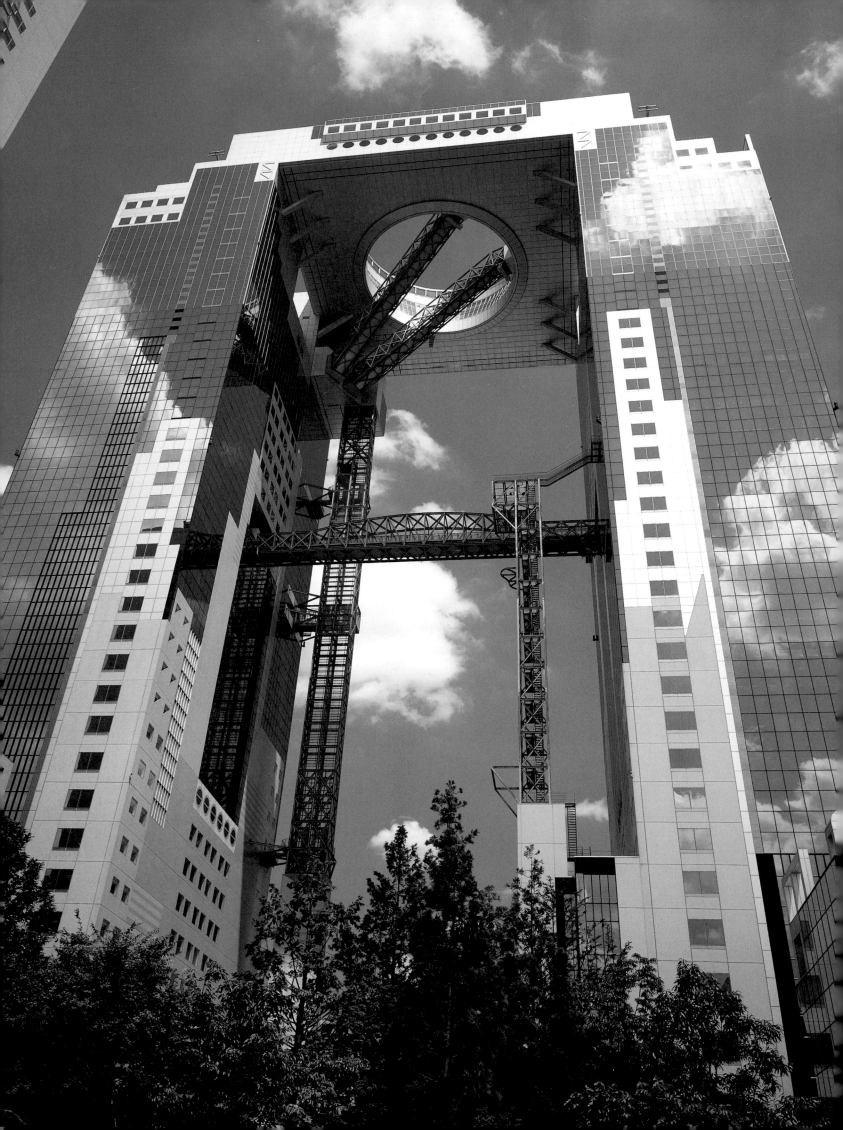

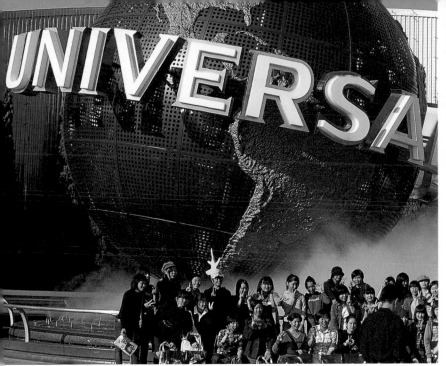

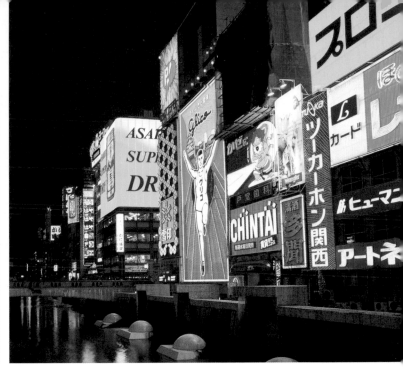

LEFT: Umeda Sky Building, a forty-story skyscraper in Osaka.
ABOVE LEFT: Universal Studios Japan theme park, Osaka.
ABOVE RIGHT: Osaka's Dotonbori entertainment district. BELOW:
Night skyline in Kobe, rebuilt after the 1995 quake.

The city of Osaka was built for business by warlord Toyotomi Hideyoshi in the late sixteenth century, and today is Japan's third-largest metropolitan area and second most important commercial hub. In the center of the city stands Osaka Castle, built by Hideyoshi to serve as his military headquarters. With his death, however, power passed to Tokugawa Ieyasu, who moved the shogunate to Edo (present-day Tokyo). Osaka has almost none of the historical grandeur of Kyoto, but it is a vibrant metropolis and home to the National Bunraku Theater, Japan's traditional puppet theater.

East of Osaka and south of Kyoto, Nara served as capital of Japan for seventy-four years (710–784). The temples and shrines in and around the city predate those in Kyoto, but being less famous helps Nara appear serenely quiet.

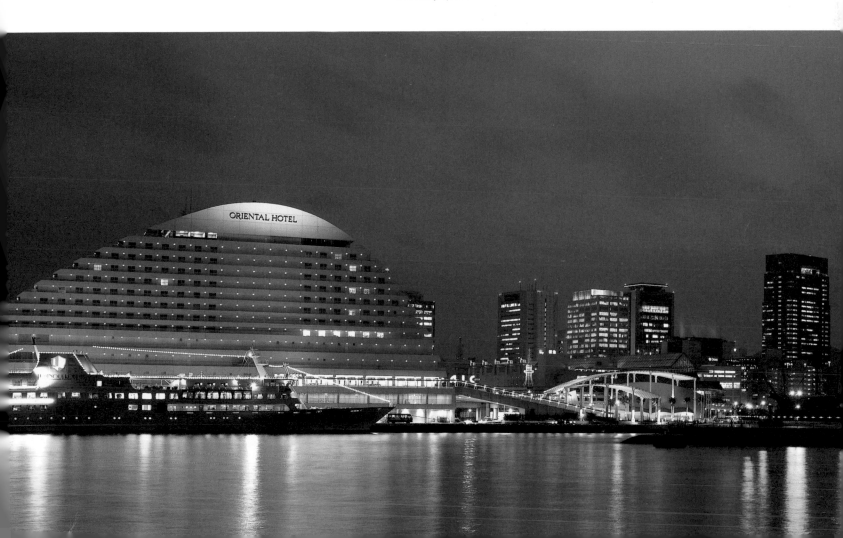

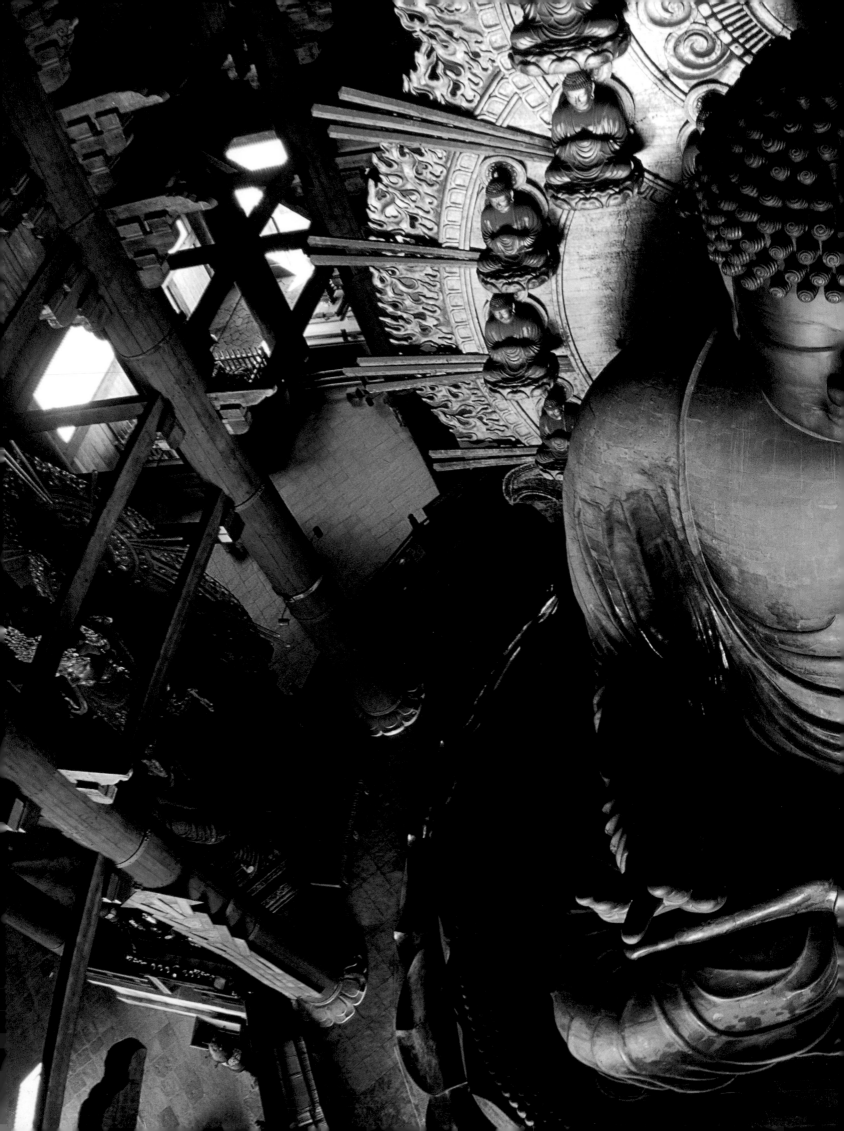

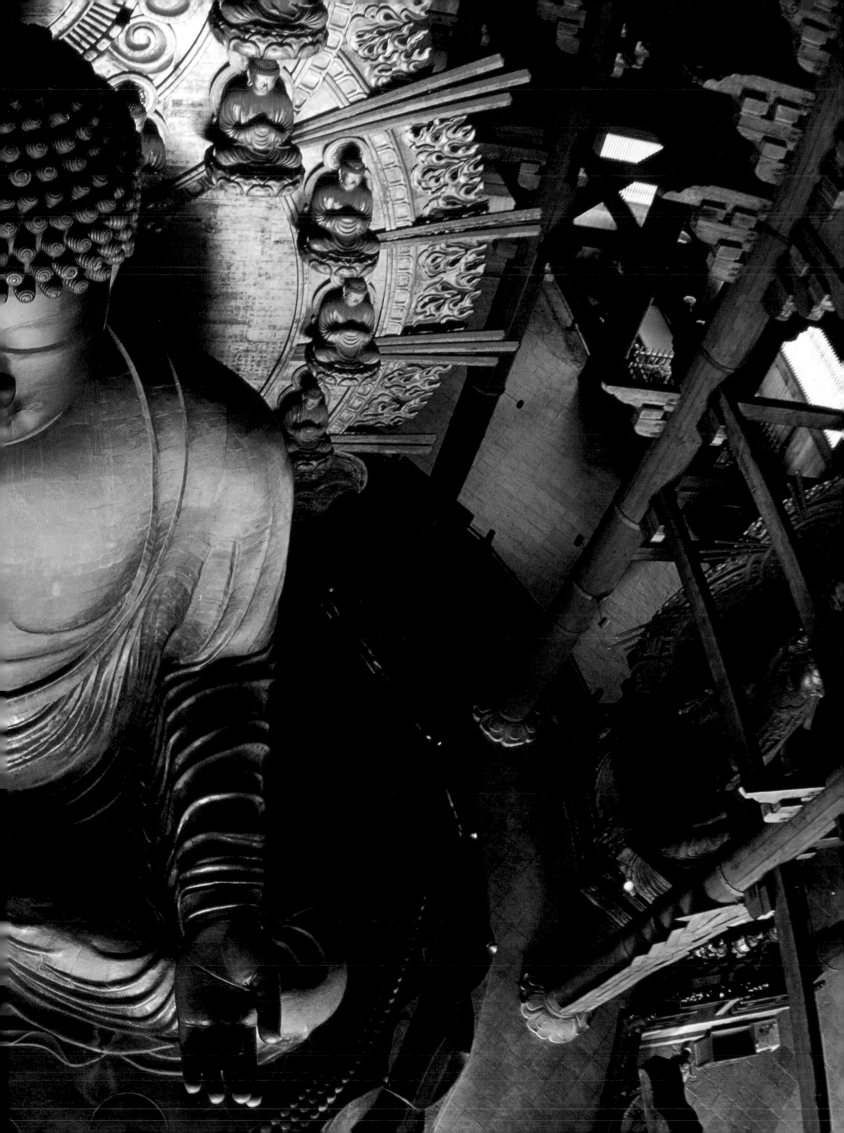

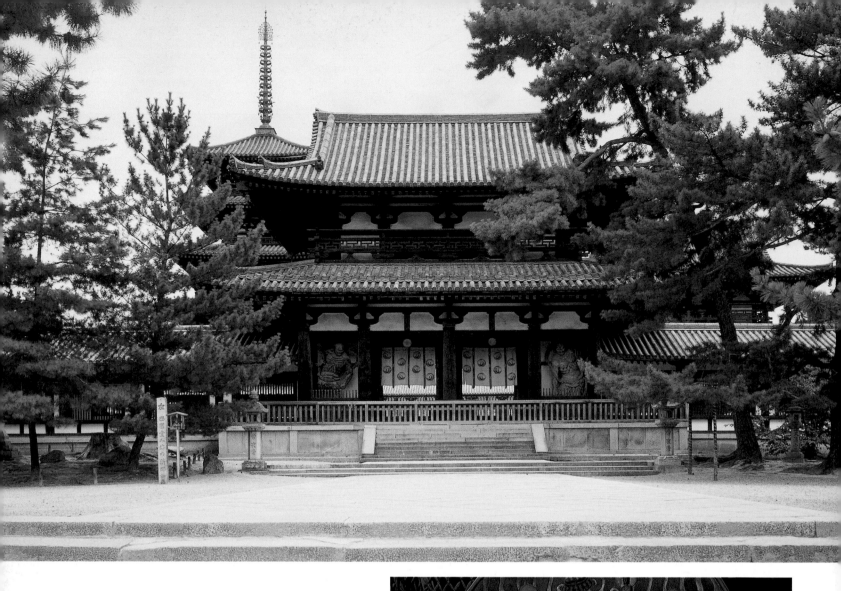

PREVIOUS PAGE: Japan's largest statue of Buddha in Todaiji temple, Nara.

ABOVE: Chumon Gate of the Horyuji temple in Nara. RIGHT: The Shaka Triad of Horyuji temple. FAR RIGHT: Pillars at Horyuji, the world's oldest wooden structure.

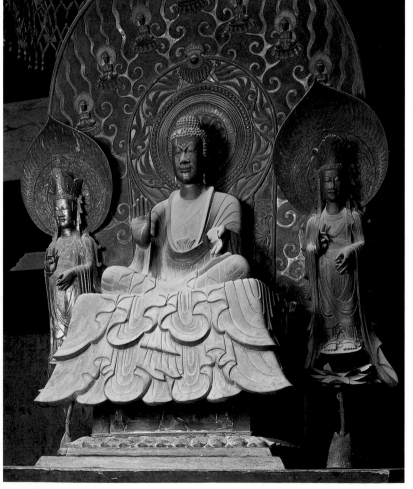

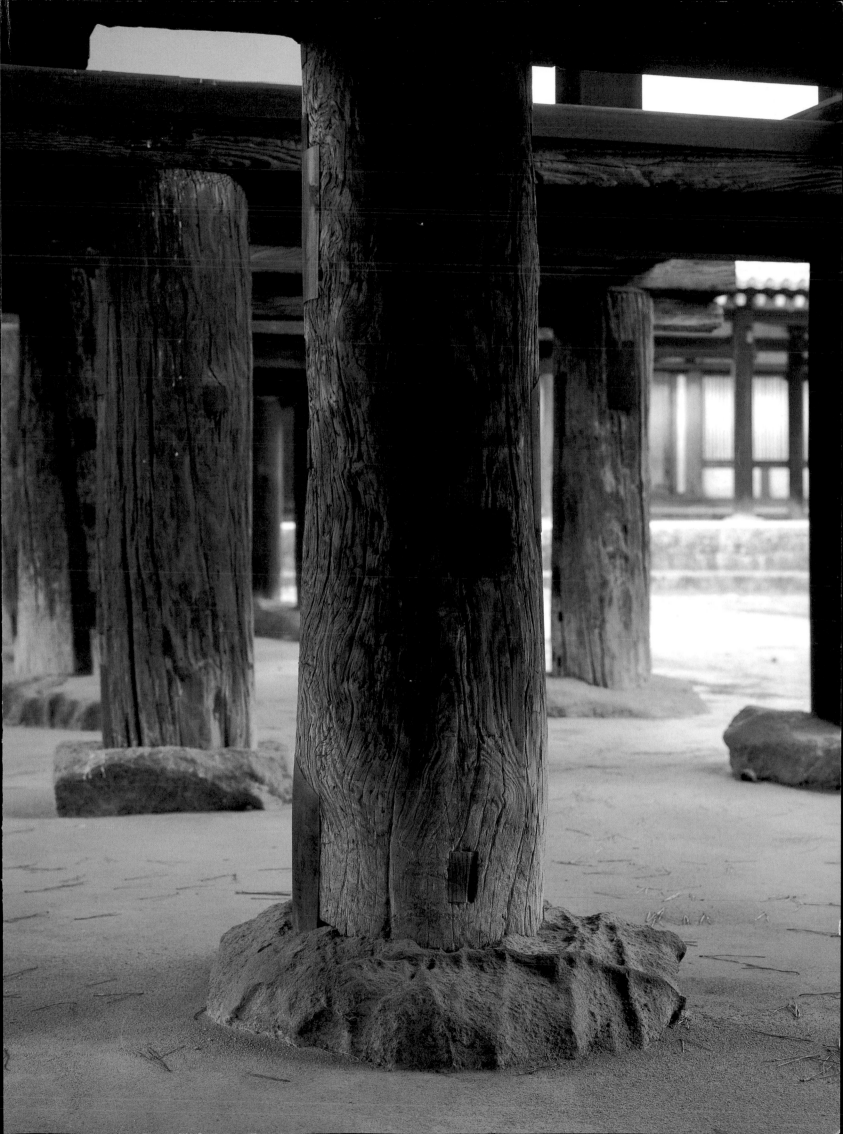

Nara is built around a huge park that is home to most of the city's attractions. One such is Kofukuji, a temple that was built in Asuka by the Fujiwara family and moved to Nara when the capital was established there in 710. The temple's pagoda and its reflection in Sarusawa Pond is one of Japan's most photographed scenes.

Todaji is another landmark temple in Nara. The present huge building, only two-thirds the original temple's size, is still the largest wooden building in the world. As such, it houses the largest statue of Buddha in Japan. Originally finished in 752, the current building dates from 1692.

The Horyuji temple complex is said to have been built by Prince Shotoku (574–622), who is credited with introducing Buddhism to Japan. The main hall, the five-story pagoda, and the central gate all date

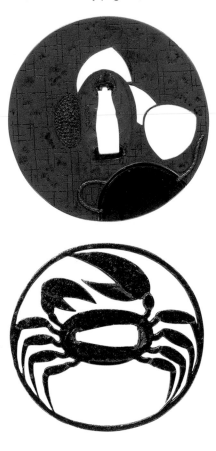

from the early seventh century, making them the world's oldest wooden structures. Horyuji is a UNESCO World Heritage Site, and houses a major collection of Buddhist art.

Southwest of Nara, in Wakayama prefecture, another major spiritual site is the mountain-top temple complex of Koyasan, established in the early ninth century by Kukai, the founder of the esoteric Shingon Buddhist sect.

Kinki's other city of note is Himeji, best known for its majestic castle, which can be seen from the railway station and is the most impressive surviving castle in Japan. Work began on its construction in the mid-fourteenth century and it was completed in 1609.

ABOVE: Sword guards: a crab (sixteenth century) and hand drum motif (eighteenth century). RIGHT: The splended gabled donjon of Himeji castle.

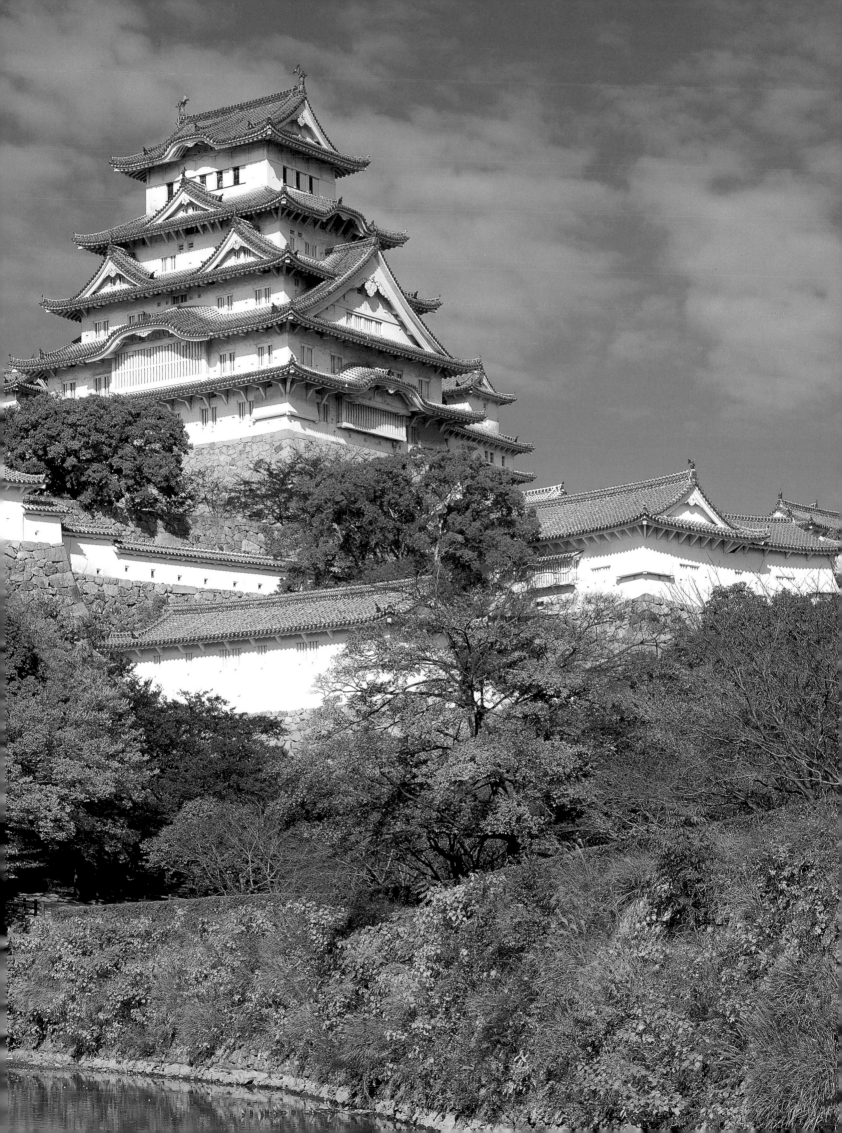

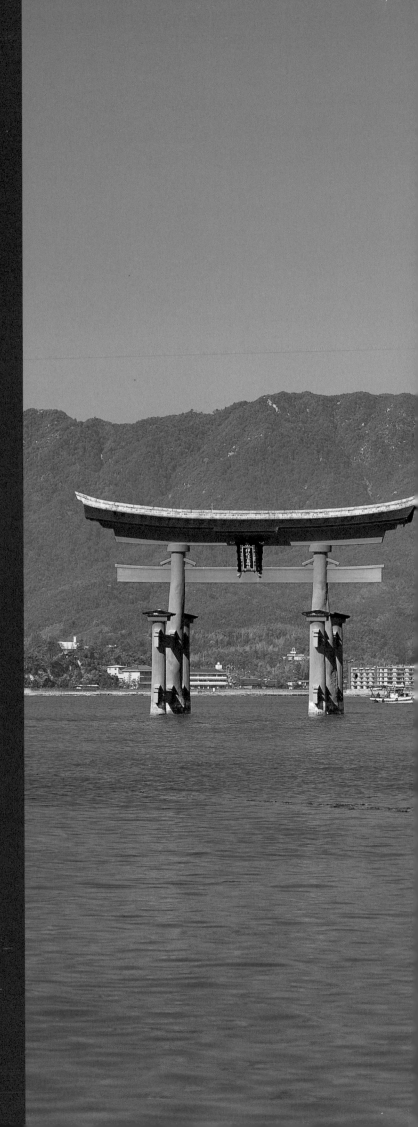

The red torii gate at Miyajima, near Hiroshima.

CHUGOKU, SHIKOKU, AND KYUSHU

Japan's Chugoku region is at the far western tip of the main island of Honshu. On the Inland Sea side lie the urban centers of Hiroshima, Yamaguchi, and Shimonoseki. The Sea of Japan coast features virgin seascapes and rural landscapes, and the Izumo Taisha shrine testifies to the area's status as the "homeland of the gods," where some of Japan's creation myths are said to have played out. Archeological evidence suggests a major population center surrounding the shrine from ancient days, although the current main shrine building dates from 1744.

Hiroshima is the region's largest city. It had its beginnings in the late sixteenth century as a castle town that grew up around the Rijo Castle of the Mori family. The Asano family took over the domain in the early seventeenth century, and in the late eighteenth and early nineteenth centuries undertook landfill projects that greatly enlarged the city and expanded its borders into the Ota river delta and Hiroshima Harbor. In the mid-twentieth century, Hiroshima's military complex made it the first target for use of a nuclear weapon in wartime. Now, the city is home to the Peace Memorial Park and Museum, and on August 6th each year the Hiroshima Peace Festival commemorates the anniversary of the bomb and declares that there shall be "no more Hiroshimas."

Hiroshima also offers one of Japan's three most beautiful scenic spots—the island of Miyajima. The island's name means literally "shrine island," perhaps after the Itsukushima shrine whose huge red torii gate stands in the sea at high tide.

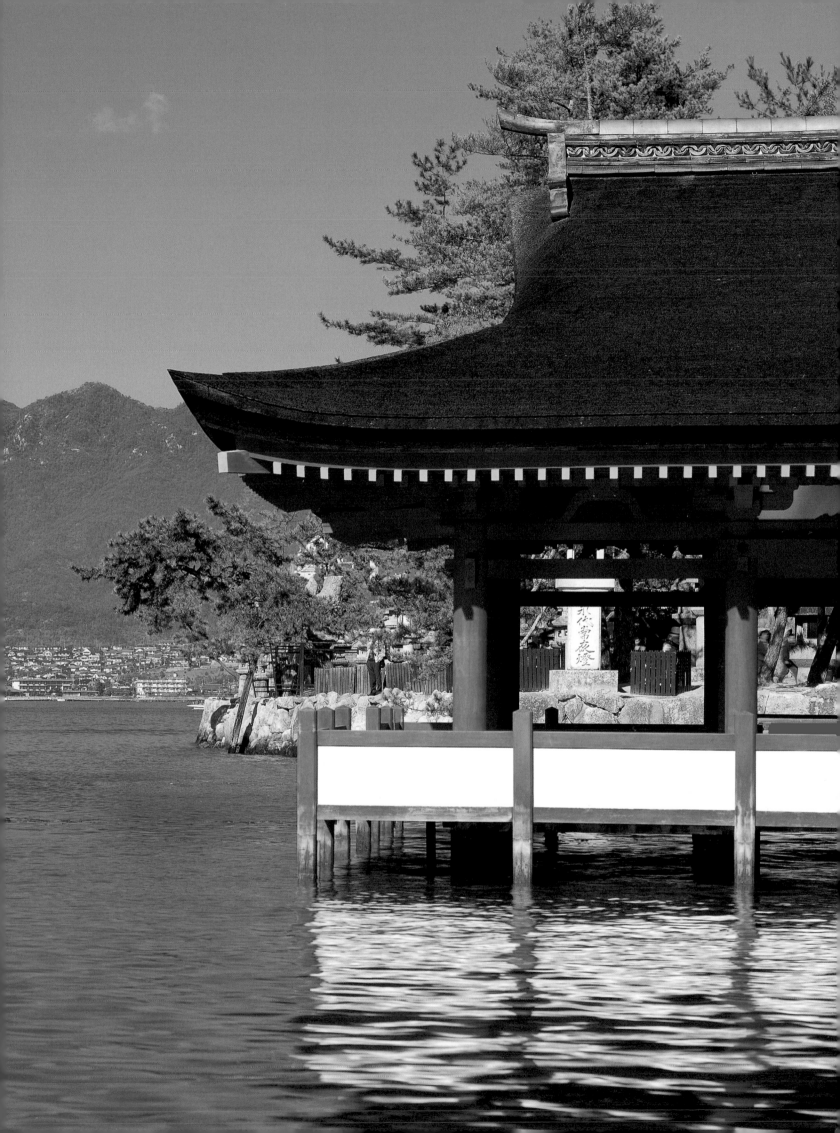

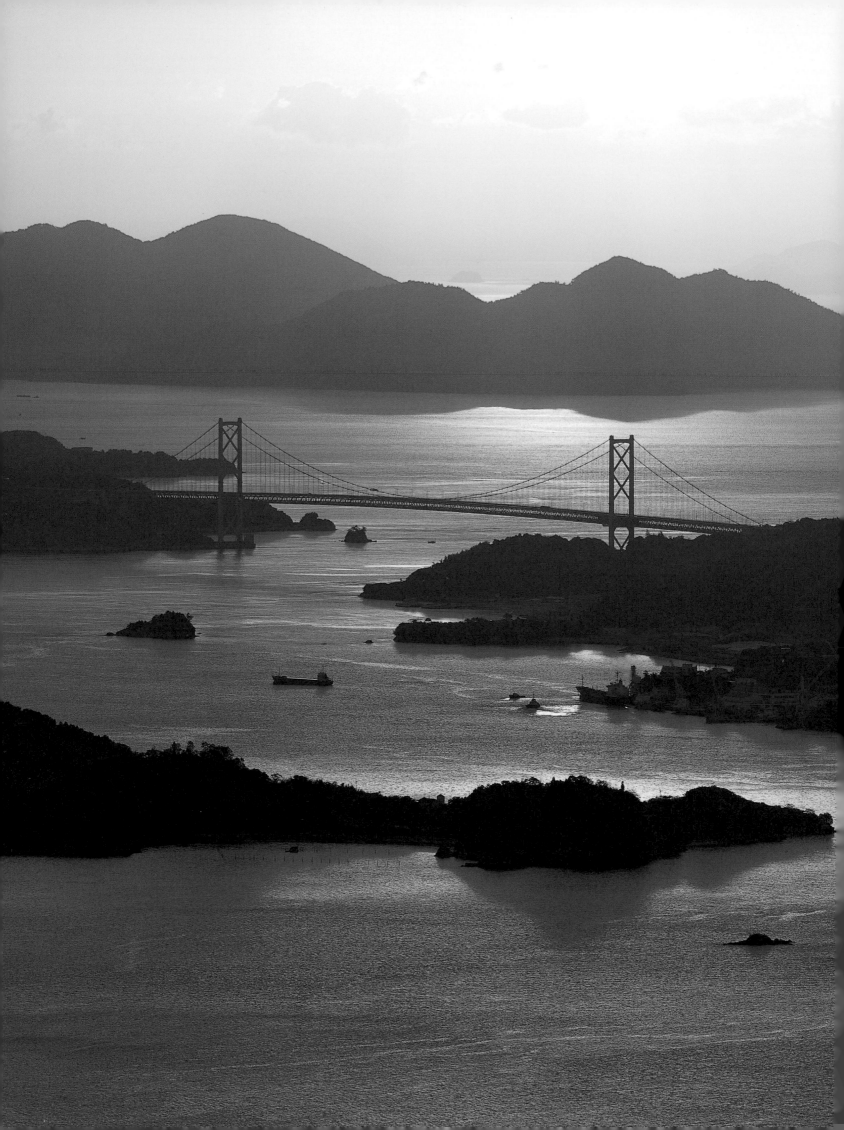

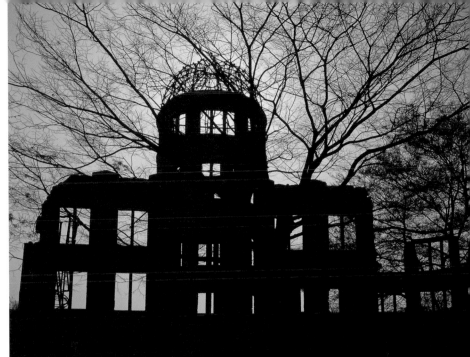

Shimonoseki occupies the western end of Honshu. From there, ferries sail to Pusan in South Korea, and cars and trucks zip over the bridge that spans the half-mile Shimonoseki Straits to Kyushu. Just off the coast lies Ganryu Island, where swordsman Miyamoto Musashi downed the feared Sasaki Kojiro with a wooden weapon hastily cut from an oar.

Across the Inland Sea from the Chugoku region, Shikoku is the fourth-largest island in the Japanese archipelago. Although Shikoku is famous for the Ritsurin iris garden at Takamatsu and the Kochi Castle, still in its original form, it is best known for its Buddhist pilgrimage, beginning at Ryozenji and ending 1,023 miles (1,647 kilometers) later at Okuboji, the eighty-eighth temple on the route. Even today, thousands make the trek each year, which can take as long as two months to accomplish on foot.

Japan's westernmost and third-largest island is Kyushu. At just a half mile distance from Honshu, Kyushu was Japan's only window to the world under the Tokugawa regime, which shut out all foreign commerce in the seventeenth century. The sole exception to this isolationist policy was a tiny manmade island in Nagasaki Harbor called Deshima, where Dutch and Chinese traders were the only ones allowed to conduct commerce with Japan. Today, Nagasaki is still a major international city, and its Huis Ten Bosch Dutch-themed village is a major attraction. Urakami Cathedral and the Peace Park offer a glimpse of the past and a look at Nagasaki history as the second target for Allied atomic bombs.

LEFT: The Innoshima Bridge in the Inland Sea. ABOVE: The A-bomb Dome, near the hypocenter of the 1945 blast.

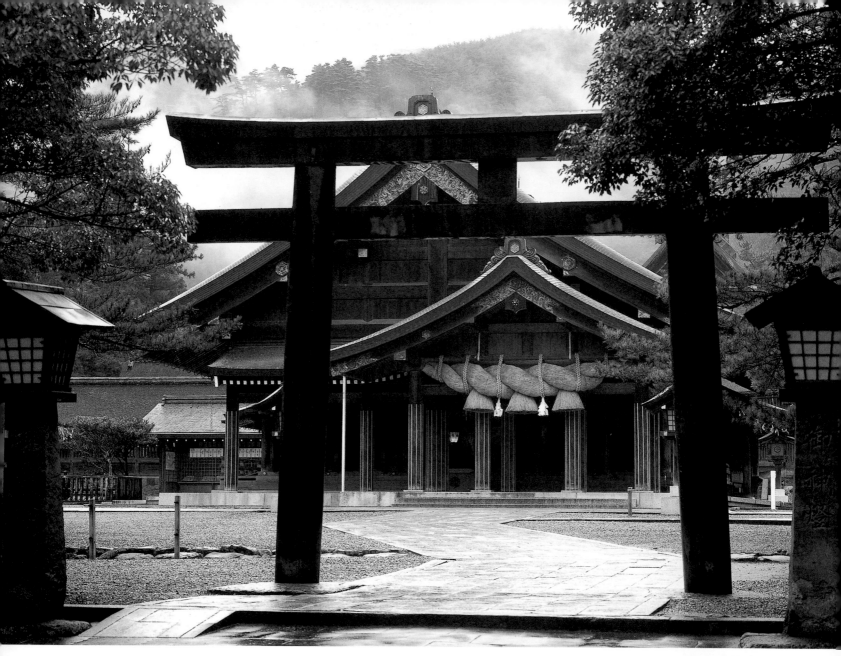

Kyushu has many sulphurous "hell valleys" and hot spring spas, most notably Beppu, as well as the live volcanoes at Mt. Aso in the center of the island and Mt. Sakurajima, which overlooks the city of Kagoshima. The island is famous for ceramics, particularly from Arita and Karatsu, and there is a fine castle in Kumamoto, the city where Miyamoto Musashi is buried.

In the seventeenth century, the Kingdom of Ryukyu, the group of islands today known as Okinawa, came under the control of the Satsuma domain in southern Kyushu. Because it was a lively trading nation with ties to China as well as to Taiwan and other countries southward, the kingdom enjoyed nominal sovereignty until 1879, when Japan annexed Okinawa as a prefecture. The islands still retain much of their unique culture, and offer local crafts as well as superb beaches and marine sports, a subtropical climate, excellent cuisine, and an atmosphere of welcome that only a southern semi-tropical island paradise can give.

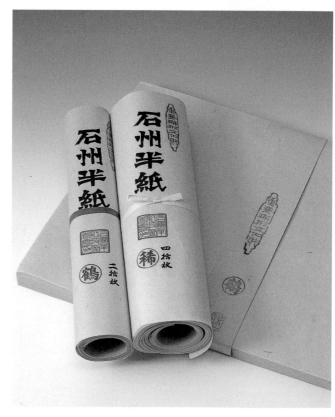

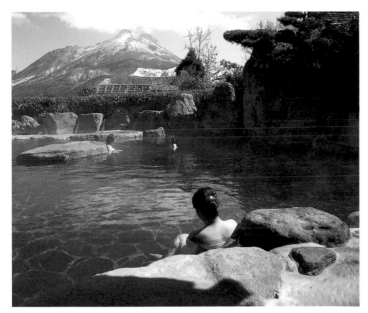

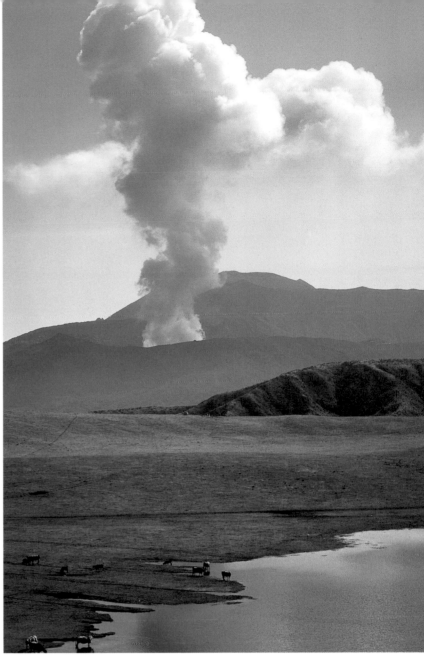

TOP LEFT: The main building at Izumo Taisha shrine. **BOTTOM LEFT:** Traditional *washi* paper. **ABOVE:** Relaxing in natural hot spring baths at Yufuin, Kyushu. **RIGHT:** Live volcano on Mt. Aso in Kyushu. **BELOW:** Takachiho in Kyushu is known as the town of myth and legend.

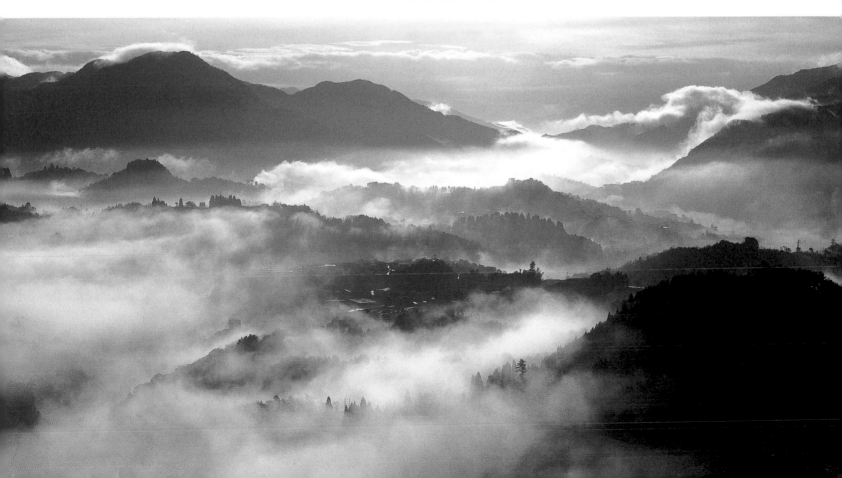

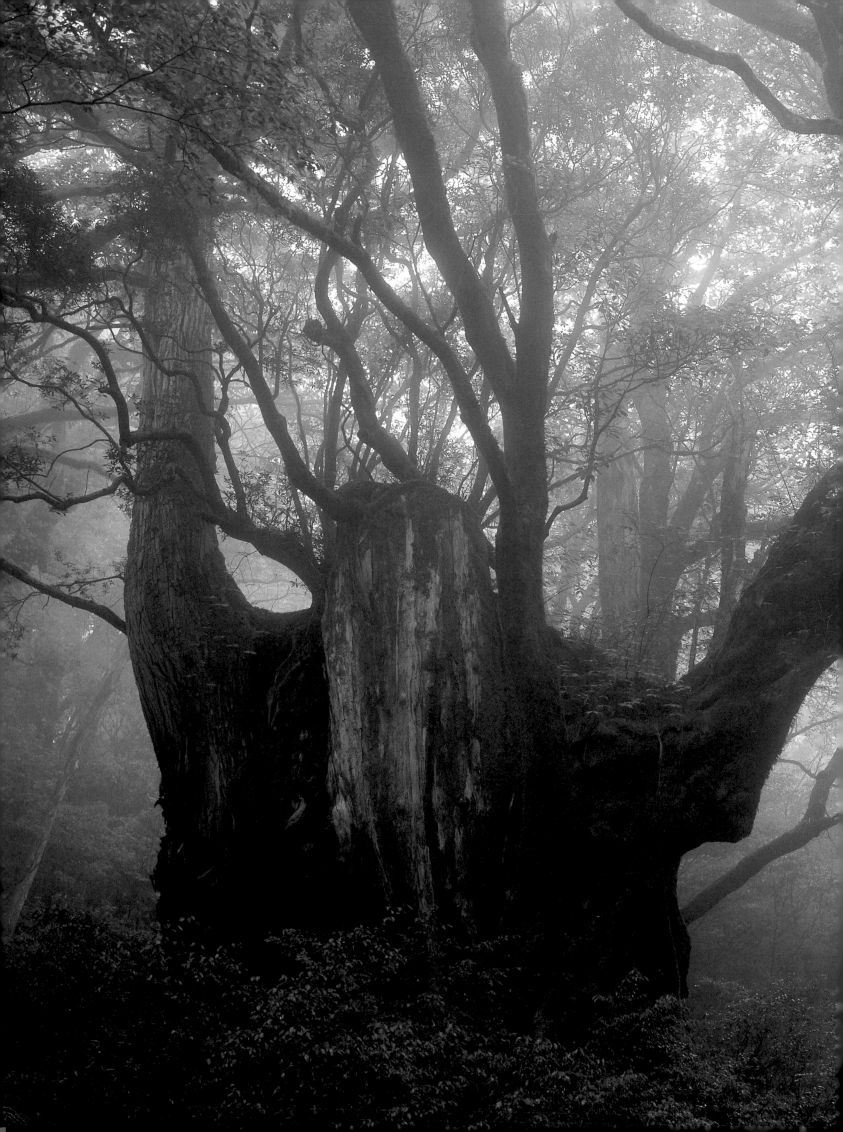

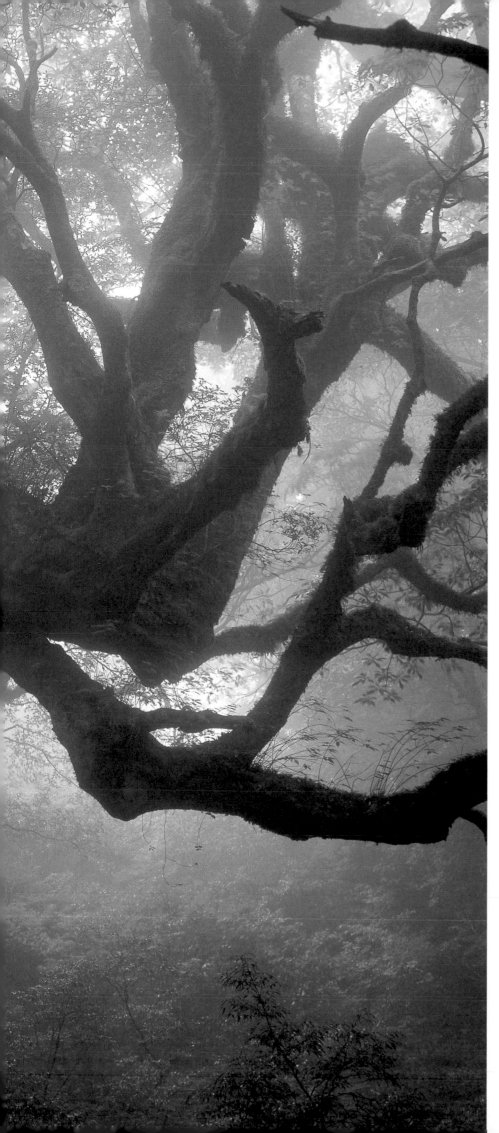

LEFT: An ancient cedar on Yakushima island, Kagoshima prefecture. **BELOW:** The Yakushima island rainforest.

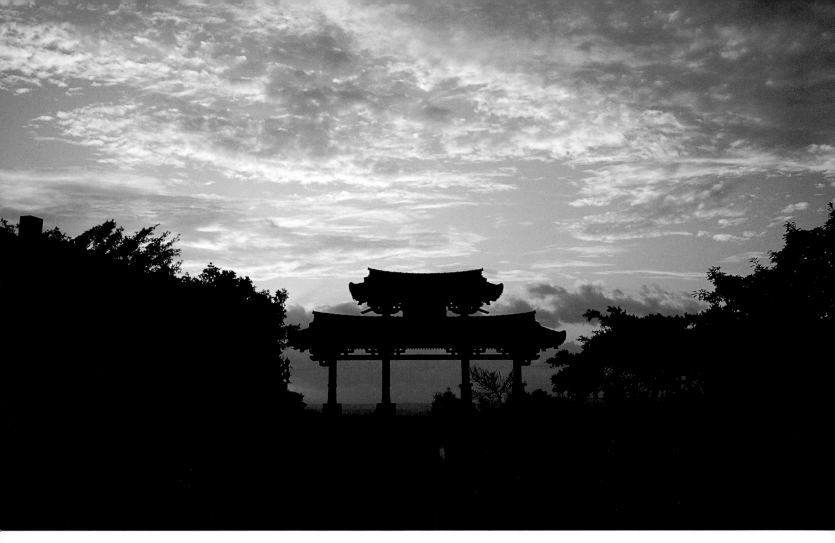

ABOVE: Shurei-mon Gate at sunset, Okinawa. **RIGHT:** Okinawan *bingata* textile.
BELOW: Underwater scene in Okinawa shows sea feather and reef fish.

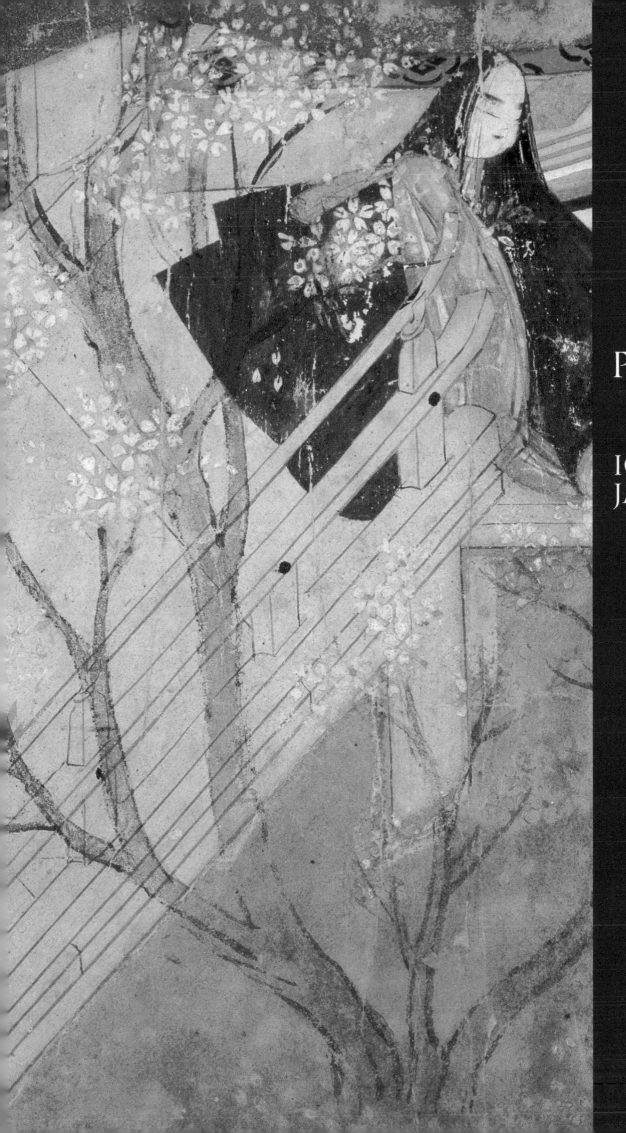

PART II

ICONIC
JAPAN

Ceramics from Japan's Jomon period (c. 10,000–c. 300 B.C.) rank among the world's oldest pottery. They are outstanding in sculptural quality and feature complex designs and surface decorations. The giant tombs of the Kofun period (c. 300–710) contain tens of thousands of artistic *haniwa* figures of both humans and animals. Some burial relics from the tombs are similar to objects found in Korea, but others such as fluted bracelets carved of semi-precious stones are unique to Japan.

The arrival of Buddhism in the sixth century brought with it artistic influence from China, and statues such as the Shaka Triad at Horyuji in Nara, characteristic of the elegant, linear Tori school, were inspired by Chinese sculpture. The eighth century saw a golden age of Buddhist sculpture, reflecting the idealized realism of early Tang China, showing fleshy, voluptuous bodies, clinging draperies, and courtly elegance. In the Kamakura period (1185–1333), sculptors were influenced by the earlier masterpieces, but also catered to the tastes of the upcoming warrior class, which preferred dynamic realism to the sophisticated, symbolic styles favored by the aristocrats of the imperial court.

Painting was a popular medium from around the tenth century. Colorful *yamato-e* showed rich landscapes with majestic mountains, rushing rivers, hills crowned with pine trees, and thatched cottage roofs. *Yamato-e* was widely used to illustrate narrative handscrolls, one highly celebrated example being of *The Tale of Genji*, Lady Murasaki's eleventh-century novel. Classical *yamato-e* provided the inspiration for the later Rinpa school, which developed in the seventeenth century under the auspices of Hon'ami Koetsu (1558–1637), admired for his calligraphy, ceramics, and lacquer design.

Monochrome ink painting, or *suibokuga*, first flourished in the fourteenth century having been introduced by Zen monks returning

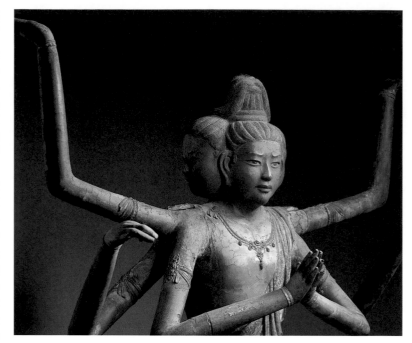

PREVIOUS PAGE: Scene from *The Tale of Genji* narrative handscroll, early twelfth century.

ABOVE: Statue of Ashura in Kofukuji temple, eighth century. **BELOW:** Amanohashidate, an ink and light color landscape by Sesshu Toyo, late fifteenth century.

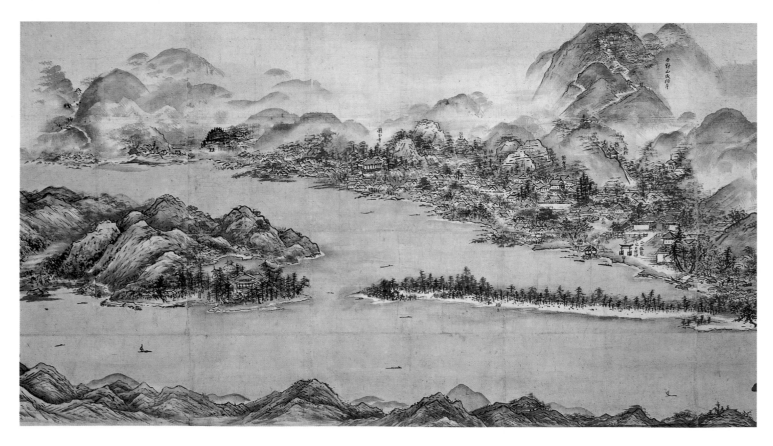

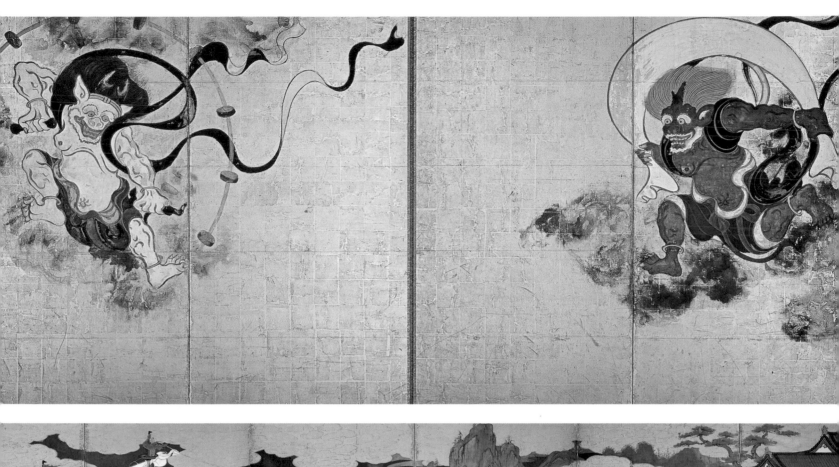

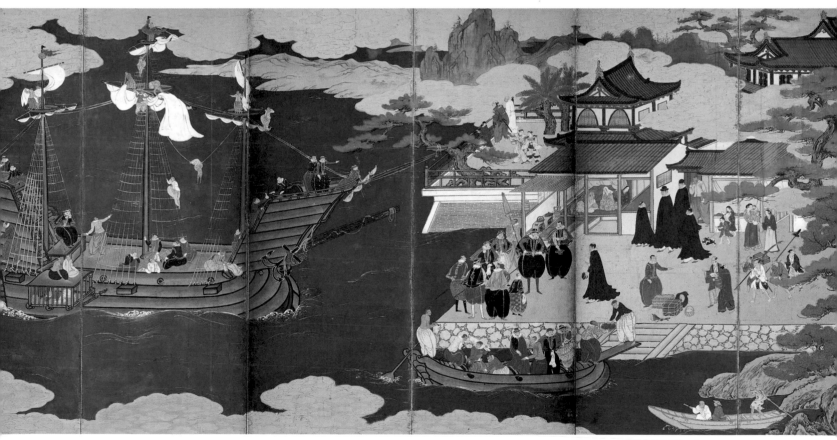

TOP: The Gods of Thunder and Wind by Tawaraya Sotatsu, early seventeenth century. **BOTTOM:** *Nanban* screen depicting Westerners by Kano Sanraku, early seventeenth century.

from China. One outstanding example is Amanohashidate, in which the artist-priest Sesshu Toyo (1420–1506) applies the Chinese-style idealistic representation of nature to a famous Japanese location.

Until the Edo period (1603–1868) art was for the rich or the pious, but from the bawdy, brawling back streets of Edo (now Tokyo) came a new popular art form called *ukiyo-e*, which relied on woodblock printing to reach the public. Some artists such as Kitagawa Utamaro (1754–1806) portrayed people and slice-of-life scenes—many were actually posters advertising theaters, tea-houses, or brothels, or portraits of popular actors and teahouse girls, while other artists like Katsushika Hokusai (1760–1849) created dynamic landscapes that influenced landscape painting around the world.

Quality lacquerware has been made in Japan since the eighth century. Especially prized by collectors today are the *inro* medicine boxes made for the newly rich merchant class of the Edo period, with a remarkable range of designs featuring *maki-e*, inlay, and colored lacquer techniques.

In the sixteenth century, ceramics were an important element in the increasingly popular tea ceremony. Stoneware pieces from the so-called "six old kilns" that escaped the destruction of the fifteenth-century wars were highly prized, especially those of Bizen, Shigaraki, and Tanba. Pieces by artists such as Chojiro (1516–92) and Hon'ami Koetsu were highly valued by grand tea masters Sen no Rikyu (1522–91) and Furuta Oribe (1544–1615). Porcelain clay was discovered in Kyushu at the beginning of the Edo period, giving rise to fine Imari and Kakiemon-style porcelain, much of which was shipped to Europe where some of the best collections remain.

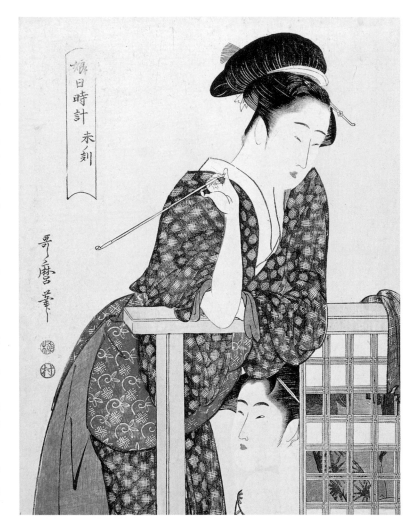

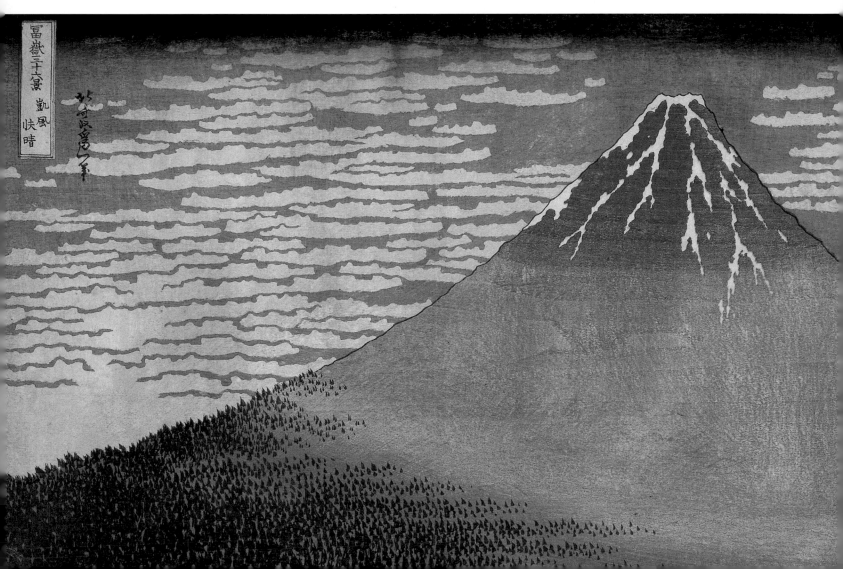

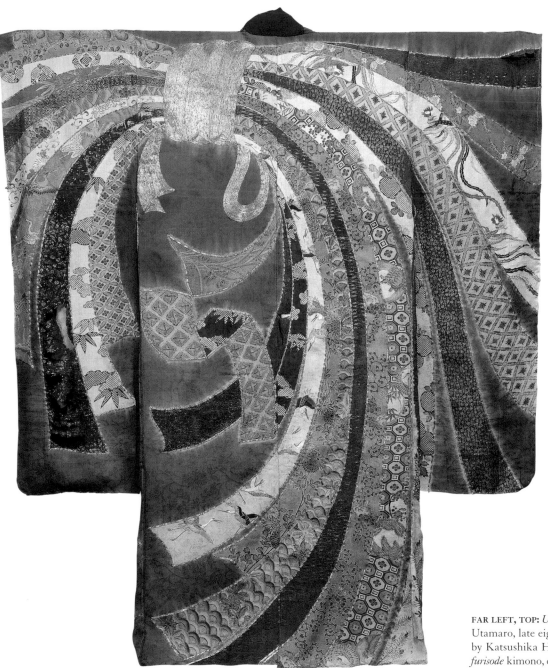

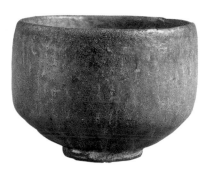

FAR LEFT, TOP: *Ukiyo-e* of young women by Kitagawa Utamaro, late eighteenth century. BOTTOM: Red Fuji by Katsushika Hokusai, c. 1831. ABOVE: *Yuzen*-dyed *furisode* kimono, eighteenth century. BELOW LEFT: Lacquerware saké pitcher with chrysanthemum motif, late sixteenth century. BELOW RIGHT: Red Raku teabowl by Chojiro, late sixteenth century.

THEATER ARTS

Noh is the oldest ongoing professional theater in the world. Noh and Kyogen, which traditionally form part of the same performance program, both stem from *sarugaku,* an early entertainment performed at temples, shrines, and festivals; but Noh is deeply symbolic and Kyogen is comedy. The playwright Kan'ami (1333–84) and his son Zeami (1363–1443) are credited with transforming *sarugaku* into Noh. Zeami's plays are still performed, and his essays defined Noh performing standards. Noh's *shite* main actor often wears a mask, portraying types such as a young woman, an old man, a demon, and expresses emotions by subtly positioning the mask and changing the play of shadows upon it. Accompanying plays are the *hayashi-kata*—four musicians with *kotsuzumi, otsuzumi,* and *taiko* drums, and bamboo flute—and the *jiutai* chorus, which chants the narration.

The aristocracy patronized Noh, but Kabuki won the masses. Kabuki plays are usually *jidaimono*—period plays set in the real or imaginary past and dealing with personal sacrifice, loyalty, and death before dishonor—or *sewamono* plays portraying the lives of ordinary people of the time. One *sewamono* of 1703, *Sonezaki shinju* ("Love Suicides at Sonezaki"), was itself based on a real story and prompted copycat suicides. Authorities responded by banning the play for decades. In its heyday, Kabuki costumes set the pace for fashion; nowadays they reflect styles of the Edo period, designating class, character traits, and even age

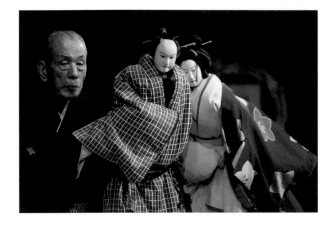

ABOVE: From the Bunraku play *Sonezaki shinju* ("Love Suicides at Sonezaki"). **BELOW:** From the Kabuki play *Shibaraku* ("Wait a Moment!"). **RIGHT:** From the Noh play *Kazuraki.*

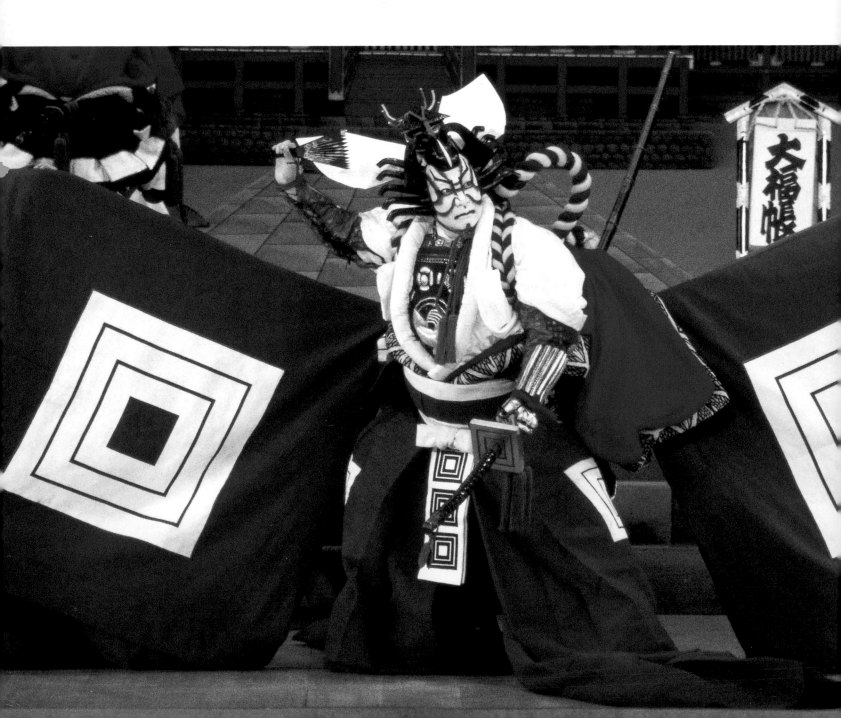

tumes, especially the blue, red, and black *kumadori* makeup depicting specific character types.

While Kabuki arose in Edo, the *ningyo-joruri* puppet storytelling that became known as Bunraku gained popularity in Osaka. Both Kabuki and Bunraku shared some playwrights and performance styles, and many Kabuki plays were adapted from Bunraku originals. Bunraku puppets are half human size and operated by three men, and the heads are carved works of art. Now centered at the National Bunraku Theater in Osaka, the genre has been enjoying a revival in recent years, although it still faces difficulties recruiting replacements for the skilled but aging backstage workers, head carvers, costume makers, and other key players.

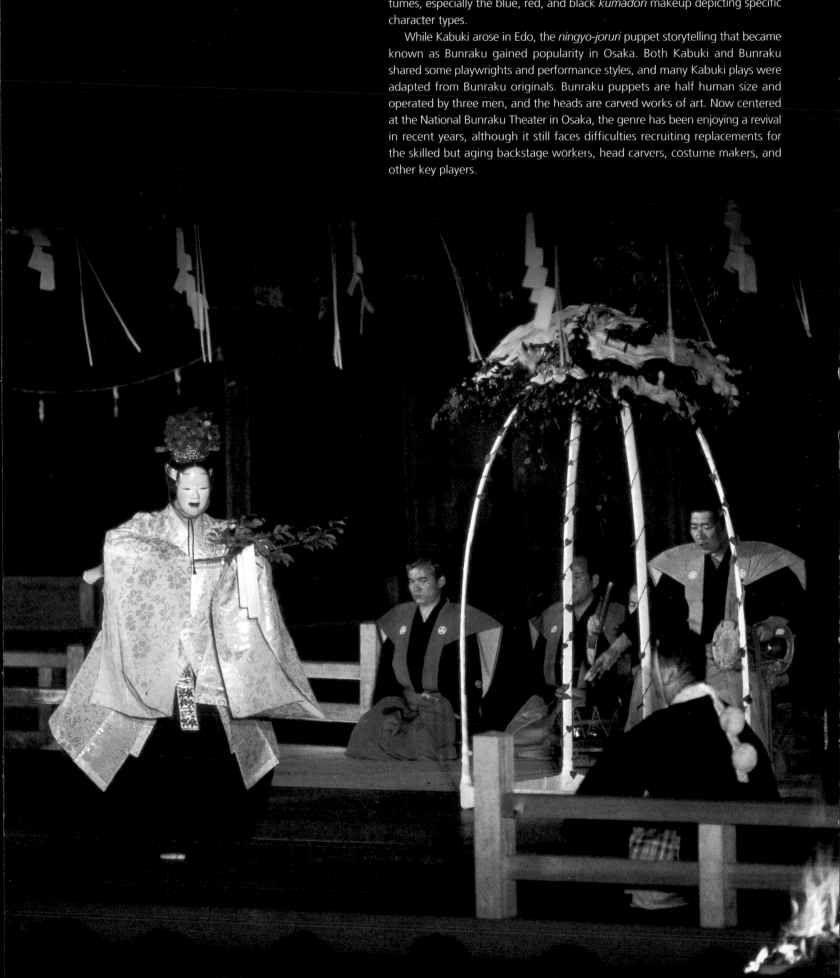

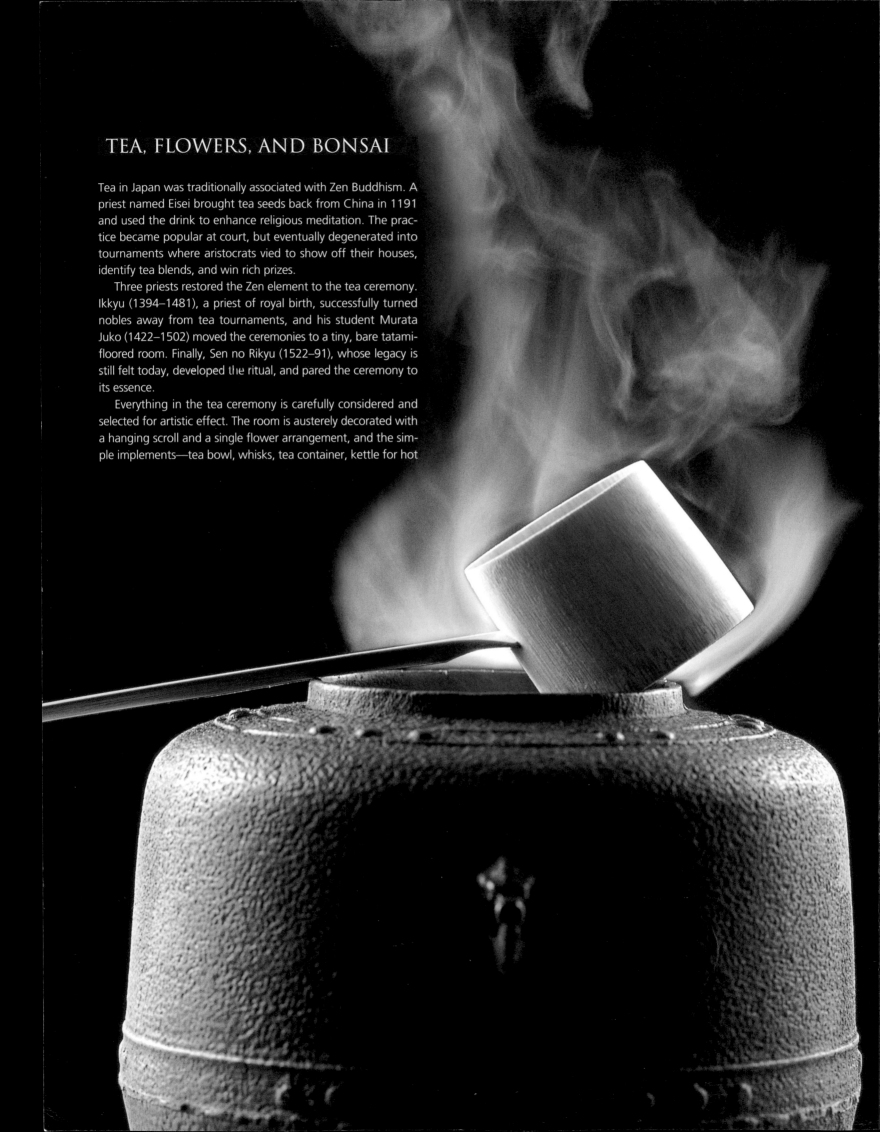

TEA, FLOWERS, AND BONSAI

Tea in Japan was traditionally associated with Zen Buddhism. A priest named Eisei brought tea seeds back from China in 1191 and used the drink to enhance religious meditation. The practice became popular at court, but eventually degenerated into tournaments where aristocrats vied to show off their houses, identify tea blends, and win rich prizes.

Three priests restored the Zen element to the tea ceremony. Ikkyu (1394–1481), a priest of royal birth, successfully turned nobles away from tea tournaments, and his student Murata Juko (1422–1502) moved the ceremonies to a tiny, bare tatami-floored room. Finally, Sen no Rikyu (1522–91), whose legacy is still felt today, developed the ritual, and pared the ceremony to its essence.

Everything in the tea ceremony is carefully considered and selected for artistic effect. The room is austerely decorated with a hanging scroll and a single flower arrangement, and the simple implements—tea bowl, whisks, tea container, kettle for hot

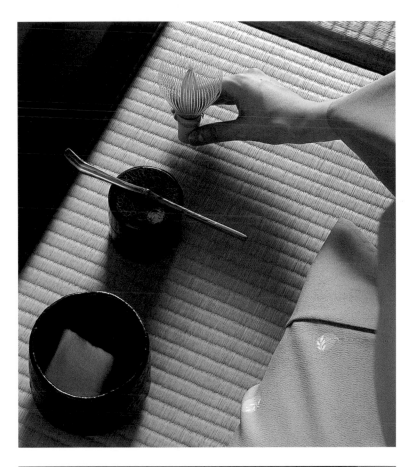

water, charcoal scuttle, ash container, waste water bowl, and bamboo ladle—are often priceless heirlooms. Every movement and reaction in the ceremony helps participants shed their everyday lives and enter into its detached universe.

Ikebana, literally "living flower," achieves artistry akin to paintings and tapestries. Ikenobo, the largest and oldest school of flower arranging, dates from the fifteenth century, and was founded by the Buddhist priest Ikenobo Senkei. Practitioners say ikebana unifies humanity and nature, combining colors, natural shapes, and graceful lines.

Bonsai are said to represent a complete cosmos in miniature. Literally "tree on a tray," bonsai are natural trees kept small by pruning branches and roots, and wired to create perfect shapes. A recent trend called Pop Bonsai is giving a new slant to this ancient art, using unusual containers such as beer cans, wine glasses, or even motorcycle helmets, and is proving popular with young people.

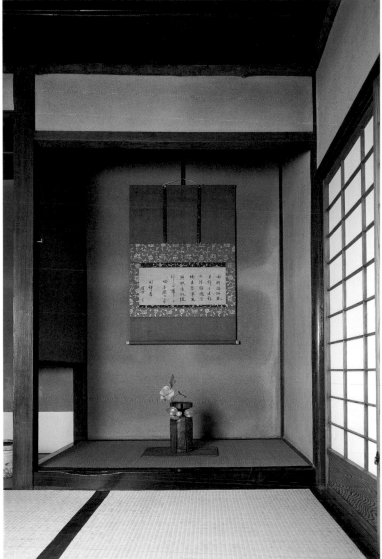

FAR LEFT: Ladle positioned properly for the tea ceremony. TOP: Ceremonial whisk, tea scoop, and teabowl ready for use. LEFT: *Tokonoma* with a flower arrangement and hanging scroll.

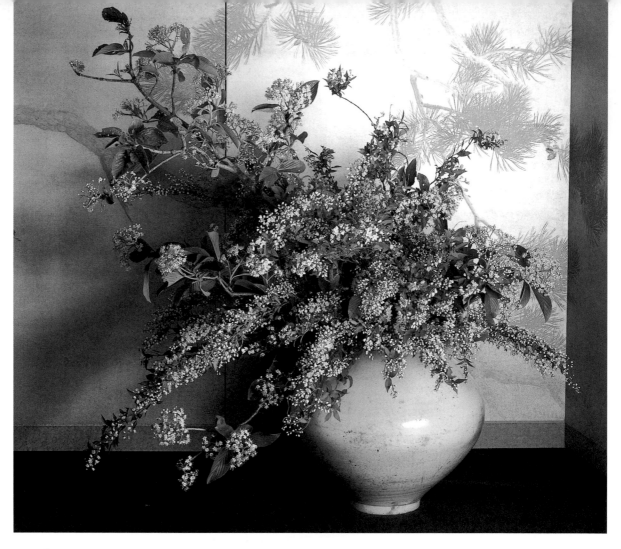

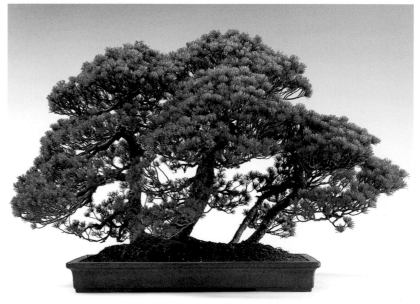

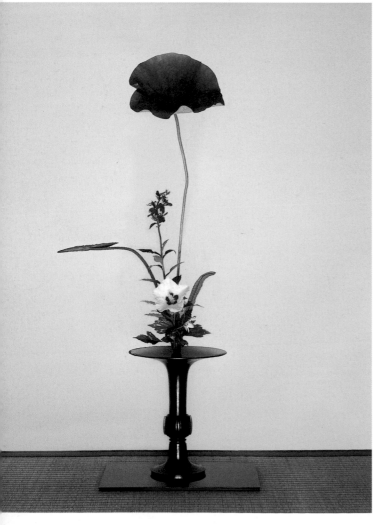

TOP: Snowflowers and hawthorn in a white ceramic jar.
LEFT: Simple flower arrangement in a bronze vase.
ABOVE: Pine is popular as bonsai.

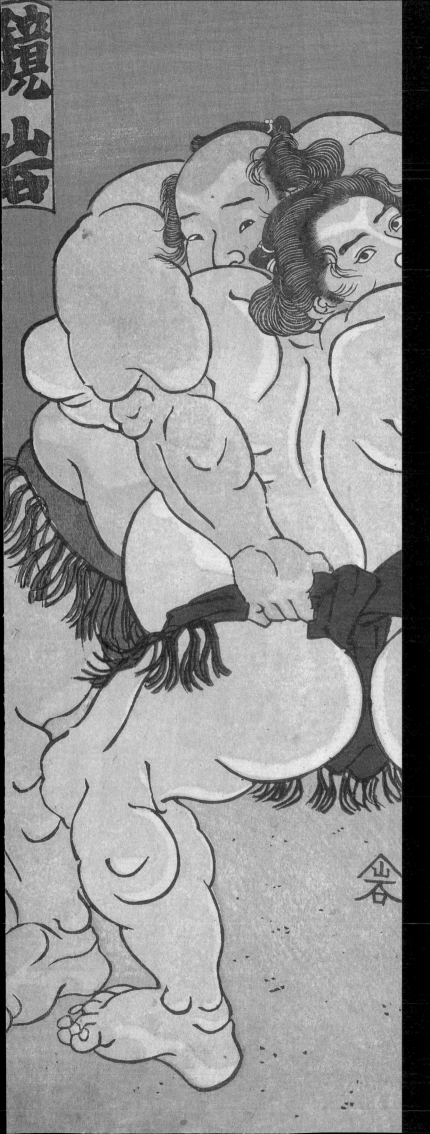

MARTIAL ARTS

Japan's national sport, sumo, was originally a ritual held to entertain the gods, and developed into a professional competition around three hundred years ago. *Sumotori* professional wrestlers vie for promotion in six fifteen-day grand sumo tournaments annually, and top-ranked *sumotori* are called *ozeki* while the grand champion is a *yokozuna*. Live media coverage makes sumo the most visible of Japanese traditional sports.

Other popular martial arts-based sports are modern refinements of traditional warrior techniques, and are practiced at competition level internationally. Now an Olympic sport, judo was perfected by Jigoro Kano (1860–1938), whose Kodokan school uses three major techniques: throwing, grappling, and striking, although striking is not used in competition. Kano also developed the grading system of five classes followed by ten ranks, all identified by belt color.

Karate was developed in Okinawa from a Chinese martial art using arm strikes, thrusts, and kicks. The master Gichin Funakoshi (1869–1957) first demonstrated karate in mainland Japan in 1917, and was invited to teach it at the Kodokan judo school in 1922. Kodokan's patronage was the key to karate's acceptance in Japan and helped establish the sport.

Aikido was developed by Morihei Ueshiba (1883–1969) from traditional jujitsu techniques. It is a form of self-defense that utilizes an opponent's power and force against them by means of throws and immobilizing holds.

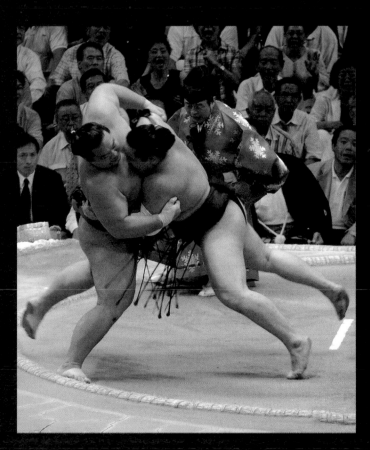

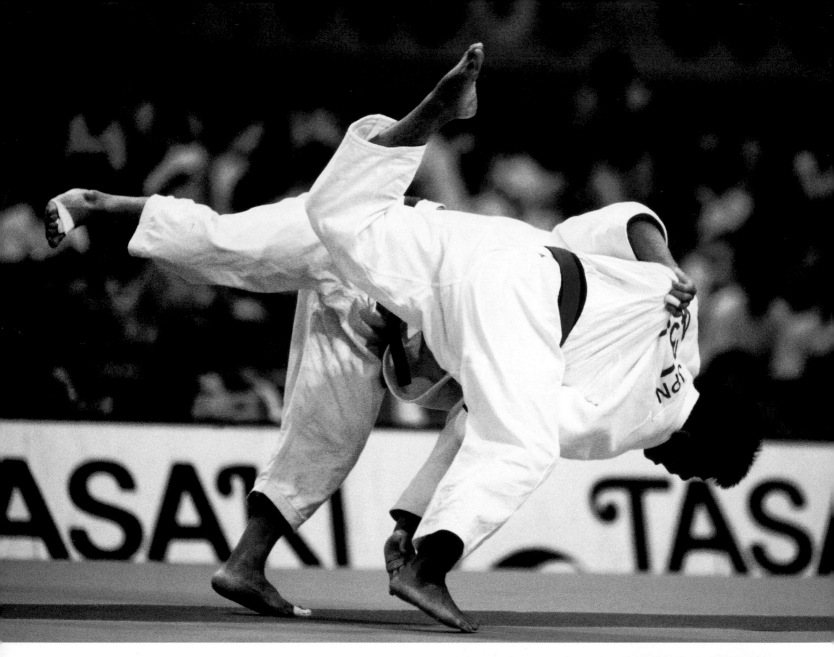

Kendo debuted as a sport in 1952, but its roots go back to Edo-period swordsmanship. It employs split bamboo swords, body armor, and helmets, and points are made by striking the opponent's head, torso, wrist, or throat.

Kyudo archery was organized as modern sport in 1953. It developed out of techniques to control a bow and arrow both from a standing position and on horseback, and places emphasis on form rather than on target accuracy.

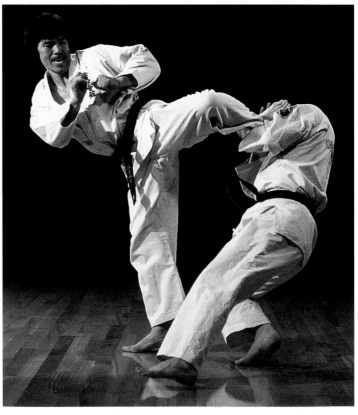

PREVIOUS PAGE, LEFT: Woodblock print of the *sumotori* Kagamiiwa and Hidenoyama. RIGHT: Sumo match between *ozeki* and *yokozuna*.

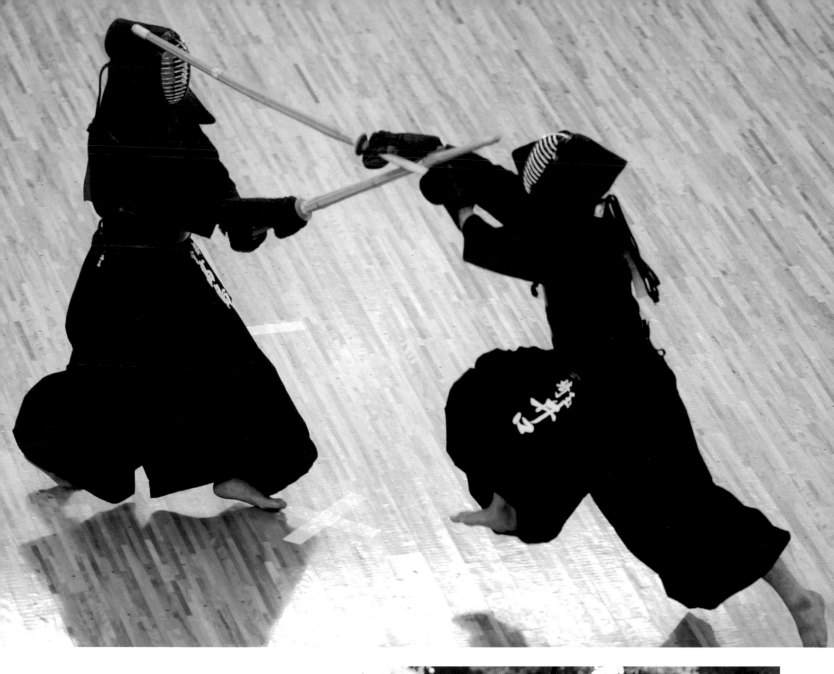

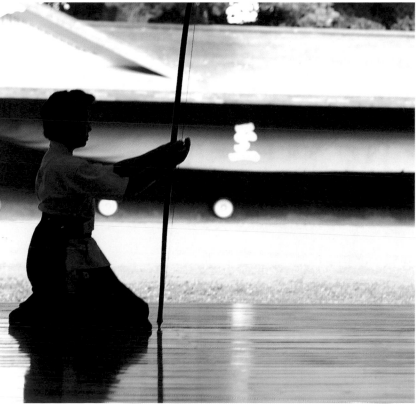

TOP LEFT: A Japanese judoist in an international competition.
LEFT: A karate practitioner fells his opponent with a kick.
ABOVE: A kendo fencer scores to the opponent's mask. **RIGHT:**
A kyudo archer meditates before shooting.

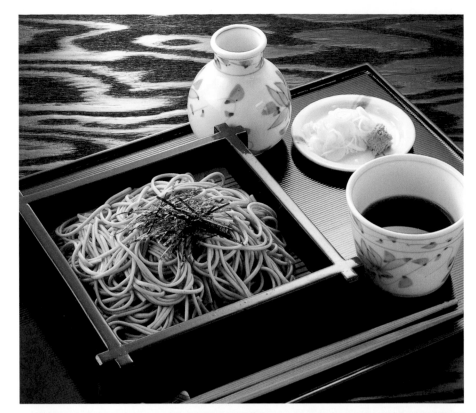

Even today, the majority of Japanese people consider rice their dietary staple, and a meal at a Japanese home will likely consist of rice, miso soup, vegetables, and fish or meat.

As the main dish, steamed rice is most often served in a bowl, but lunch may be a triangular rice ball, wrapped in seaweed with a pickled plum or other filling pressed into the center; or a *bento* box lunch, with various dishes arranged in partitions within a single container, sometimes with a package of instant miso soup.

Rice is seasoned with vinegar for sushi, a world-famous Japanese dish. The best-known types of sushi are the small oblong portions of rice topped with fish, clam, or egg, or wrapped in seaweed with salmon roe or sea urchin on top. Sushi rolls have cucumber, pickled radish, tuna and onions, or other delicacies in the center.

Rice and pure spring water produce saké, Japan's indigenous alcoholic drink. Rural towns often have breweries that produce local saké, and Japan offers more than ten thousand brands nationwide.

Noodles are another popular main dish. *Soba* is made with buckwheat flour, although wheat flour may be added, while *udon* noodles are of wheat flour. Both are boiled and served with seasoned broth or a topping such as tempura, or fried with vegetables and meat. *Soba* is often served cold in summer.

Although tempura traces its origin to Portuguese missionaries of the sixteenth century, it is an archetypal Japanese food that requires absolutely fresh ingredients such as vegetables, fish, and shrimp, as well as artful presentation and a skilled chef. Good tempura is a triumph of Japanese cooking—a fried food that is light and fresh-tasting.

Japanese chefs constantly seek perfection, and strive to present the food in ways that appeal to all the senses. This means making the most of seasonal ingredients, and selecting dishes and utensils to perfectly complement the food placed in them.

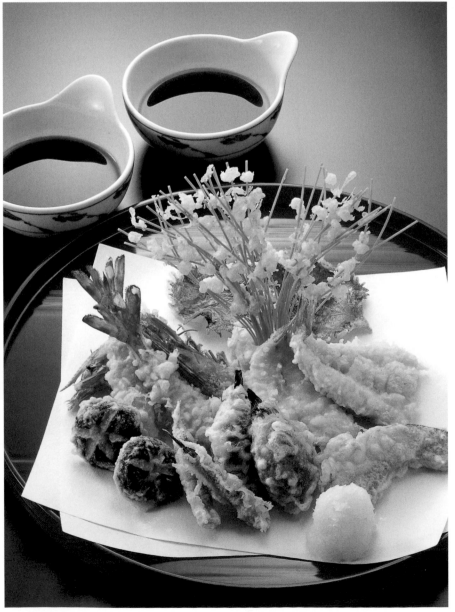

TOP : Buckwheat *soba* noodles are often served chilled with a dipping sauce. **RIGHT:** A wide range of ingredients is used for tempura. **FAR RIGHT:** Sushi is one of Japan's international dishes.

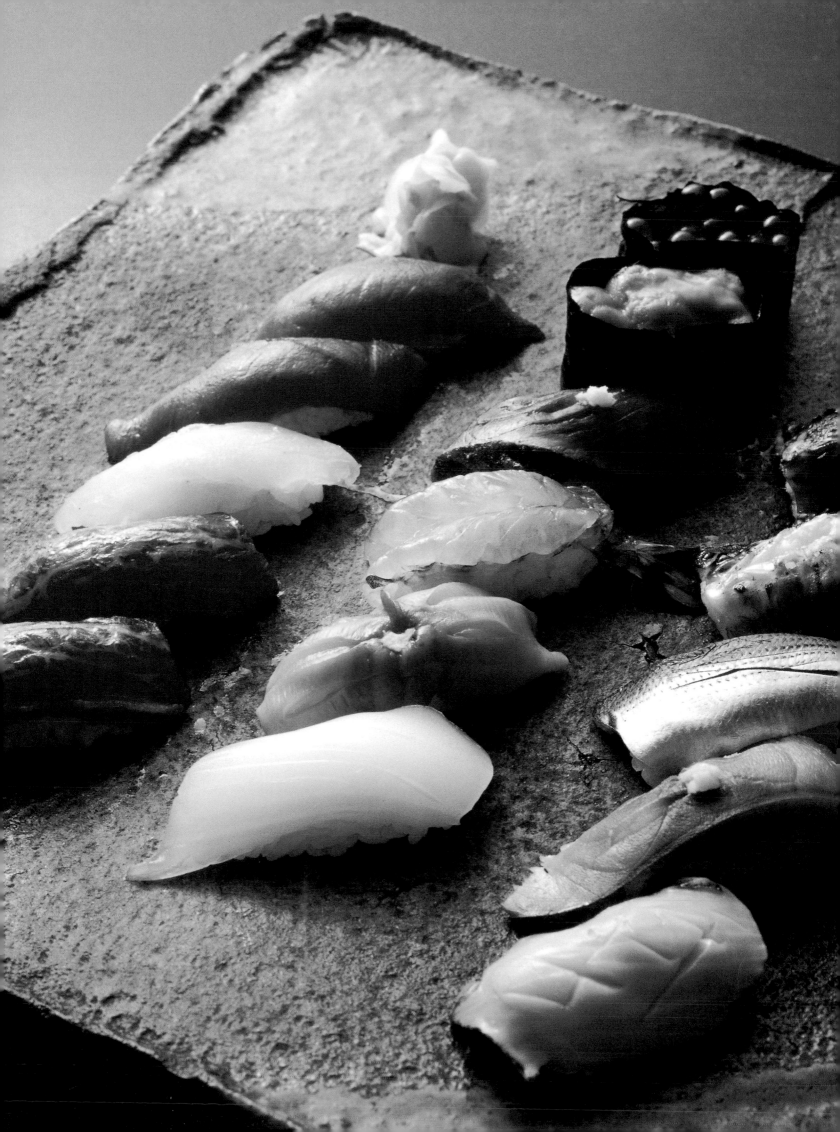

HOME

Virtually every Japanese family dreams of owning a single-family home. Modern materials have altered the way some Japanese homes are built, but for centuries residences have been post-and-beam construction, which meant walls and interior partitions could be both lightweight and mobile, and opened to let in light and air or closed for warmth and privacy.

Most single-family homes in Japan are still made of wood and adhere to the traditional structure, although they may look as if they are made of brick. As the *minka* commoner homes of the Edo period filled the gaps between supporting pillars with walls of clay and straw, so modern homes clad their wooden interior structures with modern siding. The plans of these houses and how they are used remain quite traditional. While the kitchen and eating area tend to be modern, the areas of other rooms are measured by the number of mats, whether the flooring is tatami or wooden.

Nevertheless, in urban areas where space is at a special premium, young architects are revolutionizing single-family home design, using stage-like open interiors with exposed kitchens, skylights in the roof, and transparent walls that slide away. In one example, glass shutters fold up into the roof and flowing three-story polyester curtains catch every breeze. The owners maintain that the design is very Japanese—"totally minimal and flexible."

Many homes have sliding glass doors that open to a small, often traditional garden. A small veranda-like transition space allows people to step outside, and there is often a stone step with wooden *geta* ready in case anyone wants to take a stroll. Such is the home-owner's love of nature that even in very small homes a way is usually found to incorporate a touch of greenery, such as azaleas, Japanese maple, or perhaps some bamboo.

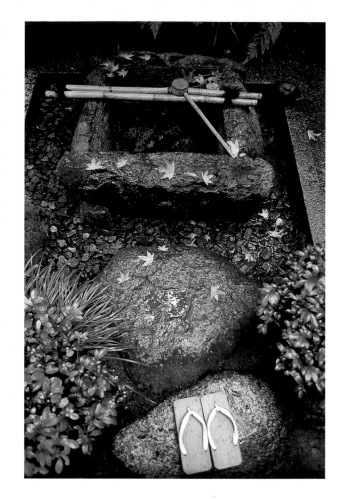

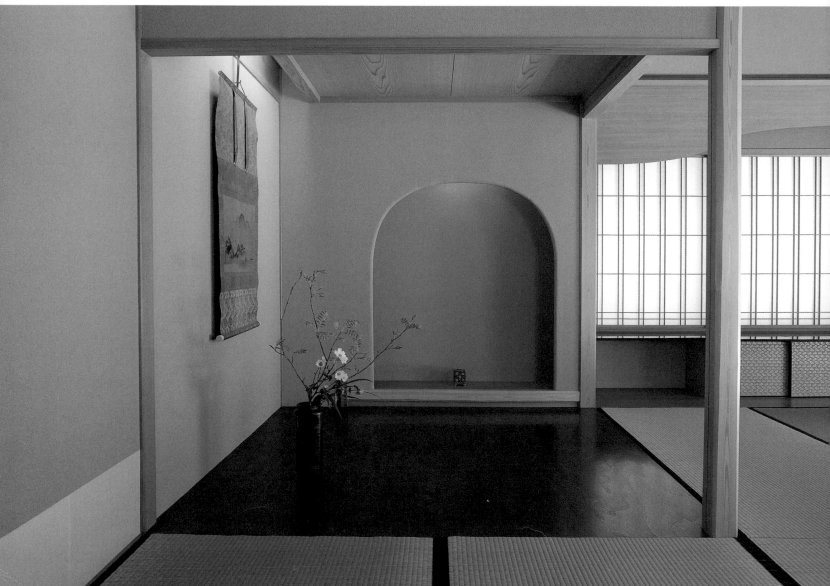

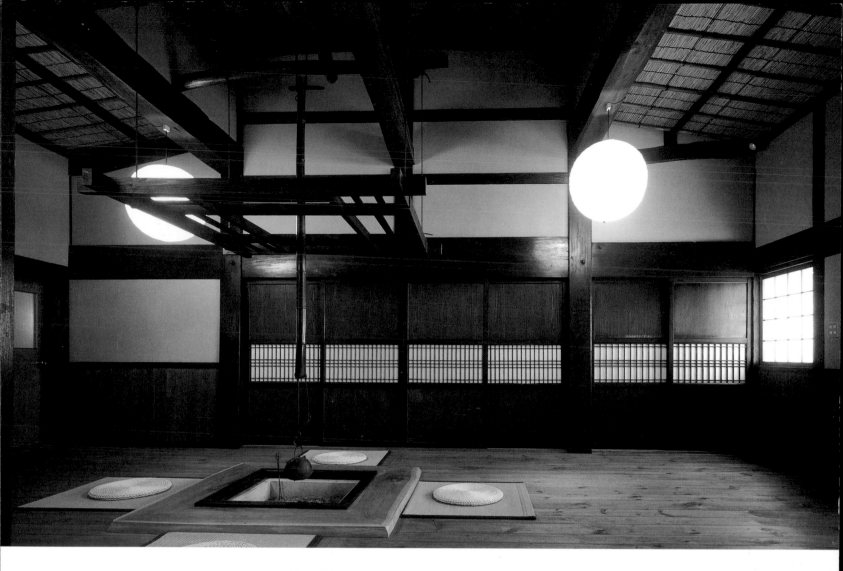

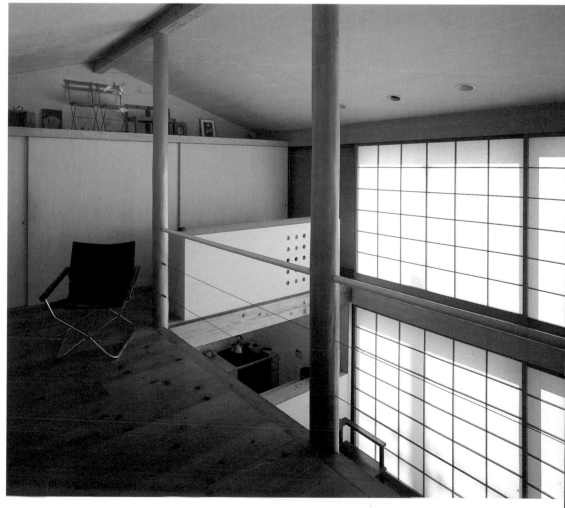

TOP LEFT: Stones are used for steps, shoe rest, and water basin for purification. **LEFT:** A traditional *sukiya*-style house. **ABOVE:** A renovated traditional *minka* house with *irori* sunken fireplace. **RIGHT:** A modern home, incorporating Japanese architectural elements.

ANIME AND HIGH-TECH

Japan's first animated one-reeler appeared in 1917. Early Japanese animation tended to dramatize Oriental folk tales, using traditional art styles rather than imitating foreign genres. Kenzo Masaoka produced Japan's first animated movie with sound in 1932, and his protegé Mitsuyo Seo directed the world's first full-length "anime" film *Momotaro's Divine Sea Warriors* in 1945. The film's stylized graphics depicting vibrant characters in a fantastic action-filled plot foreshadowed the immensely popular anime of the 1980s.

Osamu Tezuka, popular manga artist of the 1950s, produced animated TV versions of his *Astro Boy* series, the first of which aired on New Year's Day 1963 and became an instant hit. In the 1960s, science-fiction action-adventure anime were overwhelmingly popular, and many weekly manga stories became TV hits. Among the most influential was *Mazinger Z*, based on Go Nagai's manga about a teenager and his flying machine protecting Earth from alien invaders. By the mid-1980s, some forty giant-robot anime series flooded Japan's TV channels. Japanese community TV in the United States began airing the anime programs, which started a cult following.

Not all hit TV anime was science fiction, however. Another hit series was *Dragon Ball*, which began as a weekly manga created by graphic designer Akira Toriyama in 1984. It followed the exploits of an orphan martial artist, Son Goku, and his motley friends in their quest to find the seven balls that, together, summon the dragon god that will grant a wish. Soon a TV show debuted, and the series was so popular that it spun off two more. The sequel, *Dragonball Z*, had Goku as an adult with a son of his own, but the following series, *Dragonball GT*, done without Toriyama, drew mixed reviews.

While TV dominated anime production, it was difficult for new artists and companies to make a breakthrough. However, this impasse was transformed by the Hayao Miyazaki phenomenon, and by the development of original anime video (OAV).

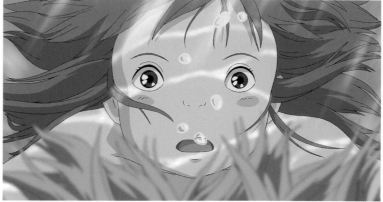

© Studio Ghibli

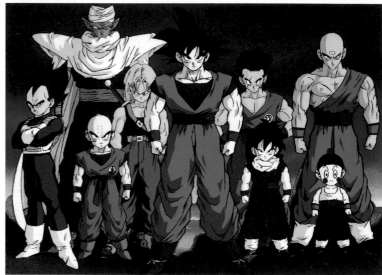

© 1989 Birdstudio/Shueisha, Toei Animation

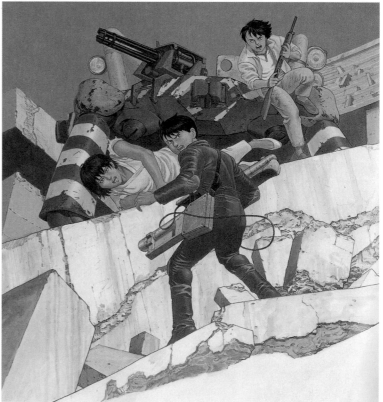

© Otomo Katsuhiro/Mushroom/Kodansha

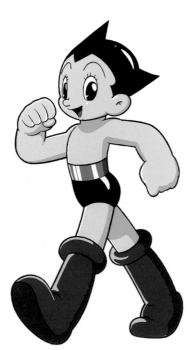

© Tezuka Productions

LEFT: Astro Boy, Japan's first animated TV hero. **TOP:** *Spirited Away* won an Oscar for Best Animated Film. **MIDDLE:** The denizens of *Dragon Ball Z*. **BOTTOM:** Neo-Tokyo faces destruction in *Akira*. **RIGHT:** Honda's child-sized ASIMO robot.

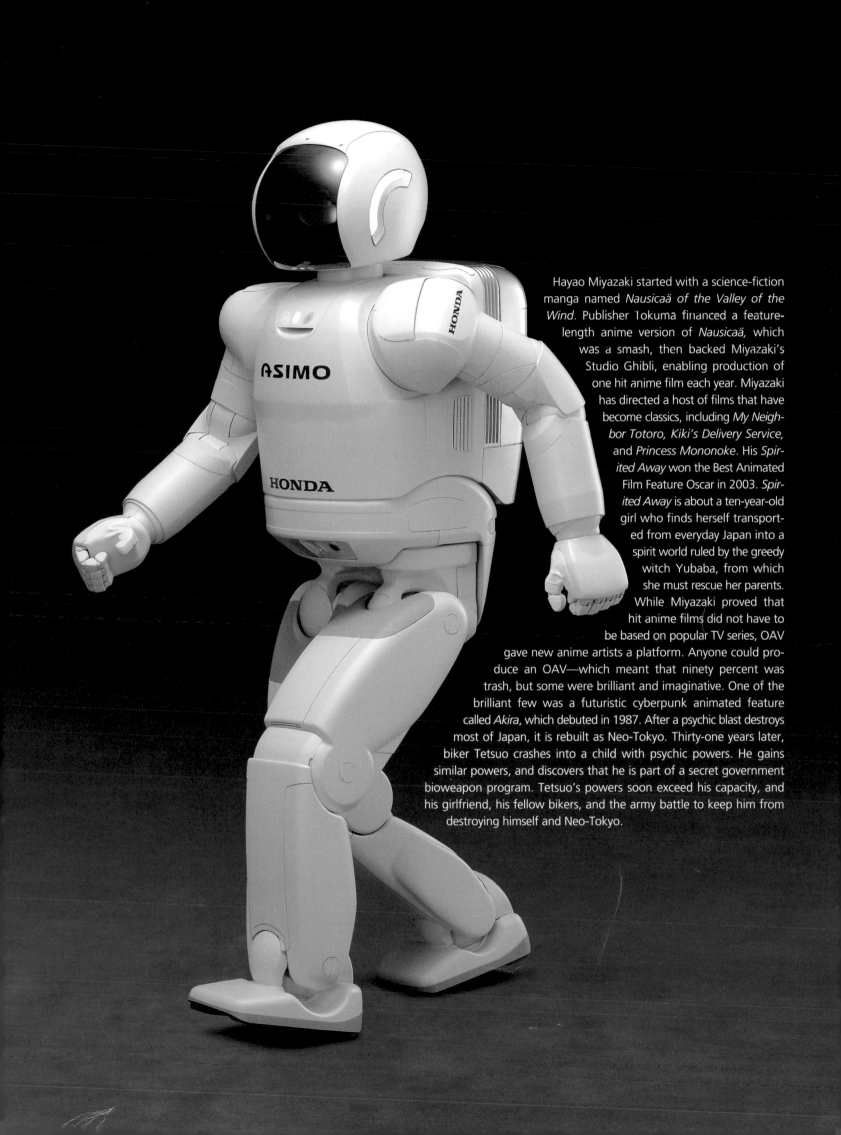

Hayao Miyazaki started with a science-fiction manga named *Nausicaä of the Valley of the Wind*. Publisher Tokuma financed a feature-length anime version of *Nausicaä*, which was a smash, then backed Miyazaki's Studio Ghibli, enabling production of one hit anime film each year. Miyazaki has directed a host of films that have become classics, including *My Neighbor Totoro, Kiki's Delivery Service*, and *Princess Mononoke*. His *Spirited Away* won the Best Animated Film Feature Oscar in 2003. *Spirited Away* is about a ten-year-old girl who finds herself transported from everyday Japan into a spirit world ruled by the greedy witch Yubaba, from which she must rescue her parents. While Miyazaki proved that hit anime films did not have to be based on popular TV series, OAV gave new anime artists a platform. Anyone could produce an OAV—which meant that ninety percent was trash, but some were brilliant and imaginative. One of the brilliant few was a futuristic cyberpunk animated feature called *Akira*, which debuted in 1987. After a psychic blast destroys most of Japan, it is rebuilt as Neo-Tokyo. Thirty-one years later, biker Tetsuo crashes into a child with psychic powers. He gains similar powers, and discovers that he is part of a secret government bioweapon program. Tetsuo's powers soon exceed his capacity, and his girlfriend, his fellow bikers, and the army battle to keep him from destroying himself and Neo-Tokyo.

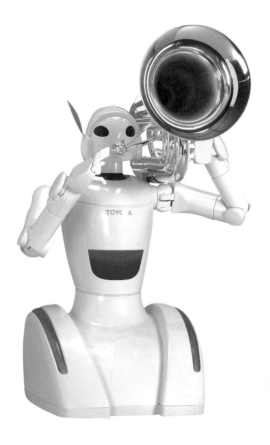

Japan's futuristic dreams recently took a step toward reality. Where Tezuka's Astro Boy was a robot with a heart, Sony's AIBO is a robot dog that doubles as a pet, reacting to its owner's voice and gaining a distinctive personality through interaction with its owner. Honda, on the other hand, developed ASIMO, a child-sized humanoid robot that currently acts as a guide for visitors at Honda headquarters.

The government also backs development of robots, concentrating on sanitation robots to take over cleaning jobs, security robots to conduct surveillance and watch for fires, guide robots with multilingual capabilities to help visitors, childcare robots, and wheelchair robots for those with disabilities. The government's thirty-year robot development program, named Atom (the original Japanese name of Tezuka's Astro Boy robot), started in April 2003 and aims to develop a humanoid robot with the mental, physical, and emotional characteristics of a five-year-old child.

High-tech moves Japan into the future, too. Once wristwatch size radios and TV phones were the stuff of comic books. Now Japan's electronics industry offers the real thing, in cellular phones that access the Internet, download music, transmit real-time video, and take high-definition digital photos. Japan is the world's most advanced cell phone market, and its high-tech companies are the world's top cell phone developers. It seems the field is limited only by the imagination of its engineers—and the speed of the electron.

TOP: Sony's interactive AIBO becomes a pet. **BOTTOM LEFT:** A musical robot from Toyota uses artificial lips to play the trumpet. **BOTTOM RIGHT:** Blue light-emitting diodes are a major technological innovation. **FAR RIGHT:** Neutrino-sensing facility called Kamiokande.

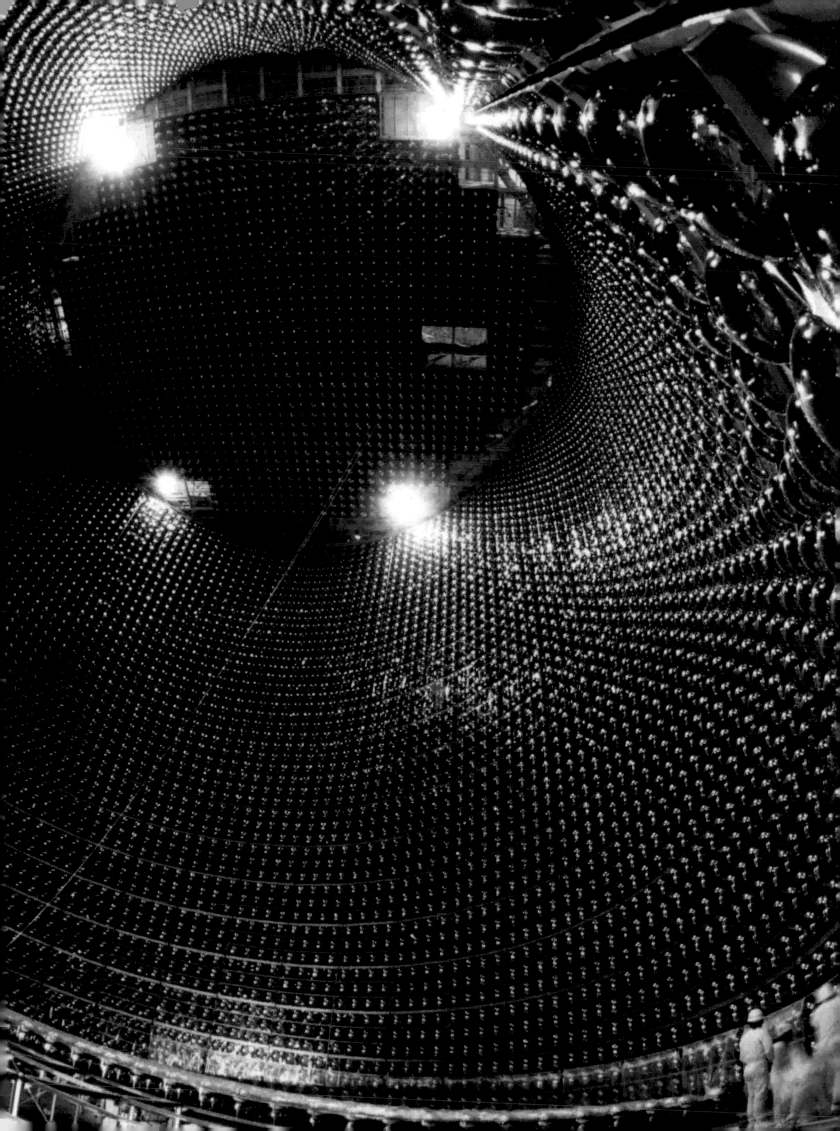

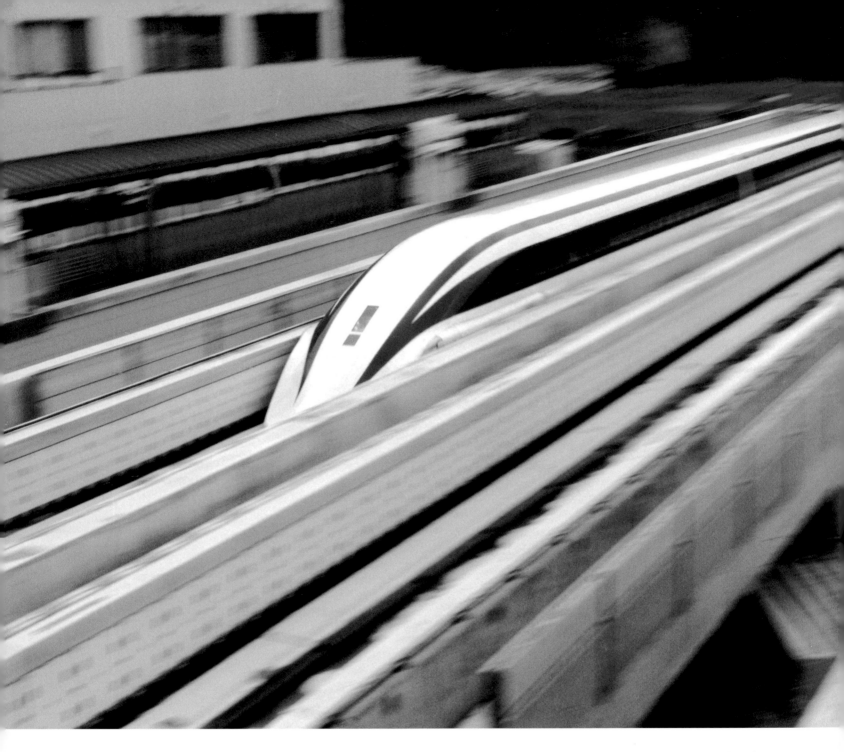

The MLX01 experimental Maglev train.

Science in Japan is much more than gadgetry, however. For example, the elusive neutrino was detected in the 1950s, but its properties remained a mystery. Researchers in Japan created a giant neutrino detector in an abandoned mine, where they have now successfully observed a distinctive pattern of neutrino oscillation. Masatoshi Koshiba received the Nobel Prize for physics in 2002, partly for his work with neutrino detection in the Kamioka mine.

In 1964, Japan astounded the world with its Shinkansen bullet train, with speeds topping 250 km/h. Now the MLX01, a magnetically levitated train, has set the world speed record of 550 km/h, exceeding France's TGV Atlantique's record of 515 km/h. Although not greatly faster than the conventional rail-based Atlantique, the "Maglev" represents new technology that allows a train to race between cities without touching the ground, levitated by magnetic power.

PART III

LAND AND OCEAN

The Japanese archipelago forms a crescent off the east coast of the Asian continent, with four main islands—Hokkaido, Honshu, Shikoku, and Kyushu—and several thousand smaller islands and islets. Japan also includes other island chains such as Izu, Ogawasara (Bonin), and Okinawa. Although its area matches the U.S. state of Montana, Japan stretches from a subtropical twenty-four degrees to a subarctic forty-five degrees north latitude—the same range as from the state of Florida on the east coast of North America all the way up to Nova Scotia in Canada.

Around seventy-five percent of Japan's land area comprises steep mountains, and habitable land is thus at a premium. Most of the population of 128 million is densely concentrated on the plains and in coastal areas, where extensive land reclamation projects have taken place over the centuries. Dikes, drainage, and landfill created land out of river deltas, inlets, and bays, and terracing made rice paddies on the sides of hills and mountains. The process continues, with artificial islands providing space for international airports in Tokyo Bay, Osaka Bay, and Ise Bay, and reclaimed areas turning into highrise urban centers in the country's major cities.

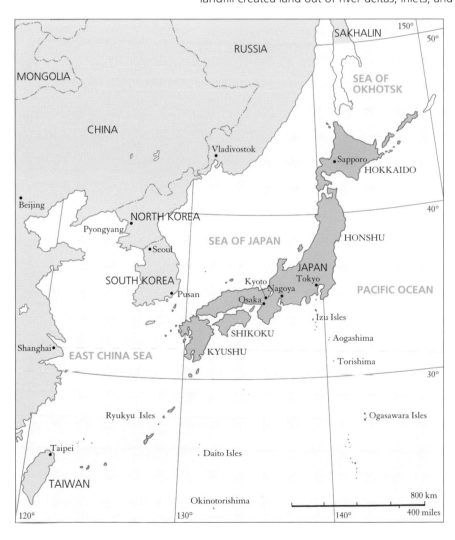

The mountainous islands, which include peaks that, like Mt. Fuji, exceed 12,000 feet in altitude, are actually the summits of huge ridges uplifted by three continental plates smashing together. The ongoing activity of the continental plates makes Japan one of the world's most earthquake-prone countries, with as many as 1,500 quakes recorded per year. Quakes with magnitudes of four to six on the Richter scale are not uncommon, but devastating major earthquakes occur infrequently. The most famous temblor of the twentieth century was the 1923 Great Kanto Earthquake, in which over 100,000 Tokyo residents lost their lives, and more recently the Hanshin-Awaji earthquake in 1995, which caused extensive damage and loss-of-life in Kobe. In addition, Japan's forty active volcanoes account for ten percent of the world's total, while another 148 in the country lie dormant.

Two major ocean currents influence the Japanese islands: the cold Oyashio current from the north Pacific and the warm Kuroshio current from the south. The Kuroshio current warms Japan's entire Pacific coast and splits to feed the weaker Tsushima current in the Sea of Japan. The Kuroshio carries many of the larvae and fry that grow into harvestable fish and other marine creatures in Japanese waters, providing much of the five million metric ton catch by domestic fishermen each year.

CLIMATE

Japan is a country of distinct seasons, and its citizens celebrate them exuberantly. The Japanese archipelago spans several climatic zones, and its position between the Pacific Ocean and the Eurasian continent causes dramatic shifts in weather as continental air masses dominate the winter and Pacific highs control the summer.

Springtime brings revelry across Japan, as the winter freeze eases and trees begin to flower. Next to Mt. Fuji, Japan's most famous symbol is probably the cherry blossom. In spring, national TV networks trace the cherry blossom front as it moves northward, giving a daily account of where the blossoms are coming out and to what degree the flowers have opened, thereby predicting the perfect timing for *hanami* flower-viewing parties.

After the sunny days of May, the country pulls out its gumboots and umbrellas for the rainy season. *Tsuyu* generally lasts from mid-June to mid-July, although the season is shorter in Okinawa and Hokkaido has none at all. As soon as the clouds lift, people head for the beaches as the hot, humid days of summer last from mid-July through August and sometimes into September. The summer fun can be interrupted by air-mass thunderstorms that hit rather suddenly with magnificent displays of pyrotechnics. More temperate Hokkaido is a popular summer holiday escape from the suffocating temperatures of Kanto and Kansai. Late August and September see typhoons roar up from the Marianas to pelt Japan with heavy rains and sometimes destructive winds.

The cooler weather of October brings another front—the changing colors of autumn leaves, which TV networks monitor as they do the cherry blossoms. Japanese festivals are related to the agricultural calendar, making fall a season of festivals giving thanks for the harvest. As the reds and yellows of autumn leaves move slowly southward, the festivals begin in the northern part of the country in early fall and reach a high point with Kyoto's Arashiyama Maple Festival in November.

Japanese celebrate winter, too. Monsoon winds from Siberia bring winter snow to Japan, piling it up on the Sea of Japan coast, in the Japan Alps, and in Hokkaido. There are more ski resorts per capita here than in any other country, and Japan has already hosted two Winter Olympics, one in Sapporo and one in Nagano. The peak of winter festivities, however, is the New Year season, when families get together and visit their local shrine to wish for a good year.

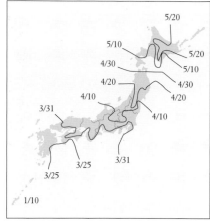

Example of a map showing the cherry blossom front.

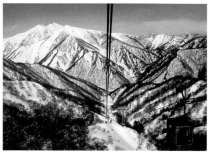

The popular ski resort of Tanigawadake Tenjindaira (Gunma prefecture).

HISTORY

Archeologists say humans have inhabited Japan for some thirty thousand years, but the Jomon period (10,000–300 B.C.) is the first in which we get a sense of history. The Jomon people were hunters, gatherers, and rudimentary farmers who left village sites, tools, graves, and rope-patterned coil pottery to mark their passing. It is said that during this period, Emperor Jimmu, descendent of Amaterasu Omikami, the Shinto sun goddess, founded an empire, and the current imperial family traces its lineage to him.

The subsequent Yayoi period (300 B.C.–A.D. 300) brought rice cultivation, metalworking, and wheel-thrown pottery, while clans made strides toward becoming a nation.

Around A.D. 300, political power concentrated in the Yamato court, which unified Japan for the first time and is distinguished by the huge tombs built for its rulers. There is evidence of influence from Korea and China, and the arrival of Buddhism from the mainland in 552 is documented. Although the Emperor served as head of the indigenous Shinto belief, the regent Shotoku Taishi (574–622) threw the weight of his office behind the new religion, which was adopted in syncretism with Shinto. Shotoku also strived to mold government and society after Chinese patterns, and created Japan's first constitution in 604.

The next 150 years saw a wave of reforms aimed at strengthening the emperor's power. However, Buddhist monasteries in the capital of Nara became increasingly powerful politically, prompting the imperial court to establish a new capital in Heiankyo (now Kyoto), marking the beginning of the Heian period (794–1185).

An extended period of peace led to a flowering of culture in Heiankyo, in which the arts flourished. While Chinese was the written language of government, a simplified kana syllabary enabled the court ladies to write poetry and stories—including Lady Murasaki's *Tale of Genji*. However, while the nobles of the capital neglected government of the regions, the power of local clans increased. This culminated in the Genpei War, which resulted in the establishment of Japan's first military government under shogun Minamoto no Yoritomo in 1192. He moved the seat of government to Kamakura, a quiet town in eastern Japan, well away from the influence of the imperial court in Kyoto.

Late in the Kamakura shogunate, the flotillas of Kublai Khan attacked Kyushu, only to be repelled by a typhoon. Nevertheless, manpower and funds used to defend against the Mongols weakened the shogunate and eventually brought its downfall. Shogun Ashikaga Takauji moved his government to Kyoto's Muromachi district, where it ruled until the Onin War (1467–77) disintegrated central government and the nation

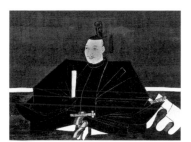
Portrait of Oda Nobunaga, 1583.

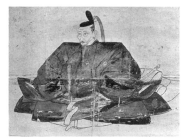
Toyotomi Hideyoshi, Momoyama period.

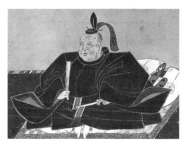
Tokugawa Ieyasu, Edo period.

degenerated into a period of civil war among powerful domains. During this time, Japan saw its first firearms introduced by the Portuguese, and Christianity introduced by Francis Xavier.

A century of civil war finally brought three successive leaders who managed to unify the country. Oda Nobunaga started the process, followed by Toyotomi Hideyoshi. After Hideyoshi's death in 1598, Tokugawa Ieyasu defeated his rivals and eliminated Hideyoshi's heirs to become shogun. Ieyasu took his government to Edo (now Tokyo) and set up a system that stripped domain rulers of wealth and power, and which led to a period of peace and isolation that lasted nearly two and a half centuries. During this time, Christianity was outlawed, foreign trade was limited to Chinese and Dutch traders, and a rigid social hierarchy established samurai in the highest rank, followed by farmers, artisans, and merchants. Cities flourished, along with an affluent merchant class.

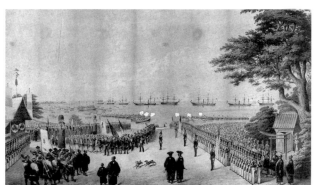
The arrival of Perry and his "black ships" in 1853.

Americans, British, and Russians began pushing Japan for trading rights and the shogunate was forced to agree when U.S. Commodore Matthew Perry arrived in 1853 with a fleet of steam frigates. The foreign influence weakened the shogunate and it was overthrown in favor of imperial restoration in 1868, with which the transition to modern nation-state began.

The new Meiji government eliminated the Edo-period class system, and strengthened the military as well as laid the foundations for an industrial state in order to catch up with the West. As a result, it became involved in the expansionist race among the advanced countries. Following victories against China in 1895 and Russia in 1905–6, during World War I and in the Taisho period (1912–26) Japan was accepted as an economic and military power. In the subsequent Showa period (1926–89), however, Japan's expansionism was met with trade and economic sanctions by leading Western nations, which led to further militarism. Japan's military leaders waged war on China, invaded Southeast Asia, and then sided with Germany and Italy in the Axis alliance in 1940. A Japanese attack on the U.S. fleet at Pearl Harbor brought the United States into the war, which was waged in both Europe and the Pacific. Japan surrendered after two nuclear bombs were dropped, one on Hiroshima and one on Nagasaki.

Western-style architecture appeared during the Meiji period.

Under the postwar American occupation, Japan demilitarized and conducted sweeping reforms. The emperor renounced divinity, and the government promulgated a new constitution, instituted democratic policies, and inaugurated a new education system. The economy burgeoned due to growth-oriented governmental policies and the high quality of manufactured products. Japan gained international prominence with the 1964 Olympics, Expo '70, and normalization of relations with China in 1972. High growth continued, turning Japan into the world's second largest economy.

Prince Akihito's succession to the throne in 1989 saw the start of the Heisei period. Almost immediately, the Gulf War broke out, and although Japan bore a large share of the cost, controversy arose over the fact that no Japanese personnel took part in the operation. Hot debate ensued within the country over what Japan's role should be in the international community. Japan seemed ready to take a more active role in international affairs, but there is widespread concern over changing the pacifist constitution to allow military participation in international conflicts.

LANGUAGE

No one knows exactly where the Japanese language originated. Some say it is related to extinct languages from Korea and Manchuria, while others claim that it is a mix of a core vocabulary of Austronesian applied to an Altaic grammatical structure. While there are regional dialects in Japanese, so-called standard Japanese is understood and spoken nationwide.

Japanese has a rich and varied vocabulary, drawing on three kinds of words: native words, the largest category; words created with combinations of kanji—the Chinese characters borrowed from China centuries past; and loan words from other languages, mostly English. The type of word used varies according to the situation. In magazines, for example, native Japanese words tend to predominate over kanji words, while major newspapers and formal documents tend to use mostly kanji words. This difference is also reflected in a predominance of kanji words in formal speech, with more native words in everyday conversation.

Traditionally, Japanese is written vertically and from right to left. Since the end of World War II, however, it has been more frequently written horizontally from left to right. Japanese had no writing system until the adoption of Chinese in the sixth century. Consequently the basis of written Japanese consists of the Chinese-based kanji characters, as well as two phonetic syllabaries derived from simplified kanji. In the past, tens of thousands of kanji were used, but in 1946 the government specified 1,850 characters as the minimum needed for everyday use. This list was updated to 1,945 characters in 1981. Part of the difficulty in reading and writing Japanese comes from multiple ways to pronounce a single character: most kanji have at least two pronunciations and some have a dozen or more. The two phonetic kana syllabaries cover the same sounds: hiragana is used in combination with kanji to provide inflection, and for some words, while katakana is used for foreign loan words and sometimes for emphasis.

One of the most difficult aspects for the beginner student of Japanese is the system of honorific language. In general, one speaks with different degrees of politeness depending on the social standing of the person being spoken to, the person's age relative to the speaker, the relationship to the speaker, and many other considerations. The system is difficult even for Japanese to master, and the government is proposing to publish guidelines on usage. Furthermore, men and women use different words, especially pronouns and final sentence particles, further complicating the spoken language.

EDUCATION

Schooling begins early for many Japanese children, who often start kindergarten at two years of age. At six, children enter primary school for six years, and go on to junior high school for an additional three years to complete compulsory education by the age of fifteen. During these years, all students in a particular grade level study the same material at the same time and the same pace, to standards set by the Ministry of Education. The following three years of high school are not compulsory, but over ninety-five percent of Japanese students attend and graduate.

Japan's high literacy rate, approaching ninety-nine percent, indicates the quality of education through high school, and is especially impressive considering that Japanese is one of the most difficult languages in the world to read and write. However, examinations are the foundation of the system after compulsory education. Admission to both high school and university is determined by competitive examinations, and performance in these exams can have a heavy impact on a student's social and economic future. Thus students put a great deal of effort into preparing for the tests. An entire shadow education system consisting of private tutors, *juku* cram schools, correspondence courses, and so on, helps students prepare. If a student fails the entrance exam to the university of choice, an alternative is to spend a year or more at a *yobiko* prep school, doing nothing but preparing for the next entrance exam.

The student who has graduated from a Japanese high school is said to have the level of education of an American student after two years of college. The university education, however, is seen as a relative weakness in Japan's education system, even though many programs, especially at graduate level, show high standards of achievement. After enduring stringent entrance exams, students often slack off during their university years, as they are virtually assured graduation, and Japanese employers base their hiring decisions on the prestige level of the school, rather than the grades of the student. That said, many large Japanese companies and government agencies provide their employees with excellent education and training, such as job rotation, required reading, qualification certification, and seminars.

Most Japanese adults continue to study throughout their lives. Reading is a popular pastime and Japan publishes nearly as many books per year as the United States, even though Japan has less than half the population. Also, many people study as a hobby, as they seek to gain competence in music, foreign languages, or painting, for instance, and cultural centers where the elderly can study new subjects are very popular.

MASS MEDIA

The mass media in Japan is a lively and potent force, reaching a broad spectrum of the population. The country's daily newspapers are at the center of massive media conglomerates that often include TV net-

works and a range of weekly and monthly magazines, as well as non-media businesses. Japan produces more newspapers per capita than any other nation in the world, with total circulation of dailies topping fifty million. The content of the dailies tends to be circumspect, reflecting establishment views—largely due to the exclusive press club system that controls access to government agencies, public figures, and industry organizations. The tabloids and sports papers, on the other hand, cater to the ordinary citizen's thirst for sensation, scandal, exposé, and rumor, and they account for nearly half of all newspapers sold in Japan.

Weekly magazines offer much the same content as the tabloid press, although the weeklies owned by newspaper conglomerates are said to print the backroom information that cannot be put in the dailies. These magazines target salarymen, who relish the behind-the-scenes stories, invariably alongside suggestive pictures of girls. They also brim with dirt and innuendo, and are frequently sued for breach of privacy. Other top-selling magazines providing gossip on celebrities, the royal family, and fashion are aimed mostly at women, teenagers and, increasingly, older citizens.

A phenomenon unique to Japan can be seen in the weekly manga publications, some of which are full book length. One manga weekly sells four million copies per issue, and indeed forty percent of all books and magazines sold in Japan are manga. They deal with a wide range of subject matter—both entertainment and educational—and are popular with people of all ages.

Television broadcasting is governed by the 1950 Broadcasting Law, which stipulates that channels must carry a certain level of cultural and educational programming in addition to popular news and entertainment programs. The Japan Broadcasting Corporation (NHK) is a public service organization financed largely by a public license fee and regulated by government legislation, and operates two channels featuring programs with content of a rather more serious nature than the other five commercial channels. Morning TV news programs tend to base programming content on the morning papers, and gain high viewer ratings, as do other information-based programs called "wide-shows," which vie with the sensationalist tabloid and sports press. Popular prime-time viewing includes comedy, chat shows featuring celebrities, and drama series.

FAMILY

Traditionally, the family has been at the heart of Japanese society. In the Meiji period, authorities codified the time-honored Confucianist system and made the patriarch of the family, or *ie*, legally responsible for all family members. The role of the members was strictly defined according to age, gender, and relationship to the patriarchal family head. Eldest sons, for example, were considered future heads of the family and ranked after the father but before younger brothers. Daughters were last as they were expected to marry and leave the household, and brides were lowest of all.

After World War II, laws passed by the Occupation authorities overturned the patriarchal law and defined marriage as a union between two consenting adults. The nation, however, still assumed that a woman's role lay in marriage and that they should be good wives and wise mothers. During these post-war years, the most desirable husband was a "salaryman"—a company employee—especially one of the minority with "lifetime" employment. The key to these plum jobs was education, so the wife and mother fulfilled an important role in corporate Japan in seeking the best possible education for her children. She also managed the household and its finances, and her husband was expected to work long and hard and turn his pay envelope over to her unopened.

After Japan's high-growth era moved into one of minimal growth and then economic stagnation, the so-called "new family" arrived as couples believed that husbands and wives should be companions and share interests. Then Japan signed the U.N. Declaration on Women and passed the 1986 Equal Employment Opportunity Law. Women began to marry later; birth rates fell; and "corporate warrior" men gained reputations as undesirable husbands and burdens in old age. In the more woman-friendly Japan of the early 1990s, women could be responsible for their own economic security, but combining a career with family was still problematic because companies expected total commitment from employees. In addition, Japan's rapidly aging society means that many women must care for elderly family members.

In today's Japan, more couples are divorcing after twenty or more years of marriage. Once the children are grown, mothers want to retire—from housekeeping, from looking after their husbands, from taking care of aged parents, from being a wife. Furthermore, with the children out on their own, a divorce on the family record can no longer harm their careers.

In the twenty-first century, a single desirable family model no longer exists. Instead, it has changed to a range of socially acceptable choices. Young people firmly reject many of the assumptions of the ruling generation and look for greater flexibility at work and in the home. As a nation, Japan must still find viable solutions to the problem of balancing child care and care for the elderly with careers.

NOTES TO THE PLATES

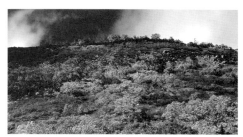

PAGES 6–7: Riotous autumn leaves at Daisetsuzan, Hokkaido. Autumn leaves are said to come earliest to Daisetsuzan, where layers of coniferous dark green combine with deciduous reds and yellows to turn the mountain into a symphony of fall colors. Daisetsuzan National Park features hot springs, gorges, and mountains, and attracts three million visitors annually.

PAGES 8–9: Terraced rice paddies at Doya, Nagasaki. Rice has been cultivated in Japan since the Yayoi period, and has historically had a major impact on the Japanese way of life. Wet rice cultivation is labor intensive, and families traditionally pooled labor and shared water resources and irrigation facilities. Many festivals celebrate planting or harvesting.

PAGE 10: Skyline at night in Odaiba, Tokyo. The globe-shaped observation deck on the twenty-fifth floor of the Fuji TV headquarters building, with its breathtaking view from one hundred meters above the ground, is a favorite of visitors to Odaiba. The entire area is built on reclaimed land, and has many cutting-edge examples of modern architecture.

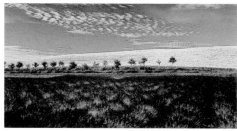

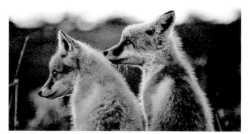

PAGE 11: Matsushima is one of Japan's top three scenic vistas. The scenery at Matsushima in Miyagi prefecture consists of over 260 small islands in Matsushima Bay, each distinctively weathered by wind and tides, and offering natural splendor and beauty that has been praised throughout history. Matsushima was a favorite of the famous haiku poet Matsuo Basho.

PAGES 12–13: Fields of lavender in Furano, Hokkaido. The lavender blooms from May through September with striking flowers ranging in color from blue, light purple, and pink to white, and its heady, intoxicating aroma is known to promote relaxation. As a crop, lavender is especially valued for its aromatic oil, and perfumeries pay well for top-grade lavender oil.

PAGE 14: Red foxes are native to Hokkaido. Red foxes often appear at rest areas in mountain passes and are most active in the early morning and evening. The natural habitat for many wild animals has deteriorated, and in recent years foxes have begun taking food from humans and making dens in populated areas.

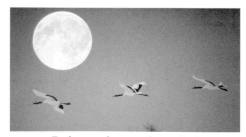

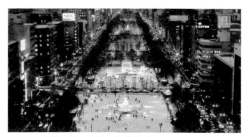

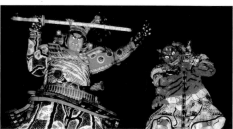

PAGE 14: Red-crested cranes beneath the moon at Kushiro, Hokkaido. Red-crested cranes are a native Japanese species. In the Edo period, they were found throughout Hokkaido and often came as far south as present-day Tokyo in winter. Now a protected species, some six hundred of the cranes live year round in the eastern flatlands of Hokkaido.

PAGE 15: The Snow Festival in Sapporo, Hokkaido. Every February, some two million people flock to Sapporo to see the hundreds of beautiful sculptures in snow and ice. The displays include full-size palaces—often accurate replicas of famous buildings—as well as ice sculptures of celebrities and hit anime characters such as Pikachu and Doraemon.

PAGE 16: Lighted figures in the Nebuta festival, Aomori prefecture. Said to have begun as giant figures built to frighten the enemy, wooden Nebuta floats are covered with colorfully painted paper and illuminated with hundreds of bulbs, and are paraded accompanied by drums, flutes, and dancers. Nebuta festivals are held every August in the cities of Aomori, Hirosaki, and Goshogawara.

PAGES 16–17: **Forest in the Shirakami mountain range, a World Heritage Site.** The Shirakami range, with summits around 4,000 feet (1,200 m), is home to over five hundred plant and eighty-seven bird species, as well as black bears and serows. It harbors the last remaining virgin cool-temperate Siebold's beech forest, which led to the region being declared a World Heritage Site.

PAGES 16–17: **Sanriku coastline, Iwate prefecture.** Cliffs over 650 feet (200 m) high stretch for 5 miles (8 km) along the coast from Kitayamazaki point in Tanohata, Iwate prefecture. From Kitayamazaki, 753 steps lead to the bottom and a hiking trail follows the base of the cliffs as far as Bentenzaki.

PAGES 17–18: **Tokyo, heart of Japan's urban culture.** Twenty-eight million people live within a 30-mile (48 km) radius of Nihonbashi, close to the Imperial Palace at the heart of the city. Tokyo is a dynamic center for commerce, fashion, and entertainment, and glimpses into its past as the shogun's capital can still be seen in some of its older districts.

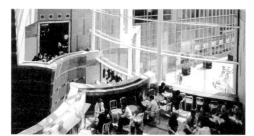

PAGE 20: **A relaxing tearoom in a highrise in Shiodome, Tokyo.** Caretta Shiodome is a multipurpose commercial building housing a range of gourmet restaurants, as well as theaters and other cultural facilities. Situated 650 feet (200 m) above ground, the building's penthouse restaurant and observation deck are especially popular.

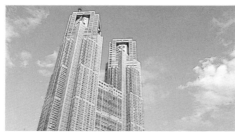

PAGE 20: **The Tokyo Metropolitan Government Office Building, Shinjuku, Tokyo.** The cathedral-like building designed by Japan's preeminent postwar architect, Kenzo Tange, features mammoth twin towers that soar 797 feet (243 m) above ground. Observation decks on the forty-fifth floor offer superb views of the city, reaching to Yokohama in the southwest and Mt. Fuji in the west.

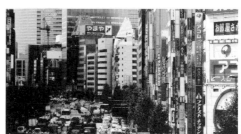

PAGE 21: **A forest of skyscrapers in Shinjuku.** The Shinjuku Park Towers loom from behind a plethora of offices, hotels, showrooms, and shops in downtown Shinjuku. The pyramid roofs of the towers set them off, and offices and a hotel fill the floors not occupied by restaurants and retail outlets.

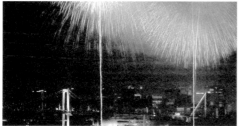

PAGES 22–23: **The Tokyo Bay Fireworks Festival.** The festival takes place in early August and lofts over twelve thousand aerial fireworks over the Tokyo Bay Area, filling the sky with starbursts, pinwheels, imaginative designs that include popular anime characters such as Doraemon, and ending with a Niagara Falls of fire.

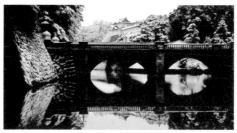

PAGE 24: **Nijubashi Bridge leads to the Imperial Palace, Tokyo.** The imperial court moved to Tokyo in 1868, occupying the site of the deposed shogun's castle. The two-arch bridge seen here has become known as Nijubashi, although this name originally belonged to a different bridge so named for its double structure with a top level resting on a lower level.

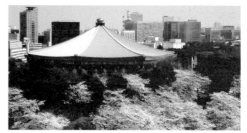

PAGE 24: **Cherry blossoms around the Budokan Hall, Tokyo.** The Imperial Palace is surrounded with over three hundred cherry trees that cover the area with billows of pink and white in late March to early April. The Budokan, built in 1964 to host the Olympic judo events, is in Kitanomaru Park in the northern reaches of the palace grounds.

PAGE 25: **Firemen demonstrate traditional skills on New Year's Day, Asakusa, Tokyo.** The annual *dezomeshiki* New Year's celebration of the fire brigades dates to 1659. Special events are held in many places around the city, at which firemen demonstrate the traditional skills and acrobatics that were highly valued in a city so vulnerable to fire.

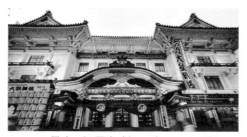

PAGE 25: **Tokyo's Kabuki-za theater in Ginza.** The Kabuki-za first opened in 1889, but was rebuilt in 1951 after being destroyed by firebombing in World War II. Kabuki was created in around 1603 by Okuni, a female shrine attendant, but is now performed entirely by male actors, with female roles played by specialist *onnagata* actors.

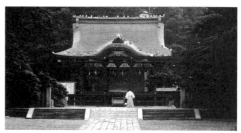

PAGE 26: **Kamakura's Tsurugaoka Hachimangu, a shrine dedicated to the Minamoto family.** The shrine traces its history to Minamoto Yoriyoshi, who established a Minamoto family shrine in Kamakura in 1063. When Minamoto no Yoritomo moved the seat of his military government to Kamakura, he relocated the family shrine to its present site and had the upper and lower shrine buildings constructed.

PAGES 26–27: **Meigetsuin temple in Kamakura is famous for hydrangeas and irises.** With more than two thousand hydrangeas on its grounds, Meigetsuin is also referred to as Ajisaidera—the hydrangea temple—and its gardens turn shades of lavender and purple during the rainy season. The temple was founded in 1160.

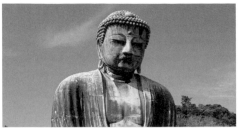

PAGE 27: **The Kamakura Daibutsu, the second largest statue of Buddha in Japan.** The statue is 36 feet (11m) tall and weighs 124 tons. Construction began in 1252, and it was originally covered in gold leaf. The great Buddha was once housed in a huge building, but since 1495 it has remained in the open air.

PAGE 27: **Kamakura-bori lacquerware.** These wooden items are first carved, then lacquered. The technique traces its roots to the Kamakura period when Zen monks brought similar items back from China. Originally used in Buddhist ceremonies, Kamakura-bori ware found its way into the tea ceremony in the Muromachi period and now graces the home.

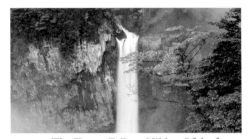

PAGE 28: **The Kegon Falls at Nikko.** Of the forty-eight waterfalls in Nikko National Park, the most famous is Kegon-no-taki, which is 23 feet (7 m) wide and drops 318 feet (97 m). Two lovers jumped to their deaths here, and local superstition says photos of the falls may show the lovers' faces in the mists.

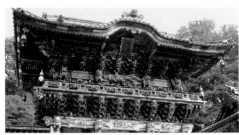

PAGE 29: **Toshogu, Tokugawa Ieyasu's mausoleum and shrine at Nikko.** This splendid group of buildings, lavish with gilded and polychromed carvings—including the "see no evil, hear no evil, speak no evil" monkey trio detail shown—were constructed at tremendous cost to the daimyo lords, a deliberate attempt by the shogun to reduce their power and impose his control. Eight of the buildings are National Treasures.

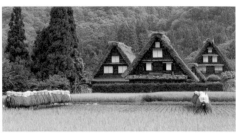

PAGES 30–31: **Traditional *minka* thatched homes in Shirakawa, Gifu prefecture.** The villages of Shirakawa and Gokayama consist mostly of *gassho-zukuri* farmhouses with steep-sided thatched A-frame gable roofs adapted to the snowy climate. The entire village assists in rethatching the houses, from planting and mowing the grasses to the thatching work itself.

PAGES 32–33: **Frost on bare pines in the northern Japan Alps.** Mountaineers find the northern Japan Alps a challenge and a joy with breathtaking vistas. The Chubu Sangaku National Park is the starting point for an assault on such peaks as Hotakadake, and serves as a cool respite from the summer heat for other visitors.

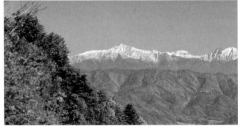

PAGES 32–33: **Kasagatake peak and an alpine ridge in the northern Japan Alps.** At 9,508 feet (2,897 m), Kasagatake is not the highest peak in the northern Alps, but is popular with hikers who enjoy the mountain hut near its summit. The ridges and peaks of the Alps offer challenging trails and wonderful views.

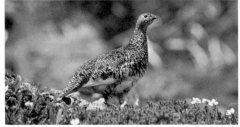

PAGE 33: **Rock ptarmigan live in the Alps.** Japan's rock ptarmigan *Lagopus mutus japonicus* lives mainly in the high rocky slopes above 7,850 feet (2,400 m). The birds keep to the cover of creeping pines to avoid eagles and hawks. Rock ptarmigans turn white in winter, and tend to mate for life.

PAGE 34: **Merchant Yoshijima's home in Takayama, Gifu prefecture.** Designated a National Important Cultural Treasure, the Yoshijima house was built in 1908 with traditional pillar-and-beam construction. It is noted for its lavish use of wood with rooms that are open to the roof, and lit by sunlight through a high window.

PAGE 35: **Takayama strives to maintain its traditional atmosphere.** Takayama was originally a castle town ruled directly by the shogunate in Edo. A traditional aura remains, apparent in the latticed bay windows and linked eaves of merchants' houses as well as the city's many temples and shrines. The famed Takayama festival features huge floats with *karakuri ningyo* clockwork manikins.

PAGE 35: **A Gifu paper lantern.** The history of Gifu paper lanterns stretches back three hundred years, and they are known for their grace and beauty. The lanterns have been officially designated as a traditional craft by the Ministry of Economy, Trade, and Industry.

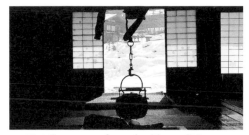

PAGE 35: **Snowscene from the *hiroma* living space of a traditional Takayama farmhouse.** Traditional farmhouses at Hida-no-Sato in Takayama feature a large room called the *hiroma*. At the center is the *irori* sunken fireplace, where the family and guests gather for meals, conversation, or tea. The iron kettle hangs ready over the charcoal fire.

PAGE 36: **Kanazawa roof tiles are slick-glazed so snow will slide off.** Tiled roofs became the norm in Kanazawa about one hundred years ago, after the Hokuriku Railway was constructed and steam engines blew cinders over the houses along the tracks. Noncombustible tiles gained favor, and residents also found that snow readily slid off the slick black surfaces.

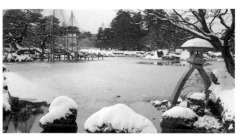

PAGE 37: ***Yukitsuri* support tree branches in the snowy Kenrokuen garden.** Kenrokuen is one of the top three celebrated Japanese gardens, ranked with Kairakuen in Mito and Korakuen in Okayama. The 25-acre garden offers vistas that change with the seasons, and as winter approaches, the gardeners set up *yukitsuri* rope supports that keep pine branches from breaking under heavy snows.

PAGE 37: **Kanazawa is famous for gold leaf.** Gold leaf was used at Kinkakuji—the temple of the Golden Pavilion—in Kyoto, and at Toshogu in Nikko. It is also used on lacquerware, Buddhist altars, Kutani porcelain, and other traditional arts. Over ninety-eight percent of Japan's gold leaf is produced in Kanazawa.

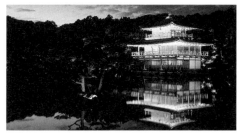

PAGES 38–39: **The temple of the Golden Pavilion in Kyoto.** The Golden Pavilion and the pond of Shogun Ashikaga Yoshimitsu's retirement villa portrayed Buddhist Paradise. Later part of a Buddhist temple called Rokuonji, the pavilion survived for centuries only to fall to arson. Yukio Mishima immortalized the story of the university student who set the fire. The pavilion was rebuilt in 1955.

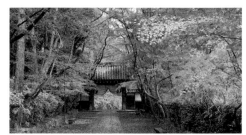

PAGE 40: **Brilliant maples at Komyoji, Kyoto.** Ryochu, disciple of Honen, the founder of the Jodo sect of Buddhism, founded Komyoji temple, the home of the Nishiyama Jodo sect, in 1198. The stone steps are called the "maple approach," and the red leaves of the maples in autumn are a marvelous sight.

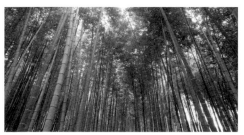

PAGE 41: **Sagano, Kyoto, is famous for its beautiful bamboo forest.** Bamboo has many uses from everyday utilitarian objects to artistic craft products. Sagano was a common place of exile for the victims of political conflicts in Kyoto, and thus has a reputation of being filled with sadness and a longing for the more flamboyant life of the capital.

PAGE 42: **Saihoji is also known as *Kokedera*, the moss temple.** The Rinzai sect temple was built 1,300 years ago on orders from Emperor Shomu, and its famous garden was created by Muso Soseki in 1339. Merely viewing the garden was a point of pride in Kyoto society then, and even today it can only be seen by appointment.

PAGE 43: **Elaborate Kyoto embroidery.** Shishu embroidery originated in China and came to Japan via Korean artisans. In the early Heian period embroidery was used to decorate the clothing of court ladies and was available only to a select group of the highest social ranking. Today, of course, Kyoto embroidery can be enjoyed by all.

PAGE 43: **Traditional sweets.** *Kyogashi* confections were developed for the traditional tea culture, which flourished first in Kyoto. The flavors harmonize with the teas used in the ceremony—rich, moist confections complement full-bodied *koicha*, while the modest-flavored dry confections shown here go best with the lighter *usucha*.

PAGE 43: ***Ogi* fans used in traditional dance.** Originally these folding fans were popular among Kyoto court nobles, who favored elegant designs. In the fourteenth century, the fans evolved to match stately Noh and *buyo* dance, and later a smaller fan was used for the tea ceremony. Exported *ogi* fans were prized by the Bourbon dynasty of France.

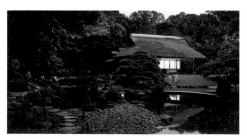

PAGES 44–45: **Kyoto's Katsura Detached Palace at night.** The Katsura Detached Palace—built in 1645 by Prince Toshihito—is beautiful in its simplicity, and is considered the finest example of Japanese architecture and garden design. Almost every room looks out upon the stroll garden, which offers stone bridges and lanterns, ponds, and manicured trees.

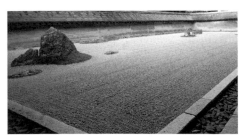

PAGE 46: **The famous Zen dry landscape garden at Ryoanji temple, Kyoto.** Many believe that Soami (1455–1525), a leading *suibokuga* ink painting artist, created the garden in 1499. The flowing lines and patterns in the white gravel, the stillness of the rocks, and the plain brown of the earthen wall on three sides create both tension and tranquillity.

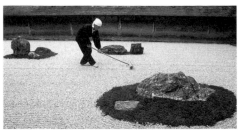

PAGE 46: **A monk tends Ryoanji's dry garden.** Zen dry gardens are designed to aid meditation and contemplation. Ryoanji's garden, with fifteen rocks arranged in five "island" groupings in a sea of white, carefully raked gravel, is one of the most famous examples.

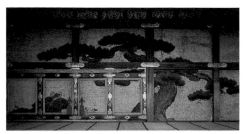

PAGE 47: **Wall painting of a pine tree in Nijo castle, Kyoto.** Tokugawa Ieyasu completed the Ninomaru compound in 1603, and his grandson Iemitsu later enlarged it. An excellent example of Momoyama architecture, Ninomaru is a UNESCO World Heritage Site. The mighty pine tree is attributed to Kano Tan'yu (1602–74), official painter to the shogun, or a member of his studio.

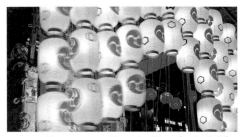

PAGE 48: **Lanterns at Kyoto's Gion festival.** The Gion festival begins July 2 when *mikoshi* (portable shrines) are blessed. On July 10, the *mikoshi* are taken to Kamogawa River, purified, and carried back to Yasaka shrine. That evening, three *mikoshi*, accompanied by lanterns on long poles, go to City Hall to kick off the festival.

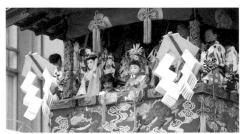

PAGE 48: **Huge floats take part in the Gion festival parade.** The Gion festival originated with a procession through Kyoto to petition the gods to end the epidemic of 869. The plague subsided, and the festival has been held annually ever since. The main parade of thirty-two festival floats occurs on July 17.

PAGE 49: **Tatsumibashi Bridge in Shirakawa, Gion.** The Shirakawa area of Kyoto offers an exquisite traditional atmosphere reminiscent of the "floating world" of the pleasure quarters it once was, and near the Tatsumi shrine there is always a chance to see some *maiko* apprentice geisha.

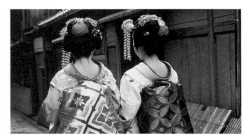

PAGE 49: *Maiko* **apprentice geisha in Kyoto.** *Maiko* are adopted by a teahouse and an older geisha teaches them the craft, such as how to hold their fans and how to walk, during a training period of about five years. *Maiko* wear a bright kimono with long sleeves and an *obi* sash that hangs to the ankles.

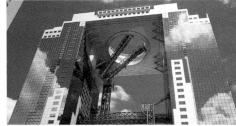

PAGE 50: **Umeda Sky Building, a forty-story skyscraper in Osaka.** The original design competition was for several towers joined at the top, though due to the prohibitive cost contractors argued for separate towers. Finally, however, Hiroshi Hara's winning design was completed in 1993 with two towers connected by the Floating Garden Observatory on the thirty-ninth floor.

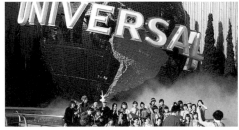

PAGE 51: **Universal Studios Japan theme park, Osaka.** Universal's first theme park outside the United States opened in Osaka in March 2001. It occupies 140 acres and offers eighteen high-tech attractions that allow visitors to relive famous movies such as *Jaws* and *Jurassic Park*. Universal Studios Japan offers rides and attractions unavailable at other Universal Studios locations.

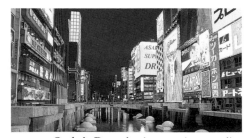

PAGE 51: **Osaka's Dotonbori entertainment district.** Dotonbori—the symbol of Osaka—lines the canal of the same name, and is famous for restaurants and amusement facilities. In addition to eateries and drinkeries, theaters offer Bunraku plays, storyteller halls put on slapstick *manzai* comedy, and cinemas play the latest hits.

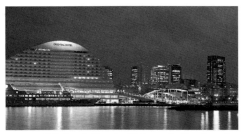

PAGE 51: **Night skyline in Kobe, rebuilt after the 1995 quake.** After Japan's centuries of isolation, Kobe became an open port in 1867. Kobe Port Tower opened in 1963 to celebrate the port's ninetieth anniversary, and Meriken Park (seen in this photo) and the Kobe Maritime Museum first opened in 1987 to commemorate its 120th anniversary.

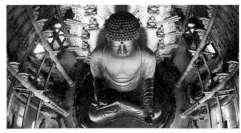

PAGES 52–53: **Japan's largest statue of Buddha in Todaiji temple, Nara.** Construction of Todaiji began in 743, ordered by Emperor Shomu. The temple's best-known relic is its 52-foot (16 m) Daibutsu, the world's largest gilded bronze of the seated Buddha. The 157-foot (48 m) high building housing the statue is the largest wooden building in the world.

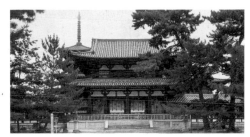

PAGE 54: **Chumon Gate of the Horyuji temple in Nara.** Completed in 607, Horyuji includes some of the world's oldest wooden structures and offers a glimpse of Japan as it was over 1,300 years ago. Today, Horyuji houses almost two hundred National Treasures or Important Cultural Properties. Listed in 1993, Horyuji was among Japan's first UNESCO World Heritage Sites.

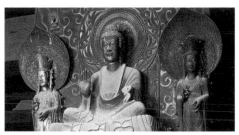

PAGE 54: **The Shaka Triad of Horyuji temple.** The Shaka Triad is typical of early Buddhist sculpture in Japan, and was created by the sculptor Tori Busshi during the reign of Empress Suiko to pray for the recovery of Shotoku Taishi. The triad's smiling faces, double pedestal, flat presentation, and large halo reflect Northern Wei Dynasty influence.

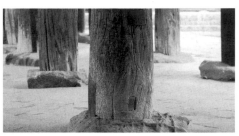

PAGE 55: **Pillars at Horyuji, the world's oldest wooden structure.** The pillars date back some 1,400 years, part of the oldest wooden building in the world. Horyuji is the only complete temple surviving from the early seventh century, soon after Buddhism entered Japan. It is associated with Shotoku Taishi, who was highly instrumental in Buddhism gaining a foothold in this country.

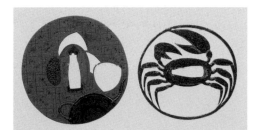

PAGE 56: **Sword guards: a crab (sixteenth century) and hand drum motif (eighteenth century).** *Tsuba* guards protect the hand and help to balance the sword. During the peaceful times of the Edo period, samurai became bureaucrats and decorative sword guards gained importance. Most antique *tsuba* admired today were made in the Momoyama and Edo periods.

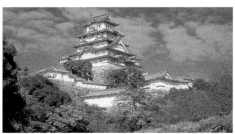

PAGES 56–57: **The splendid gabled donjon of Himeji castle.** Himeji is the best-preserved example of medieval Japanese castle architecture. It was originally built in 1346, and reconstruction work beginning in 1601 included a five-storied donjon and middle and outer moats. A National Treasure, Himeji castle was made a UNESCO World Heritage Site in 1993.

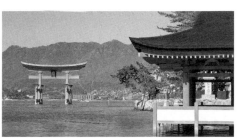

PAGES 58–59: **The red torii gate at Miyajima, near Hiroshima.** This grand torii rises from the sea in front of Itsukushima shrine. The camphor wood gate was completed in July 1875, the eighth one built there since the Heian period. The torii stands 698 feet (213 m) from the main hall, which is also in the sea.

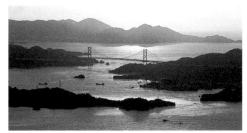

PAGES 60–61: **The Innoshima Bridge in the Inland Sea.** Begun in 1977 and completed in 1983, Innoshima Bridge stretches just under a mile (1.3 km), with suspension towers 476 feet (145 m) high, making it the longest suspension bridge in Asia. A pedestrian and bicycle corridor occupies the bridge's lower level with a highway on the upper.

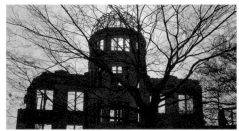

PAGE 61: **The A-bomb Dome, near the hypocenter of the 1945 blast.** The atomic bomb destroyed 70,000 buildings and 80,000 people in under a second, and a further 60,000 people died of its effects over the next few months. The twisted shell of the building now known as the A-bomb Dome is preserved as a reminder of the horror and suffering.

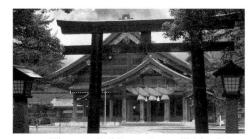

PAGE 62: **The main building at Izumo Taisha shrine.** Izumo Taisha is one of Japan's oldest and most important Shinto shrines. Originally much larger, the 79-foot (25 m) main shrine was rebuilt in 1744, with unique *taisha* architecture that is similar to ancient houses. A *shimenawa* ceremonial rope weighing some 3,300 pounds (1,500 kg) decorates the main entrance.

PAGE 62: **Traditional *washi* paper.** Handmade Sekishu *washi* is high-quality unbleached paper made of mulberry, *mitsumata*, or wild *gampi* from Tsuwano in Shimane prefecture. Once a side business to supplement farmers' income, *washi* production supported the area economy at one time, and historical records show a papermaking tradition dating back at least thirteen centuries.

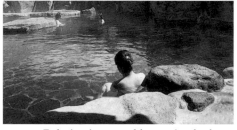

PAGE 63: **Relaxing in natural hot spring baths at Yufuin, Kyushu.** Yufuin is a well-known beauty spot with natural lakes, early morning mists, and abundant supplies of naturally hot spring water that have made it popular as a health resort. Several centuries-old Christian cemeteries provide testimony of Kyushu's past as the center of Christian activity in Japan in the sixteenth century.

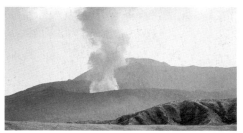

PAGE 63: **Live volcano on Mt. Aso in Kyushu.** Located in the Aso-Kuju National Park, Mt. Aso's outer caldera is the world's largest, measuring 11 miles (18 km) by 15 miles (24 km). Of its five peaks, Mt. Naka, at 4,984 feet (1,520 m), is still active and most recently erupted in 1979.

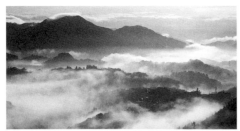

PAGE 63: **Takachiho in Kyushu is known as the town of myth and legend.** Legend says the grandson of Sun Goddess Amaterasu descended to Mt. Takachiho with the imperial Regalia. Takachiho is also where Amaterasu herself is said to have hidden in a cave, and the Yokagura festival commemorates the dance that lured Amaterasu out and brought light into the world once more.

PAGES 64–65: **An ancient cedar on Yakushima island, Kagoshima prefecture.** These huge natural cedars are unique to the island. Trails lead hikers to several of these ancient behemoths, the most famous of which is the five-thousand-year-old Jomon-sugi that stands 83 feet (25.3 m) tall, with a trunk 56 feet (16.2 m) in circumference.

PAGE 65: **The Yakushima island rainforest.** Twenty-one percent of Yakushima island is World Heritage territory, of which ninety-six percent is natural subtropical rain forest. The island claims more than forty peaks over 3,280 feet (1,000 m) high, and is home to several endemic and endangered species of plants and animals.

PAGE 66: **Shurei-mon Gate at sunset, Okinawa.** The Shurei-mon gate is attributed to the fourth Ryukyu king (1527–55). It was designated a national treasure in 1933, together with the Kankai-mon and the Zuisen-mon gates. However, these were all destroyed during World War II, and the Shurei-mon was reconstructed in 1958.

PAGE 66: **Okinawan *bingata* textile.** *Bingata* dyed textiles were among the most famous products of the ancient Ryukyu kingdom. The bold patterns using bright red, yellow, brown, blue, and green colors are applied in a form of resist dyeing using *nori* starch. *Bingata* dyeing continues as a traditional art in Okinawa today.

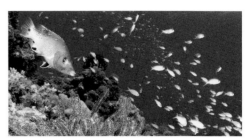

PAGE 66: **Underwater scene in Okinawa shows sea feather and reef fish.** In eons past, calcium carbonate secreted by coral polyps became Ryukyu limestone, which comprises much of the Okinawa, Miyakojima, and the Yaeyama islands. Okinawan waters harbor more than two hundred species of coral, which are vital to the health of local marine ecologies.

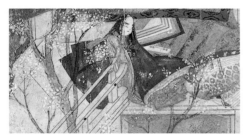

PAGE 67: **Scene from *The Tale of Genji* narrative handscroll, early twelfth century.** Designated a National Treasure, the picture scroll of the early eleventh-century romantic novel written by Murasaki Shikibu, a lady of the Heian court, is the oldest of the surviving handscrolls that portray scenes from the novel.

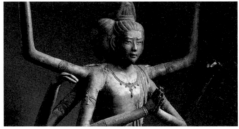

PAGE 68: **Statue of Ashura in Kofukuji temple, eighth century.** Ashura is one of the eight guardians of Buddha. In this beautiful painted dry lacquer sculpture, which is housed in Kofukuji temple in Nara, the front face has a peaceful, serene expression, while the other two faces show fiercer, warrior-like aspects.

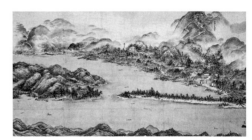

PAGE 68: **Amanohashidate, an ink and light color landscape by Sesshu Toyo, late fifteenth century.** The work depicts an actual Japanese landscape rather than an imaginary Chinese one. Amanohashidate, a sandbar in Wakasa Bay, Kyoto prefecture, was renowned for gnarled pines and a graceful sweeping shape, and is one of the three famous scenic views in Japan.

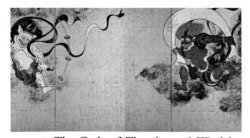

PAGE 69: **The Gods of Thunder and Wind by Tawaraya Sotatsu, early seventeenth century.** This pair of folding screens in ink and color on gold-foiled paper is designated a National Treasure and is housed in the Kenninji temple in Kyoto. The dynamic images were later copied by the Rinpa artists Ogata Korin and Sakai Hoitsu.

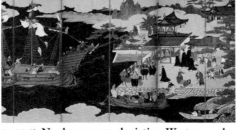

PAGE 69: **Nanban screen depicting Westerners by Kano Sanraku, early seventeenth century.** This right-hand screen of a pair said to be by Kano Sanraku seems to reflect the 1613 edict of the Tokugawa shogunate that banned Christianity. Foreign captains can no longer expect ostentatious sendoffs, the churches are closed, and the friars are limited to very small holy relics.

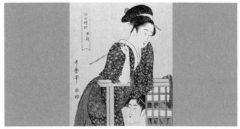

PAGE 70: **Ukiyo-e of young women by Kitagawa Utamaro, late eighteenth century.** Kitagawa Utamaro (1753–1806) is one of the most famous *ukiyo-e* artists, and is best known for his woodblock prints of beautiful women. While courtesans were his favorite subjects, he also created portraits of street prostitutes, teahouse waitresses, geisha, and housewives.

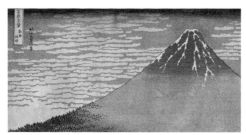

PAGE 70: **Red Fuji by Katsushika Hokusai, c. 1831.** The two masters of *ukiyo-e* landscapes, Katsushika Hokusai (1760–1849) and Ando Hiroshige (1797–1858) incorporated Western perspective to add depth to their stylized landscapes. This famous image is one of Hokusai's celebrated series of prints entitled *Thirty-six Views of Mt. Fuji.*

PAGE 71: ***Yuzen*-dyed *furisode* kimono, eighteenth century.** *Yuzen* dyeing was originated by the fan painter Miyazaki Yuzen in the late seventeenth century and marked the first major change in kimono design since the Heian period. The technique permits superior color stability and water resistance, and enables intricate designs with thin, precise lines and beautiful color blurring.

PAGE 71: **Lacquerware saké pitcher with chrysanthemum motif, late sixteenth century.** Kodaiji *maki-e*—a style of *maki*-e named after the temple—is one of the largest and most ornate categories of lacquerware from the Momoyama period. Designs were drawn directly onto raw black lacquer without an underdrawing, then sprinkled with gold or silver powder, and polished.

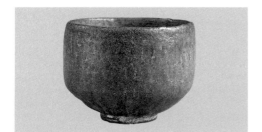

PAGE 71: **Red Raku teabowl by Chojiro, late sixteenth century.** Raku ware is thrown without a potter's wheel, either by hand or with a form, and fired at low temperatures in a small kiln, usually indoors. Chojiro was the first Raku potter, gaining repute in the Momoyama period, and it is said his craft was under the direction of the tea master Sen no Rikyu.

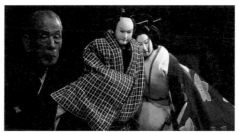

PAGE 72: **From the Bunraku play *Sonezaki Shinju* ("Love Suicides at Sonezaki").** The lovers Ohatsu and Tokubei prepare to commit suicide in the Tenjin Forest in this celebrated play by Chikamatsu Monzaemon. Tokubei (left) is operated by Yoshida Tamao, and Ohatsu by Yoshida Minosuke, in a performance at the National Theater in Tokyo.

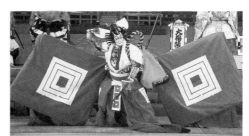

PAGE 72: **From the Kabuki play *Shibaraku* ("Wait a Moment!").** This much-loved *aragoto* play features the larger-than-life superhero Kamakura Gongoro, resplendent in fearsome *kumadori* makeup and fantastic costume. Gongoro is played here by Ichikawa Danjuro XII at the Kabuki-za in Tokyo, shown striking the famous *mie* pose with eyes crossed at the climax of the play.

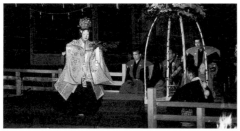

PAGE 73: **From the Noh play *Kazuraki*.** The goddess of Mt. Kazuraki dances to express her joy at having been set free by the prayers of a wandering ascetic. This is a *takigi* performance—a Noh play held outdoors at night by torchlight—with the goddess portrayed by Kanze Tetsunojo VIII.

PAGE 74: **Ladle positioned properly for the tea ceremony.** According to the sixteenth-century tea master Sen no Rikyu, the Way of Tea essentially concerns the activities of everyday life, yet requires great concentration and cultivation to master. In other words, the Way of Tea amounts to the Art of Living.

PAGE 75: **Ceremonial whisk, tea scoop, and teabowl ready for use.** Before laying out the utensils properly, the host symbolically wipes the tea container and the tea scoop with a silk *fukusa* cloth. As the guests look on, the tea whisk and teabowl are carefully rinsed and then the *macha* tea is whisked with hot water and offered to each guest in turn.

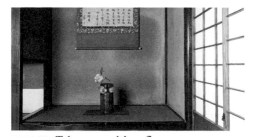

PAGE 75: ***Tokonoma* with a flower arrangement and hanging scroll.** During the tea ceremony the guests are seated so that they may enjoy viewing the *tokonoma* alcove while the host serves the tea. The *tokonoma* is decorated with a flower arrangement and a hanging scroll, which sets the scene and provides the theme for the tea ceremony.

PAGE 76: **Snowflowers and hawthorn in a white ceramic jar.** This arrangement is by the ikebana master Toshiro Kawase. Kawase was born in Kyoto in 1948. After graduating from art college in Tokyo, he toured Europe studying drama and motion picture arts. On his return to Japan, he began exploring images of Japan through ikebana flower arranging.

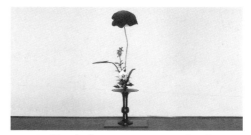

PAGE 76: **Simple flower arrangement in a bronze vase.** By Toshiro Kawase. It is said that the flowers in an ikebana arrangement express the idealism and beauty felt by the arranger. The vessel and stand are as much part of the arrangement as the flowers, and one should view the whole with feelings of gratitude toward the arranger.

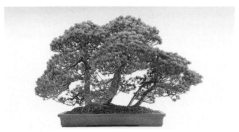

PAGE 76: **Pine is popular as bonsai.** The art of seeing nature in a single miniature tree while pruning and training it is unique to Japan, and dates back to the Heian period. This specimen is 2 feet (61 cm) high and is the popular *goyomatsu* ("Five-Needle Pine") variety. It is over one hundred years old.

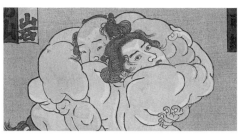

PAGE 77: **Woodblock print of the *sumotori* Kagami-iwa and Hidenoyama.** From the early Edo period, sumo tournaments were held every spring and fall. Woodblock prints were used to promote matches, and portraits of favorite wrestlers were popular with fans. This practice declined with mass color printing in the Meiji period, and was eventually superseded by the use of photographs.

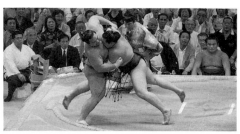

PAGE 77: **Sumo match between *ozeki* and *yokozuna*.** The basic rules of sumo are simple: the wrestler who either first touches the floor with something other than the soles of his feet or exits the ring before his opponent, loses. The bouts themselves usually last only a few seconds, and in rare cases up to one minute or more.

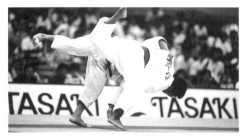

PAGE 78: **A Japanese judoist in an international competition.** The Kodokan was founded in 1882 by Jigoro Kano, who developed judo from jujitsu, a martial art for attacking or defending without weapons. Kano became the first Asian member of the International Olympic Committee in 1909. Judo became an official Olympic event in 1964, and is now popular worldwide.

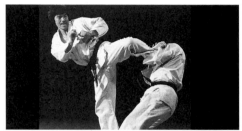

PAGE 78: **A karate practitioner fells his opponent with a kick.** Karate is a martial art to protect oneself without weapons, using punches and kicks to overwhelm an opponent. Based on a Chinese martial art, it developed in Okinawa and was introduced to Japan by the master Funakoshi Gichin. It has now become very popular abroad, and there are many styles.

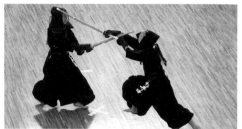

PAGE 79: **A kendo fencer scores to the opponent's mask.** Many schools of *kenjutsu,* forerunner to kendo*,* were established during the fifteenth and sixteenth centuries. In the mid-nineteenth century, use of *shinai* split-bamboo swords became popular, and dojos spread across Japan. As with all martial arts, training is much more than just a sport, and involves understanding the samurai spirit.

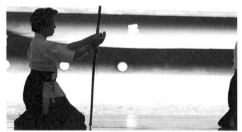

PAGE 79: **A kyudo archer meditates before shooting.** Kyudo (literally, The Way of the Bow) is one of Japan's oldest martial traditions. Diligent practice of kyudo is both healthful physical exercise and also a way of cultivating the self-awareness and spiritual maturity that leads to *shin zen bi,* or "Truth, Goodness, and Beauty."

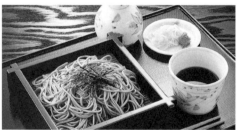

PAGE 80: **Buckwheat soba noodles are often served chilled with a dipping sauce.** Soba is believed to have come to Japan from Korea some 1,500 years ago. Nowadays it is available in supermarkets, but for many restaurateurs the skills and ingredients that go into making it are a closely guarded secret. It is traditional to eat soba on December 31 for New Year.

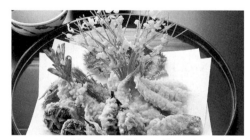

PAGE 80: **A wide range of ingredients is used for tempura.** Tempura first appeared in the mid-sixteenth century when open-air tempura stalls were popular, and the name possibly derives from the Portuguese cooking term *tempero.* Nowadays, it is eaten with a dipping sauce, or as a topping for rice or noodles. Some high-class restaurants specialize in exquisitely prepared and presented tempura.

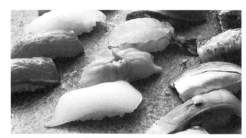

PAGE 81: **Sushi is one of Japan's most international dishes.** Sushi has its origins in techniques to preserve cleaned and salted raw fish by pressing it between layers of rice, weighting it with a stone, and leaving it to ferment. The custom of eating fresh fish with vinegared rice began in Edo (Tokyo) in the early nineteenth century.

PAGE 82: **Stones are used for steps, shoe rest, and water basin for purification.** This garden is part of the Tawaraya Inn in Kyoto, which epitomizes tradition. Here wooden clogs can be seen placed for the convenience of guests so that they may step into them directly from the veranda to stroll in the garden.

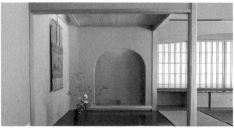

PAGE 82: **A traditional *sukiya*-style house.** *Sukiya-zukuri* houses, such as this one renovated by the architect Togo Murano, became popular with townspeople in the Edo period. The style was influenced by tea ceremony architecture, and was appreciated for its simple elegance, clean lines, and use of natural materials.

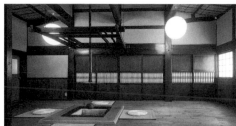

PAGE 83: **A renovated traditional *minka* house with *irori* sunken fireplace.** *Minka* houses like this one renovated by Shigekazu Imai were built according to the conventions of each region, using local materials, labor, and skills. The structure characteristically included a packed earth *doma* entrance and cooking area, and a raised-floor living area with open hearth.

PAGE 83: **A modern home, incorporating Japanese architectural elements.** The two-story Sumire Aoi House was originally built by the architect Makoto Masuzawa in 1952 in a space occupying a mere 29.16 square meters. Fifty years later Makoto Koizumi rebuilt the home and redesigned the interior, using almost the same floor plan but leaving the second floor as open space.

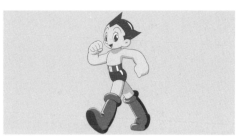

PAGE 84: **Astro Boy, Japan's first animated TV hero.** Astro Boy was a popular manga in the 1950s and premiered as a TV anime series in 1963. Created, animated, and produced by Osamu Tezuka with his own company, Mushi Productions, the series was a huge success and ran until 1966. Of the 193 episodes, 104 were dubbed and shown overseas.

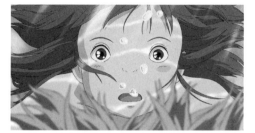

PAGE 84: ***Spirited Away* won an Oscar for Best Animated Film.** Hayao Miyazaki has been an independent producer and director since 1978, and his animated movies have won acclaim both in Japan and abroad for the beauty of their artwork, their humor and expressiveness, and their utterly charming characters. Miyazaki uses images from both Japanese folklore and Western fairy tales to create his magical worlds.

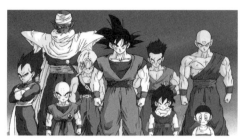

PAGE 84: **The denizens of *Dragon Ball Z*.** By Akira Toriyama, the original *Dragon Ball* manga appeared in the magazine *Shonen Jump*, and not only took Japan by storm, but gained a following worldwide. The TV anime series based on the manga began in 1986 and continued for more than a decade, including the sequels *Dragon Ball Z* and *Dragon Ball GT*.

PAGE 84: **Neo-Tokyo faces destruction in *Akira*.** Released in 1987 by Katsuhiro Otomo, *Akira* stunned audiences worldwide with its daring visuals and experimental digital and analog animation. It revolutionized anime, and its blend of new and old, tradition and rebirth, has been said to be representative of Japan as a country and as a culture.

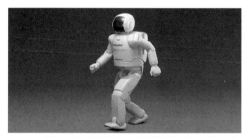

PAGE 85: **Honda's child-sized ASIMO robot.** Honda started its R&D program into humanoid robots in 1986 on the basic concept that robots should "coexist and cooperate with humans by doing what humans cannot do and by cultivating new dimensions in mobility that will ultimately benefit society." Today's ASIMO greets VIPs, shakes hands with prime ministers, and shows astonishing mobility.

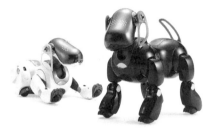

PAGE 86: **Sony's interactive AIBO becomes a pet.** Sony created artificial intelligence software to control AIBO's behavior and help make it into a lovable pet. AIBO sees, hears, feels, and of course, walks. It learns to recognize its owner's face and voice, can fetch a bone or ball, and its skill gradually improves as it plays.

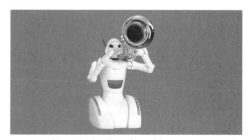

PAGE 86: **A musical robot from Toyota uses artificial lips to play the trumpet.** Toyota Partner Robots represent the first steps toward creating "personal assistant" robots. The aim is to create robots with human-like characteristics such as agility, warmth, kindness, and intelligence. Toyota developed three kinds of partner robots—walking, rolling, and mountable—each with its own areas of expertise.

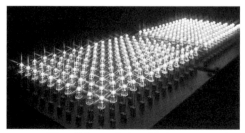

PAGE 86: **Blue light-emitting diodes are a major technological innovation.** Red and green LEDs have existed for some years, but a bright blue LED proved elusive until, in 1993, Nichia Corporation announced a blue LED sixty times brighter than any previously achieved. Nichia went on to produce the world's first blue laser diodes vital for CD and DVD recording media.

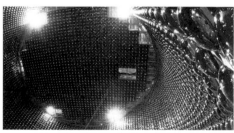

PAGE 87: **Neutrino-sensing facility called Kamiokande.** Kamioka Underground Observatory is located one kilometer underground, and investigates the stability of matter, one of the most fundamental questions of elementary particle physics. Since the 1980s, observation of cosmic neutrinos has helped determine the intrinsic properties of the neutrino itself, with important results for both astronomers and physicists.

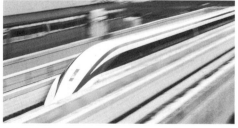

PAGE 88: **The MLX01 experimental Maglev train.** The aero wedge lead car is one of several designs to minimize drag at high speed. Maglev trains have been developed since the 1990s at a 26.6 mile (42.8 km) test line in Yamanashi prefecture, and a shorter line in Kyushu. Tests show that the Maglev is now ready for commercial high-speed travel.

ACKNOWLEDGMENTS

The publisher would like to thank the following for their collaboration:

Gion Festival Floats Association, Kita Kannonyama Hozonkai; page 48 top, Naginatahoko Hozonkai; page 48 bottom
Hatakeyama Museum of Art; page 75 bottom
Horyuji; pages 54–55
Imai Shigekazu, Architect; page 83 top
Imperial Household Agency; pages 44–45
Japan Actors' Association; page 72 bottom
Kabuki-za; page 25 bottom
Kanna Shobo; page 76 top and bottom left
Kenninji; page 69 top
Kodaiji; page 71 bottom left
Kofukuji; page 68 top
Koizumi Makoto, Architect; page 83 bottom
Komyoji; page 40
Kyoto National Museum; page 68 bottom
Kyubei; page 81
Kyukaen; page 76 bottom right
Murano Togo, Architect; page 82 bottom
Nijojo; page 47
NPO Bunraku-za; page 72 top
Ryoanji; page 46 both
Saihoji; page 42
Suntory Museum of Art; page 69 bottom
Tankosha, *Cha no kokoro*; page 75 top
Tawaraya, Kyoto; page 82 top
Todaiji; page 52–53
Yuzenshikai; page 71 top

PHOTO CREDITS

1989 Bird Studio, Shueisha, Toei Animation: page 84 center
A.M. Corporation: book band
Arai Katsumi, Dandy Photo: pages 32–33 top
Asukaen: page 68 top
Bon Color Photo Agency: page 33 bottom right
Dandy Photo: pages 26 top, 61, 63 top right, and 66 top
Egawa Museum of Art: page 71 bottom right
Goshima Kenji, Q Photo International: pages 16–17 bottom
Hata Ryo: pages 82 bottom and 83 top
Hibi Sadao: pages 43 top right and both bottom, and 66 center
Higashida Yuji, Q Photo International: pages 8–9
Honda Motor Co. Ltd.: page 85
Ichikawa Tsutae, A. Collection, Amana: pages 26–27 bottom
Inoue Hakudo: pages 52–53
Inoue Takao: page 75 top
Irie Taikichi, Nara City Museum of Photography: pages 54 both, and 55
Itsuo Art Museum: page 91 top center
JTB Photo: pages 48 both, 50, 51 top right and bottom, 60–61, 62 top, 63 top left, 74, and 78 top
Kaji Hiroya: pages 21 and 81
Kamioka Observatory, Institute for Cosmic Ray Research, The University of Tokyo: page 87
Kawahara Hisao: page 72 top
Kobayashi Tsunehiro: page 76 top and bottom left
Kobe City Museum: page 91 top left
Kodansha Photo Library: pages 68 bottom, 69 both, 70 both, 75 bottom, 76 bottom right, 78 bottom, and 91 top right
Kubozuka Hiroshi, A. Collection, Amana: pages 16–17 top; Bon Color Photo Agency: pages 30–31

Kudo Katsuhiko, Dandy Photo: page 14 top
Kuroda Isao, Bon Color Photo Agency: pages 56–57
Kuwata Mizuho: pages 10, 18–19, and 20 both
Kyoto National Museum: page 71 top and bottom left
Lisle, Chris, Corbis, Corbis Japan: page 49 bottom
Maeda Akira, Tankei: pages 6–7 and 12–13
Maeda Shinzo, Tankei: page 1
Masuyama Norio, A. Collection, Amana: page 36
Matsunaga Koki: pages 22–23
Minowa Tadashi, Pan-Asia Newspaper Alliance: page 40
Miyoshi Kazuyoshi: page 47; Pacific Press Service: pages 2–3, 38–39, and 46 top
Muromachi Masahiko, Dandy Photo: pages 5 center and 28
Negishi Soichiro: pages 27 right, 35 bottom left, 43 top left, and 62 bottom
Nichia Corporation: page 86 bottom right
Nihon Sumo Kyokai: page 77 both
Nishida Takao, Sekai Bunka Photo: page 5 bottom
Ogawa Tomoko: page 72 bottom
Otomo Katsuhiro, Mushroom, Kodansha: page 84 bottom right
Ozawa Hiroyuki: page 25 top
Photo Agency Eye: page 80 both
Photo Kishimoto: page 79 both
Portal Site of Culture—Digital Archives of Ishikawa, Japan: page 37 bottom
Railway Technical Research Institute: page 88
Saegusa Teruo, Pan-Asia Newspaper Alliance: page 24 top
Shinkai Yoshio, Sekai Bunka Photo: page 37 top
Shintani Shuji, Sekai Bunka Photo: page 65
Shiratori Yoshio: page 83 bottom
Simmons, Ben: page 51 top left

Sony Corporation. page 86 top
Studio Ghibli: page 84 top
Sudo Koichi, Bon Color Photo Agency: page 49 top
Tabata Minao: pages 44–45
Takada Yoshihiro, A. Collection, Amana: pages 58–59
Takeuchi Tokiko, Q photo International: jacket
Tanaka Masaaki, A. Collection, Amana: page 15
Tanji Yasutaka, Dandy Photo: pages 14 bottom, 34, 35 top and bottom right, and 64–65
Tezuka Productions: page 84 bottom left
Tohru Higuchi, Sekai Bunka Photo: page 16 left
Tokugawa Art Museum: page 67
Tokyo National Museum: page 56 left both, and 91 bottom left both
Tomita Fumio, A. Collection, Amana: pages 27 top left and 29 bottom
Tonoshiro Hiroshi, Dandy Photo: page 63 bottom
Toyama Takayuki: page 25 bottom
Toyoda Naoyuki, Q Photo International: page 66 bottom
Toyota Motor Corporation: page 86 bottom left
Tsuchiya Yutaka, Sekai Bunka Photo: page 29 top
Ushiki Kazuomi, Bon Color Photo Agency: page 24 bottom
Wakita Ippei, A. Collection, Amana: page 5 top; Bon Color Photo Agency: page 30 left
Yamamoto Kenzo, Tankei: page 4
Yamanashi Katsuhiro, Tankei: pages 32–33 bottom left
Yamashita, Michael S., Corbis, Corbis Japan: pages 11 and 46 bottom; Pacific Press Service: page 82 top
Yoshida Noriyuki: pages 41 and 42
Yoshikoshi Ken: page 73

Maps by Omori Tadamitsu

英文ビジュアル版　日本——うるわしき姿
Seeing Japan

2005年6月27日　第1刷発行

著　者　チャールス・ウィブル
発行者　畑野文夫
発行所　講談社インターナショナル株式会社
　　　　〒112-8652 東京都文京区音羽 1-17-14
　　　　電話　03-3944-6493（編集部）
　　　　　　　03-3944-6492（営業部・業務部）
　　　　ホームページ　www.kodansha-intl.com
印刷・製本所　大日本印刷株式会社

落丁本・乱丁本は購入書店名を明記のうえ、講談社インターナショナル業務部宛にお送りください。送料小社負担にてお取替えいたします。なお、この本についてのお問い合わせは、編集部宛にお願いいたします。本書の無断複写（コピー）は著作権法の例外を除き、禁じられています。

定価はカバーに表示してあります。

Printed in Japan
ISBN 4-7700-2337-5

CHRONOLOGY

JOMON PERIOD — c. 10,000–c. 300 B.C.

YAYOI PERIOD — c. 300 B.C.–c. A.D. 300

KOFUN PERIOD — c. 300–710

552 — Introduction of Buddhism from China.

607 — First official embassy to China.

645–50 — Taika Reform.

NARA PERIOD — 710–94

710 — Nara becomes Japan's first capital.

752 — Dedication of the Great Buddha of Todaiji temple, Nara.

781–808 — Reign of Emperor Kanmu.

HEIAN PERIOD — 794–1185

794 — The capital is moved to Heiankyo (Kyoto).

838 — Twelfth and last embassy to Tang China.

995–1027 — Supremacy of Fujiwara Michinaga, official of the imperial court.

c. 1002 — Sei Shonagon writes *The Pillow Book*, a diary of Heian court life.

c. 1008 — Murasaki Shikibu writes the *Tale of Genji*.

1180–85 — Genpei War between the Minamoto and the Taira clans, won by the Minamoto.

KAMAKURA PERIOD — 1185–1333

1191 — The monk Eisen returns from China and founds the Zen sect.

1192 — The title of shogun is granted to Minamoto no Yoritomo.

1219 — Minamoto no Sanetomo, the third shogun, is assassinated, ending the line of Minamoto shoguns.

MUROMACHI PERIOD — 1333–1573

1374–1408 — Noh drama flourishes through Kan'ami (1333–84) and Zeami (1363–1443) under the patronage of shogun Ashikaga no Yoshimitsu (1358–1408).

1392 — Reunion of the Northern and Southern Courts.

1397 — Kinkakuji (Golden Pavilion) temple built by Yoshimitsu.

1542 — Portuguese land at Tanegashima, an island south of Kyushu, and European firearms are introduced.

1549 — St. Francis Xavier (1506–52) arrives in Kyushu.

1568 — Oda Nobunaga (1534–82) occupies Kyoto.

AZUCHI–MOMOYAMA PERIOD — 1568–1600

1573 — Nobunaga consolidates his power and the fighting ends.

1682 — Nobunaga is assassinated by Akechi Mitsuhide; Toyotomi Hideyoshi (1536–98) succeeds him.

1586 — Osaka Castle is built by Hideyoshi.

1587 — Sen no Rikyu (1522–91) officiates the grand tea ceremony held in Kitano, Kyoto, under the sponsorship of Hideyoshi.

1589 — Christianity is proscribed.

1600 — Tokugawa Ieyasu (1542–1616) wins the Battle of Sekigahara.